# PAINTING
# THE TOWN
# ORANGE

# PAINTING THE TOWN ORANGE

## THE STORIES BEHIND
## HOUSTON'S VISIONARY ART ENVIRONMENTS

## PETE GERSHON

Charleston    London

THE
History
PRESS

Published by The History Press
Charleston, SC 29403
www.historypress.net

All images from author's collection unless otherwise noted.

First published 2014

Manufactured in the United States

ISBN 978.1.62619.439.7

Library of Congress CIP data applied for.

*This book is dedicated to Cleveland Turner, the Flower Man,*
*1935–2013*

# CONTENTS

# ACKNOWLEDGEMENTS

I am deeply indebted to countless individuals who provided crucial information and assistance and generally made me feel welcome in the course of writing this book. First and foremost I want to thank Barbara and Marks Hinton, who opened up their home and their personal archives to me as well as provided drinks, advice and encouragement. What's more, Marks's painstakingly researched visitors' guide to the Beer Can House formed the basis for my understanding of the timeline of the site's construction. I must salute Rebecca Jacobs-Pollez for her remarkable research into the life of Jeff McKissack. Her graduate thesis on the Orange Show was an invaluable starting point and framework for studying his life story. Susanne and David Theis and the current Orange Show staff—Lynette Wallace, Wendy Schroell and Ruben Guevara—also shared their time, observations and/or research, as did James Harithas, John Alexander, Sharon Kopriva, Dadi Wirz and Ty and Ginny Eckley. Thanks to Ken Penuel, chairman of economic development in Fort Gaines, who provided information that only someone from McKissack's hometown would know, and to David McKissack, for his extensive genealogical portrait of his family. Leonard DeGraaf, archivist at the Thomas Edison National Historical Park, and Peer Ravnan, special collections assistant at Mercer University's Tarver Library, dug around in their files for a complete stranger. And kudos to Bill Martin, Tom Sims, Ken Hudson and Joe Lomax for their foresight in bringing their tape recorders and video cameras to the Orange Show when Jeff McKissack was still alive. John and Barbara Siml, Dennis Hollander, James Kachtick,

# Acknowledgements

Ken Knisely and Julie Birsinger provided Beer Can House background, as did Ronnie Milkovisch, who also made some amazing custom bottle cap earrings for my wife. Thank you Cleveland Turner for letting me sit on your porch for hours and pepper you with strange questions. Jim Pirtle, Nestor Topchy, Rick Lowe, Cameron Armstrong and Jack Massing recounted the history of Notsuoh and Zocalo/TemplO for me. Dan Phillips and Stephanie Smither likewise brought the future of Smither Park to life. Legions provided background, context, and incidental memories or helped me sift through rumors and half-truths: the Reverend Bryan Taylor, Tom LaFaver, Geraldine Aramanda, Lisa Barkley, James Surls, Mel Chin, Bill Camfield, Mimi Kilgore, Robert Pearson, Glenn Carman, "isuredid," Missy Bosch and others I'm probably forgetting. Larry Harris, George Hixson, Ben DeSoto and Paul Kuntz shared incredible documentary photography. Of course I am grateful to the people at The History Press, especially Christen Thompson and Ryan Finn, for their help and their enthusiasm for the project. And then there's Marilyn Oshman, without whom there might not have been anything left for me to write about. Most of all, for support above and beyond the call of duty, I thank my parents, who sent me to college to learn how to do this (and not at all incidentally my writing professor, Michael Lesy, for kicking my butt daily there); my kids, who provided constant love and entertainment; and my beautiful wife, who has been an incomparable source of affection and encouragement over these past decades. Zaeza, I couldn't have done it without you.

# INTRODUCTION

Founded in 1836 on the banks of Buffalo Bayou and named after the charismatic president of the Republic of Texas, Houston is the fourth-largest city in the United States. This sprawling, paved-over urban megalopolis is home base to the country's energy industry, its busiest port, its largest concentration of healthcare and research facilities, professional teams from almost every sport, resident companies for all major performing arts from theater to ballet to opera, several internationally renowned museums, the world's largest rodeo and livestock show and NASA's Johnson Space Center.

The city that boasts North America's third-tallest skyline contorts in a constant state of demolition and construction, with charming bungalows and shotgun row houses daily giving way to cookie-cutter townhomes and bland commercial parks. In the country's largest urban area without zoning regulations (defeated in citywide referendums in 1948, 1962 and 1993), property rights reign supreme, with the matter of historic preservation largely swept under the rug.

But tucked away within the city's Telephone Road Place subdivision, just to the east of the Gulf Freeway and less than seven miles south of the downtown skyscraper district, the visitor will find a blue-collar neighborhood left largely untouched since its construction in the 1940s and '50s. Take the Telephone Road exit off Interstate Route 45, follow the access road for four blocks and hang a right on Munger Street. Up and down this narrow road are rows of asbestos-sided cottages that retain a certain charm even if they've clearly seen better days. Only the dull roar of the freeway disrupts

this otherwise quiet thoroughfare that harkens back to a vanishing era in the city's history, hinting at a time before the Magnolia City became the Space City, before pollution began killing the trees and before John F. Kennedy sent a man to the moon.

Keep driving, and you won't miss it. On the left hand side of the street, colorful minarets of welded steel topped with waving flags peek over the tree line. Then, ornately filigreed grillworks come into view, exploding with an eye-popping conglomeration of brightly colored awnings, wagon wheels, parasols and whirligigs spread out over multiple open-air levels. Finally, set into its white stucco façade, gleaming in the midday Houston sun, you see the mosaic tiles that boldly proclaim the structure's name. You've by now slowed to a stop in front of…the Orange Show.

In the words of its creator, a retired postman named Jefferson Davis McKissack, it's the "most beautiful show on earth, the most colorful show on earth, and the most unique show on earth." Beauty may be in the eye of the beholder, but on the latter points it's difficult to argue. What the heck is this crazy thing? Amusement park? Monument? Sculpture? Official consulate to an artsy-fartsy bizarro world? It's all of these things and more.

McKissack, by all accounts a hale, hearty fellow with an easy smile and a perpetual twinkle in his eye, toiled on this one-tenth-acre plot from 1956 until its official public unveiling in 1979 shortly before his death, first as the American Tree Nursery and Worm Ranch and then, presumably as a ploy to meet women, a prospective beauty salon. But sometime in the mid-1960s, inspiration struck, and he amended his building permit by typing, "Beauty salons went out of style and many closed down. Had a better idea—THE ORANGE SHOW."

The Orange Show was McKissack's monument to the orange, linking the fruit's nutritional benefits to the concepts of healthful living, self-reliance, hard work, civility and clean, efficient steam power. "That's right," he told Bill Martin during one of only four known recorded interviews he gave, which resulted in a 1978 exposé in *Texas Monthly*. "I associated steam with oranges because both of them produce energy. People are interested in steam. It doesn't pollute the air and it's good for economy reasons."

"That's as close as he could get to people," said Ty Eckley, McKissack's neighbor during the last five years before he died. "You know, 'I've got something very valuable to tell you, and it's so valuable, and you need to know it so severely, that I'll sacrifice my entire life for it.'"

His life's work has come to be considered as one of the nation's premier examples of what's known to many as the "folk art environment," right

alongside the ceramic-studded metal spires of Sabato Rodia's Watts Towers in Los Angeles, the Bottle Village constructed in Simi Valley by Tressa "Grandma" Prisbey to house her collection of pencils and dolls and the devotional paintings adorning Howard Finster's Paradise Garden near Summerville, Georgia (which also began as a plant farm, coincidentally). Within this admittedly rarified framework, the fruits of McKissack's labor fit right in.

These unreal estates are handmade living (or working) spaces, often crafted obsessively but intuitively over the course of decades by self-taught individuals without formal blueprints in order to express some kind of personal, moral vision. Frequently they are made of whatever cast-off and reclaimed materials may be at hand, employing a process that anthropologist Claude Lévi-Strauss called bricolage. Often their makers live in isolation and begin their work during their final phase of life. And sadly, these environments almost always fall into disrepair and outright destruction after the passing of their creators. Neighbors and family members tend to regard such structures as just so much junk, although that's beginning to change as various groups, including representatives of the respectable fine art crowd, have begun to make serious attempts to catalogue, preserve and promote such sites.

The pioneering figure in this field of study was one Seymour Rosen. Born in Chicago in 1935, he moved with his family to Los Angeles in the early 1950s and, while attending its Phoenix University, became a protégé of architectural photographer Marvin Rand, who had been among the first to document the Watts Towers. The Towers comprise a series of decorated walls and spires, the tallest of which stands ninety-nine and a half feet, built between 1922 and 1955 by Sabato "Simon" Rodia, an Italian immigrant who used the simplest of tools: a pipe fitter's wrench and a window washer's belt and buckle. Rosen tried his own hand at photographing the Towers, but according to legend, he gave up after three shots, assuming that it would be a fool's errand to try to capture their awe-inspiring beauty on film. He would return again and again to the Towers, however, and his subsequent images, collected in a 1962 photo exhibit at the Los Angeles County Museum, along with a groundbreaking article on Rodia and his project by Calvin Trillin in the *New Yorker* in May 1965, were the first serious efforts at legitimizing such structures as important works of art. "If a man who has not labeled himself an artist happens to produce a work of art, he is likely to cause a lot of confusion and inconvenience," wrote Trillin, neatly distilling the entire subject of visionary environments down to one pithy opening sentence.

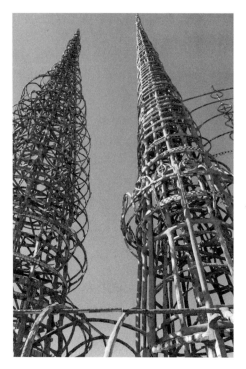

Watts Towers, Los Angeles, California. *Photo by InSapphoWeTrust.*

In 1978, Rosen formally turned his voluminous archive of periodicals, books, objects and some twenty-five thousand photographs into SPACES (Saving and Preserving Arts and Cultural Environments). He died in September 2006, but his work continues, both at SPACES (now under the stewardship of San Jose State gallery director Jo Farb Hernandez) and by other groups, notably the Preserve Bottle Village Committee in Simi Valley and the Kansas Grassroots Arts Association. Materials developed by Rosen still prove instrumental in helping to save sites—often, as Hernandez likes to say, "at the eleventh hour when the bulldozers are at the other end of the block."

Hernandez discourages me, or anyone else for that matter, from referring to sites like the Orange Show as folk art environments:

> *The use of the term "folk" implies an aesthetic that's recognizable, understood and shared by members of a group, whether it's ethnically, religiously, occupationally, geographically or whatever-based. For example, a group of quilters would be able to assess any given quilt and judge its quality, as would a group of fiddlers or a community assessing the proportions of a new barn. In contrast, these art environments are really idiosyncratic expressions that are unique and are therefore much more akin to contemporary art than to folk art. They're not linked to any group. They are individual artworks, monumental though they may be.*

While SPACES has done the most to protect and preserve such environments, another such organization following in Rosen's footsteps is housed in a drafty bungalow across the street from the Orange Show itself. Founded shortly after McKissack's death by his friend, arts patron and

sporting goods magnate Marilyn Oshman, the Orange Show Foundation (now operating as the Orange Show Center for Visionary Art) was established in 1981 to purchase the postman's land and preserve his shrine. In the thirty years since, its mission has grown to offer a range of educational programs for both children and adults, to administer the world's largest art car parade, which uproariously chugs down Allen Parkway each May, and to document and support other visionary art environments in Houston and around the Southeast.

In fact, Houston is the country's leading city for this kind of thing. It's home to a bungalow clad entirely in an armor of flattened beer cans, a house anointing itself a "shrine to swine" in which its late owner's famous pet pigs are celebrated with yard art and modified road signs, a man who's overcome his drinking problem and enlivened a blighted neighborhood by turning his neighbors' trash into treasure and a performance artist whose major work is the stewardship of a neglected architectural jewel still filled with one hundred years of pawnshop flotsam.

"It has to do with the absence of a need for permission," suggested Cameron Armstrong, a Houston-based architect who's studied the city's site-specific structures extensively. "Or rather, the assertion that the need for permission is totally irrelevant. It's this extreme ideology of the self-reliant individual and how it orients itself against planning, while at the same time it's very opportunistic. Ultimately it's about the libertarian spirit."

The confluence of seemingly limitless, wide-open space; the lack of zoning restrictions; and a fiercely independent, wildcatter attitude has resulted in a climate where these visionary spaces have survived, and sometimes thrived, against the odds. The sites themselves are redolent with notions of identity, biography, memory, history, transformation and social organization. They overlap and reinforce one another and blur the very boundaries between art and life. In each case, the structures point back to German Fluxus artist Joseph Beuys's concept of "social sculpture" and his proposition that, in fact, everyone is an artist. Indeed, that's the very motto of the Orange Show Foundation: "Celebrating the artist in everyone."

"This art is about as advanced as anything you can find in the world, excuse me," insisted Armstrong. "And it comes completely out of the soil and the ideology of Houston. That's strong stuff."

Chapter 1

# THE ORANGE SHOW BY JEFF MCKISSACK

One day in the spring of 1979, workers at the Schlumberger Well Surveying Corporation's office and industrial complex near the Gulf Freeway received a curious invitation amid their usual memos and business correspondence:

*DEAR FRIEND    COME TO THE ORANGE SHOW!*
*IT IS AS NEW AS THE MOON* ———— *AS NEW AS THE DOME STADIUM*
*OPENING DATE WEDNESDAY MAY 9 1979*
*Admission—only $1.00—Please bring correct change*
*Come to The Orange Show and Vote! We need your vote.*
*What you will be voting on* ———— *A yes or no vote.*

*Can you say The Orange Show is the most beautiful show on earth?*
*Can you say The Orange Show is the most UNIQUE show on earth?*
*Can you say The Orange Show is the most COLORFUL, in harmony, show on earth?*
*Can you say The Orange Show is the 9th wonder of the world?*
*Can you say that Jeff D. McKissack, who built the Orange Show, all by himself, over a period of many years is a CREATIVE, ARTISTIC BUILDING GENIUS?*

Following some directions and parking information, it concluded:

*THE ORANGE SHOW IS A JEFF D. MCKISSACK, PRODUCTION*
*Located at 2401 Munger Street, Houston, Texas 77025*
*COME TO THE ORANGE SHOW—IT'S NEW—IT'S GREAT*
*YOU'LL LOVE IT*

It's hard to imagine what the Schlumberger paper pushers and metal fabricators made of this immodest entreaty, and it's impossible to know how many, if any, actually made the effort to visit their neighbor and cast a ballot. But one thing we can be sure of is that when May 9 finally arrived, it was the day that Jeff McKissack had been working toward all his life. The former mail carrier had spent almost every waking moment since his retirement in 1966 thinking about and constructing the Orange Show, his personal monument to the sweet orange and a rigorous program of healthy living laid out in his self-published treatise *How You Can Live to be 100 and Still Be Spry*.

Buoyed by coverage by the local news stations, popular radio personality Alvin van Black and *Houston Chronicle* reporters Patricia Johnson and Ann Holmes, McKissack expected thousands to arrive for his grand opening. No matter that only about 150 visitors showed up—dressed smartly in orange slacks, a white collared shirt and an orange fedora, the southern gentleman greeted his guests with a broad smile and guided them through his maze-like creation with the enthusiasm of a child.

Within white stucco walls decorated with colorful tiles, some spelling out mottoes like "We are glad you are here" and "Be smart—drink fresh orange juice," he showed them the elaborate fences and railings he made by welding together rebar, metal buggy wheels and portions of discarded fire escapes. He pointed out the water fountains and statuary he'd picked up at antique stores between Houston and Hot Springs, Arkansas, where he made annual sojourns to bathe in its restorative radioactive waters. He encouraged them to marvel at his "museum," in which costumed mannequins, stuffed animals, a wooden Indian, a ceramic frog, a holiday display Santa and a metal scarecrow stand beside plaques relating parables about the benefits of a positive attitude, hard work and stick-to-itiveness. And it was with special pride that he showed off his Tri-State Steamboat, a metal contraption that, when fired up, would paddle its way around the circumference of a circular pond, twenty-seven feet in diameter. The pond's walls were inscribed with the four major stops of the Chattahoochee River, alongside which the young Jeff McKissack was born and raised.

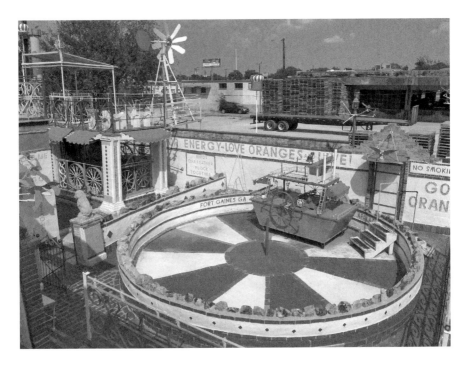

The steamboat pond, August 2011.

When University of St. Thomas professor Tom Sims's film class dropped by in the fall of 1979, McKissack told the students, "Well, I put a tank here and built a steamboat. I didn't know how I was going to do it, but fact is, I didn't know how I would build the show when I started it. About two years I was lost. But I kept on working and trying to form a pattern. So, I built this tank here and had this steamboat going round and round and have three bells and steam whistles. I built this stadium here where people could sit down and watch the steamboat going round and round the tank."

McKissack's "stadium" accommodates as many as 250 guests on long benches and, one tier above, on multicolored tractor seats that look down on the boat pond or, at a half turn, toward a "sideshow" stage where McKissack planned one day to have a beautiful young lady in a black evening dress playing an organ atop a rotating platform. He'd "give a spiel" on oranges, he told friends, and a young boy would tap-dance.

Looking down from this upper deck, one gets the full appreciation of McKissack's accomplishment. Staring through the spokes of multi-hued wagon-wheel railings near and far, whose design mimics the segmented appearance of a sliced orange half, at the panoply of metal birds, spinning

weathervanes and proverbs laid into the stucco walls with colorful tile, the details accumulate into a dizzying, kaleidoscopic visual *Weltanschauung*. It may have been McKissack's alone, but he wanted it to be yours, too.

When *Texas Monthly* writer Bill Martin visited in 1977, McKissack graciously guided him through the work in progress. Here he describes his ambitious plans for the steamboat:

> *We'll put on a show with this steamboat. I'll have miniature bales of cotton for cargo and a colored man sitting on the bales of cotton—dolls, you understand—and they will fire the cannon at the Indians. I've got a monkey that runs by battery and he'll clap his hands. I've also got some frogs that run by batteries. We'll stop the boat and let folks watch the frogs perform. They're not real, but people will think they're real. They won't be able to tell the difference.*

When McKissack took Martin into his twelve- by thirty-two-foot-long exhibit hall, the writer found decommissioned department store mannequins in a state of undress. On one side, a golfing mannequin had swapped his 9 iron for a woodsman's axe, with his female companion pleading with him to "spare that orange tree." On the opposite wall, he saw a teepee, a wooden cigar store Indian, a stuffed snake and a blank space where McKissack told him he planned to install a "go-rilla." A placard read thusly:

*Indian Hate Gorilla*
*Gorilla Steal Indian's Corn*
*Indian Hate Snake*
*Snake Bite Indian—*
*Poison Indian*
*Indian Hate White Man*
*White Man Steal All Indian's Ideas*
*White Man Shoot Indian—*
*Take All Indian's Land*
*Indian Love Orange*
*Orange Make Indian*
*Heap Big Strong*

Clearly, the connection to oranges was sometimes tenuous at best. But as McKissack assured Martin, "Nobody'll get mixed up about my show once I get my decorations up. I've got orange banners and orange umbrellas with flags on them and lots of orange trees with oranges on them. They're

artificial trees made in Korea, and they're tough, too. They got wires in them. You cain't hardly tear them up."

The sad fact is that the steamboat sprang a leak and took on water, and McKissack never mounted his hay bales, never found a doll to represent the "colored" man and never put his battery-operated monkey and frogs fully to use. Although he interviewed several applicants, he never hired his organist and never got the sideshow's rotating dais to work properly. He never found the right "go-rilla" and had to make do with a stuffed bear given away as a carnival prize at the annual Livestock Show, and he adjusted his sign accordingly. And the tens of thousands of visitors he was convinced would stream through the cherry-red front gate he constructed from welded machine gears came too late for him to guide them personally.

By late 1979, friends and neighbors had noticed a different Jeff McKissack—sad, withdrawn and occasionally housebound. With his life's work largely completed and without the hordes of guests to be entertained and to replenish his bank account, he gave up the ghost. In late December, almost nine months after the opening of the Orange Show, Jeff was on the way home from the Dinner Bell Cafeteria, his daily lunch spot, when he stepped off his bike, staggered into his bank, suffered a stroke and crumpled to the floor. A security guard attempted to revive him, but too much damage had already been done. He was rushed to Southern Methodist Hospital, where he lingered speechless for a few weeks and then passed away quietly. The man who was certain that he'd live to be one hundred died on January 26, 1980, just two days shy of his seventy-eighth birthday. In his will, the lifelong bachelor left all of his property to his sister Ruth's boy, Alex Hurst, who flew in from Santa Barbara, California, to find a bizarre, rusting folk art monument to the orange and a note on his uncle's desk that read, "If anything happens to me, call Marilyn Oshman."

"It was the last thing I expected in my life, that the Orange Show would be open to the public and that I'd be running it," said Marilyn Oshman, who befriended Jeff McKissack in 1975 when she was the board president of Houston's Contemporary Arts Museum (CAMH) and who still chairs the foundation she started in 1981 to preserve his work.

Oshman is the heir to the Oshman Sporting Goods Company, established by her father, Jake, in 1931, as well as its unconventional board chairwoman—when the chain briefly foundered in the mid-'90s, she wore camouflage clothing every day for over a year, "hunting for profit," until the company was back in the black. She is also well known in Houston as an enthusiastic patron of the arts who besides having helped lead the CAMH in

the mid-1970s has also amassed a spectacular private collection with works by such modern masters as Jasper Johns, Joseph Beuys, John Chamberlain, Thornton Dial and Frida Kahlo (until Oshman sold her Kahlo masterpiece *Roots* via Sotheby's in 2006 for a record-setting $5.6 million). She'd also commissioned the "House of the Century," a mysterious postmodern lake retreat that looked like the Yellow Submarine got it on with an Eames chair, built forty-five miles south of Houston in 1972 by a group of avant-garde conceptual artists that called itself Ant Farm.[1]

"What do I look for in art?" asked Oshman. "Probably the same thing I look for in people. It's really not that far apart. Something that's authentic. And authenticity has a vibration. You can't hear it, but you can feel it. It's like that. That's the whole reason why I loved the Orange Show. Okay, here was a man living in this universe that he had built over a twenty-five-year period, not interested in selling it, just doing it because he had to. That was very attractive to me. It's about the human spirit. Something very real is happening here."

McKissack might have expected to live to be one hundred years old, but he was practical enough to hedge his bets. He actively cultivated his relationship with Oshman with hopes she might preserve the Orange Show after his passing, suggested Susanne Theis, who would serve as the first director of the foundation Oshman established to safeguard his work and who, in the years since, has done as much as anyone else to document and promote such sites in Houston.

According to Theis, when McKissack found himself lacking the funds needed to meet some permit obligations with the city, Oshman offered to lend him the money. Jeff refused the loan, but she did convince him to sell her a large iron figure that he'd welded together for the show called *The Clockman*, with arms and legs jutting from a wagon-wheel torso and a stylized clock for a face. "That was a very specific intervention," said Theis. "When he came to her house to install it, he understood that she was a person of means, and he also understood that she was interested in helping him."

When it fell to Oshman to maintain her friend's legacy, she went at it with gusto, raising money to buy and restore the property and setting up a board and an administrative staff with a mandate to connect with the community. According to Oshman, she wasn't interested in preserving the site as mere roadside kitsch. "You know," she said, "like the kind of place you go on a Saturday to show your cousin visiting from Iowa…I wanted it to be a living, breathing monument."

Over the next three decades, the foundation would put on hundreds of quirky, educational presentations for both kids and adults; launch a series

of "Eyeopener" bus tours to attract attention to unique, handmade folk art spaces throughout Houston and beyond; purchase and preserve a West End bungalow completely covered in flattened beer cans and surrounded by a marble-studded concrete sculpture garden (more on this in chapter 2); and produce the world's largest art car parade, annually drawing more than 250,000 spectators. In 2003, the Orange Show Foundation changed its name to the Orange Show Center for Visionary Arts and adopted the tagline, "Celebrating the artist in everyone."

Meanwhile, it's been a constant struggle to stabilize the site. For all of his artistic vision, gumption and dogged determination, McKissack had only rudimentary construction skills. Standing in the entrance foyer of the Orange Show one hot day in August, I asked Ruben Guevara, its eager young property manager since 2010, for his assessment of McKissack's strengths as a builder. He paused thoughtfully and rubbed his hand affectionately over a wall's rough, white stucco surface.

"One way or other, he made it happen," he said. "And that's still the Orange Show style. Sometimes, you just have to make it happen. It might be at the last minute before the show opens, and it may not always be done the way it's supposed to be, but it'll go up. To work on a place like this, you have to be versatile." McKissack once told his neighbor (and frequent verbal sparring partner) Lew Harrison that nobody else, not even the engineers at Brown and Root, could have built something like the Orange Show. "I don't think they would want to build something like the Orange Show," Harrison retorted.

The dodginess of its structural integrity notwithstanding, its value is in the details. Tucked away in the northeast corner is a charming little wishing well ringed by heart-shaped tiles. ("I guess they're gonna wish for love and money," McKissack told Sims's film class. "That's about the only two things everybody seems to want.") A small courtyard features an array of gas tanks, funnels and pipes representing a chemical converter plant and the elements found within the orange; toilet bobbers welded to skinny posts like oversized green lollipops are labeled "Riboflavin (Vitamin B2)," "Thiamine" and "Vitamin C." A statuette of Confucius stands atop a pillar offering the following advice, spelled out in pale blue tile: "Conficious [sic]: If you do not want to be criticized, say nothing do nothing be nothing." An open-air booth labeled "The Gift Shop" is flanked by a row of tiles depicting automobiles from the early 1900s, like the kind that once rattled down the unpaved roads of Fort Gaines, Georgia, where McKissack was born and raised.

Sometimes directly, sometimes obliquely, almost every detail points backward to the biography and psychology of this very unusual man. And

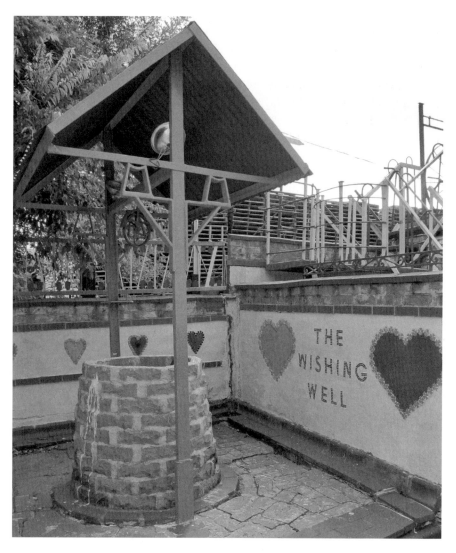

The wishing well, September 2013.

for all of his trials and tribulations, the message he put across in his life's work is overwhelmingly hopeful and forward thinking. In the postscript of a yellowing letter buried in the Orange Show's archives, this optimistic visionary's nephew Alex quoted him thusly: "I may look at the world through rose-colored glasses, but what I see sure makes me happy."

For just one dollar, he offered his typewritten manuscript, *How You Can Live to Be 100 and Still Be Spry*, thirty-nine pages of advice on what and where to

eat, "the result of 600 hours spent in research work in the public libraries of America, plus 40 years of study, observations, and accumulated experiences… reading time—ONE HOUR," according to its frontispiece. On page one, he wrote, "If you think you do not want to live 100 years or more, then try this adventure for sure. Select the best and most beautiful funeral home you can find. Go to it and take a good look at a body in a casket. Even though the body is well dressed and well fixed, you will know that you would like to defer that event as long as possible. After the good look you will be more enthusiastic about 'getting busy' and prolonging your life as never before."

David McKissack of Blacksburg, Virginia, has traced his family's genealogy back to John and Rebeccah McKissack, who built a homestead on land south of Halifax, North Carolina, in 1744, although David presumes earlier unnamed ancestors to have immigrated to the United States from Scotland. John and Rebeccah's descendants would farm and fight their way from the Carolinas to Tennessee and eventually to Georgia by 1792. Like so many other settlers, they raised tobacco and cotton and battled both the Native Americans they helped displace and British troops in the Revolutionary War and the War of 1812. The 1820 lottery for property in southwest Georgia drew Jeff McKissack's great-grandfather Archibald and his brothers, Thomas and James, to land just ceded to encroaching white men by the local Creeks and Seminoles. For the next several generations, McKissacks would live on either side of the Chattahoochee River in Henry County, Alabama, and in Clay County, Georgia.

The steamboat era on the Chattahoochee from 1828 to 1921 was undoubtedly the most interesting and romantic in the region's history. "The mighty blast of the steamboat whistle usually aroused enough curiosity to cause half the town to run to the docks or the bridge to see the steamboat glide by," wrote one turn-of-the-century diarist. "[I] fondly recall seeing large steamboats on the Chattahoochee River carrying bales of cotton and other cargo and some passengers and it was my desire as a boy to ride one of the steamboats down the river to Apalachicola."

Indeed, the steamboats carried passengers as well as cotton, and some installed saloons, lounges and sleeping apartments for the comfort of their first-class riders, who naturally paid a premium. The best-known and longest-running steamer was the *Naiad*, on which waiters in starched white uniforms served gourmet meals to cabin passengers and whose amusements ranged from playing cards and listening to early jazz bands to shooting at alligators from the guardrail.

Established in 1816 by the order of General Edmund P. Gaines, Fort Gaines, Georgia, emerged as an important river town, the "Queen City of the Chattahoochee," strategic both for trade as well as for the local settlers' protection. Forts were erected on the bluffs overlooking the river during uprisings of the Creeks and Seminoles and again during the War Between the States, although in the end no Civil War battles were fought there. Clearly, Jeff's grandfather Archibald Junior was a proud Confederate man—he named his three boys Jefferson Davis McKissack, Robert E. Lee McKissack and Samuel Stonewall Jackson McKissack.

Jefferson was born across the river in Henry County on February 24, 1861 (just two weeks, in fact, after Jefferson Davis resigned his Senate seat and was elected provisional president of the Confederate States of America). At twenty-three, he opened his dry goods store in a two-story brick building at the intersection of Hancock and Commerce Streets in "downtown" Fort Gaines, then as now just a few blocks long. He married Beulah Cummings Hill on August 21, 1885, and moved into the house on North Hancock Road that she shared with her widowed mother, Elizabeth; they added a second floor with an ornately balustraded veranda to accommodate their rapidly growing family. Bessie was born in September 1886, followed by John in 1889, Ruth in 1893, Winnie in 1895 and Hope in 1899. Our man Jefferson Davis McKissack Jr. was born at home on January 28, 1902, as recorded in the family Bible. His only younger sibling, Wilmer, was born in 1905 and died two years later.

The McKissack general store prospered, with the elder Jefferson making regular train trips to Atlanta and sometimes as far away as Baltimore to search for goods. "He sold just about everything," according to his great-granddaughter Carol Coleman. "Clothes, shoes, hats, blankets, bedding, matting for floors, rugs, art squares, curtains, trunks, suitcases, furniture, groceries, toys, caskets, farm supplies such as plows, feed, seed, sewing machines and phonographs." Truly the store where you bought not only your children's toys but your caskets, too, had something for everyone, cradle to grave.

In the summer of 1986, a volunteer by the name of Caroline Bowles collected a series of correspondence with Jeff's sisters Winnie and Hope, as well as some of his nieces and nephews, to try to glean what she could about McKissack's early life for the preparation of a poster display at the Orange Show.

What emerges from these letters is a patchy, sepia-toned portrait of turn-of-the-century life in rural Georgia. There's a Xerox of a cabinet photo of

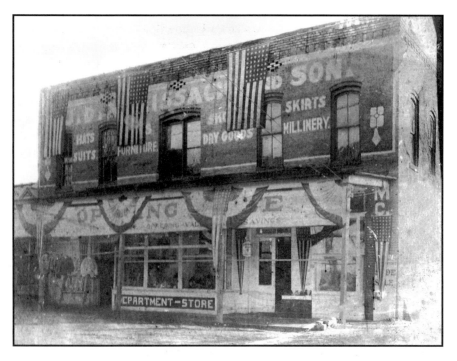

J.D. McKissack Dry Goods in downtown Fort Gaines. *Courtesy Ken Penuel.*

young Jeff Jr., no more than six or seven, dressed as George Washington for a school play. He sports a three-cornered hat, a military jacket with chest ruffle, pilgrim shoes with large buckles and, of course, the hatchet with which he'd chopped down the apocryphal cherry tree. A letter from his niece Doris Coleman Gilreath relates a charming, slice-of-life vignette concerning the arrival of the first automobile in Fort Gaines. As it is driven down the muddy, rutted road by her grandfather S.D. Coleman the neighborhood children rush along beside it. Young Jeff is jostled in the crowd and falls to the ground, crying. Coleman notices this and returns to hoist the young boy into the buggy for a ride. "He was one sweet young brother," remarked his sister Hope at the age of eighty-seven. "No bad habits as he grew up…we all loved him."

As a boy, Jeff Jr. enjoyed school, worked alongside his father in the store and spent his free time in a Huck Finn–style existence, running barefoot along the river as he watched the steamboats chug past, their immense paddle wheels churning the brackish water and propelling them to or from the river's other major steamboat stops in Columbus, Georgia; Eufaula, Alabama; and Apalachicola, Florida. They were an impressive sight, but

in fact, the steamboat era was already winding down during McKissack's boyhood. Heavy sedimentation from deforestation and cotton cultivation was filling the riverbed with silt; during dry summer months, the Chattahoochee became shallow in places, and commerce suffered. An attempt by the Army Corps of Engineers to widen the channel made the problem worse. And with the southwestern rail line out of Savannah now providing faster and more consistent means of transportation, the steamboats were already outmoded by the time young Jeff was walking down to the landing at the end of Commerce Street to attend dances on their brightly lit decks. The last steamboat still plying the river was sold off in 1921.

In the summer of 1918, while World War I raged in Europe, the teenaged McKissack joined his mother and sisters on a trip to Hot Springs, Arkansas, to soak in the 140-degree water that bubbled out of the ground and into facilities on its famed Bathhouse Row. We don't know what else the McKissacks did during their visit to the "Valley of the Vapors," but I'll bet the locals were still telling anyone who'd listen about the 573-foot home run hit out of Whittington Park and into the ponds of the Arkansas Alligator Farm a few months earlier during a St. Patrick's Day training match by an up-and-coming ballplayer named Babe Ruth. The hot thermal baths, mountain views, golf courses and racetracks that so impressed both the Babe and young Jeff McKissack are the same things that draw visitors today (even the Alligator Farm is still open for business). McKissack's visits to Hot Springs would become an annual tradition throughout his life.

Many years later, in his book *How You Can Live to Be 100 and Still Be Spry*, McKissack wrote, "A good place for you to go on your vacation is Hot Springs National Park…If there is something wrong with you, the radio active waters will cure or help you. Thousands of people have lost their soreness, thrown away their walking sticks, their crutches and their rolling chairs by taking the radio active baths." Such claims have never been substantiated by the mainstream medical community, and in fact, the FDA prohibits spas from advertising their springs as a cure-all, but obviously Jeff McKissack thought that he'd found his fountain of youth.

In 1921, he enrolled at the School of Commerce at Mercer University in Macon. Founded in 1833, the college has been the alma mater of such notables as Jimmy Carter's attorney general Griffin Bell (class of 1948); George Oslin, the inventor of the singing telegram (1920); a dozen governors leading various states across the centuries; and CNN's ornery legal pundit Nancy Grace (1981). Peer Ravnan, the special collections assistant at Mercer's Tarver Library, reported that McKissack kept a very

low profile around campus: "He has no individual photograph in any of the Mercer yearbooks, and there is no indication of membership in any clubs, organizations or athletic teams in the yearbooks either." Jeff does turn up in group photos in the 1922 and 1923 yearbooks, but as Ravnan noted, "even if you knew what he looked like at the time, it would be very difficult to pick him out of the one-hundred-plus students in the photos."

At the time McKissack entered Mercer, it was a conservative, all-male Baptist institution with fewer than four hundred undergraduates, with tuition set at forty dollars per semester. How conservative was it? "In the fall of 1924, Mercer biology professor Dr. Henry Fox was dismissed for teaching evolution," Ravnan told me. "It's doubtful that visionaries who looked at the world from a different perspective were very numerous here."

Perhaps on one of his summer breaks, McKissack was one of the 718 respondents to a peculiar job ad that ran in the *New York Times* between 1921 and 1923. Each man was directed to go to Newark, New Jersey, where he would then take an early bus to Thomas A. Edison Industries in West Orange. No résumé was needed; instead, applicants would sit in a laboratory for two and a half hours and take a bizarre aptitude test comprising 163 seemingly unrelated questions. What voltage is used on streetcars? Of what wood are kerosene barrels made? What city in the United States is noted for its laundry-machine making? Who was Leonidas?

"Men who have been to college I find to be amazingly ignorant," Edison complained to the *Times* in 1921. "They don't seem to know anything." So he devised a test that would separate the "Grade A men," who could correctly answer at least 90 percent of the questions and thereby earn a position with his company, from the "XYZ men," that is to say, the failures. The world-famous inventor himself oversaw the test and graded it while the presumably terrified applicant watched. Leonard DeGraaf, archivist at the Thomas Edison National Historical Park, searched its files for me and was unable to find McKissack's test, although many do still survive. So we don't know whether Jeff knew who invented logarithms or whether Australia is larger in area than Greenland. But we do know that Edison found him to be just another XYZ man.

Years later, McKissack would tell his friend Barry Moore that after grading his test, Edison barked at him that he "would never amount to anything." Jeff was understandably upset, but he needn't have taken it so hard. The test became a media sensation in its time, and eager journalists sprang the same battery of questions on New York's governor, New York City's mayor, police commissioner and superintendent of schools and even Edison's own

son, then a student at MIT. They all failed. As Albert Einstein walked into a restaurant in Boston in 1921, a writer shouted one of Edison's questions at him: "What is the speed of sound?" Stumped, Einstein replied that if he ever wanted to know, he'd simply look it up in a book.

At least Mercer considered McKissack to be an A man, awarding him a BS degree in commerce in June 1925. After graduation, he returned to New York City, where it's thought that an uncle arranged for him to work in a bank on Wall Street. Meanwhile, he continued his studies in the graduate program at Columbia University in 1926. However, he dropped out after only one year. "Someone along the way" told Jeff's niece Doris that he had written something unflattering about one of his professors and was asked not to return. Later he'd refer to New York as "a crazy place," and between his rural, small-town upbringing, the sting of Edison's rejection just a few years before and his failure to succeed at Columbia, it's not surprising that he moved on to seek his fortune elsewhere. "Americans would serve themselves and their country better by pursuing trades rather than college degrees," he'd write pointedly later on in his book. "The United States needs craftsmen, not Ph.Ds. It is a tremendous mistake to think financial security and happiness come only to those who have a college degree."

The 1930 census puts McKissack in Signal Hill, California, just outside Los Angeles and bordering, naturally, on Orange County. A neatly scripted census form has him working as a bookkeeper in the trust department of a bank and living in a rental property owned by his Aunt Lucy's daughter, Minnie Glenn, and her husband, Moses Varcoe, a laborer in one of the area's many petroleum refineries.

A boarder at the same address from just a few years later recalled a bucolic scene at 1996 Dawson Avenue. "We were so comfortable there," remembered ninety-year-old Marjorie Gromme in a memoir published digitally by friends at the *Signal Tribune* in 2009. "There were at least six fig trees and two easy producing avocado trees on the property...Mrs. Varcoe would tell us stories about growing flowers to sell, picking oranges and orange blossoms in orchards, plumping prunes and making jelly with orange blossoms for the fancy Long Beach hotel restaurants."

In Signal Hill, Jeff lived only a little over an hour away from the National Orange Show, founded in San Bernadino in 1911 by the city's civic leaders in celebration of California's citrus fruit industry. Displaying massive architectural models made from oranges on 100,000 feet of floor space, its facility, dedicated in 1925, was the largest structure of its kind in the state

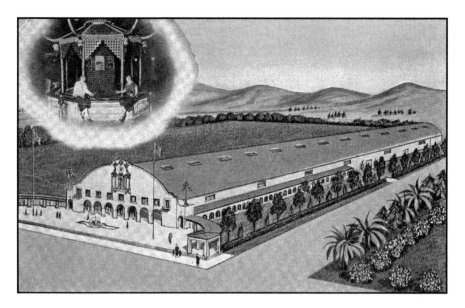

Postcard view of the National Orange Show in San Bernardino, 1925. *Collection of the author.*

when Jeff was around. Its program of beauty pageants, livestock expos and arts and crafts events drew about 300,000 people each year.

"An exposition of rare beauty," gushes a postcard from 1927, "a scene from Fairyland—nowhere else in the whole world such a dazzling sight—colorful, magnificent. A visit to California is not complete without a trip to the National Orange Show. Presented in its own great exposition building in the dead of winter when all nature is at its best in California the National Orange Show has the distinction of being the world's most gorgeous spectacle."

Richard Thompson, librarian at the San Bernardino Historical Society, noted that thousands were shuttled in from Los Angeles by trolley and added that as such a popular and well-publicized tourist attraction, "it is hard to see how anybody in Southern California, including Signal Hill, would not have known about the Orange Show." It's unknown why or exactly when Jeff left California, but by the time he had moved back home to Fort Gaines in the early 1930s, he probably already had orange fever.

About fifteen years after Bowles collected her letters, Rebecca Jacobs-Pollez picked up the thread while researching McKissack and the Orange Show for her graduate thesis at the University of Houston's Clear Lake campus. She went as far as to travel to Fort Gaines in 2001 to sift through courthouse records and interview a few elderly residents who'd known Jeff as a young man.

Her notes paint a picture of a southern Gothic grotesque who could have stepped out of the pages of a novel by William Faulkner (who was only five years McKissack's senior), the extensively intermarried Fort Gaines his own little Yoknapatawpha County. Despite his college degree and his stints in the banks of cosmopolitan New York and Los Angeles, Jeff's friends and family describe a pattern of personal idiosyncrasies and mildly odd behavior. His cousins Brooksie Brown and India Wilson ("a couple of really feisty old ladies," said Jacobs-Pollez) seem to have had the dish on Jeff, telling the eager grad student that he exhibited "nervous qualities" and strode around with an "unusual gait," placing his lower arms just under his belt and hitching up his pants as he walked. He also talked to himself constantly.

Even if he did cut a peculiar figure, he was by all accounts a likeable and industrious young man. Jeff opened a dance hall and café alongside his father's store where he'd play records on his phonograph and serve dinners finished with his own homemade Grape Nut ice cream. He hatched a scheme with Brooksie Brown to design, fabricate and sell metal weathervanes in the store ("We'll make our fortunes!" he told her), but sales were few. Eventually, he again looked outside Fort Gaines for employment. In her letter, his niece Doris sketched out a sort of itinerant existence during the Depression years: "He said he would board a while and live in a house a while…when he would find himself cleaning house when it didn't need it then he would move in with other people."

McKissack himself told Tom Sims's film class that he spent the Depression trucking oranges through the Deep South: "I hauled produce out of Florida, oranges and produce, during the '30s. I'd go down there and get a whole truckload of oranges, fifty dollars. Just dumped 'em in the truck. I didn't make any money off of it, but I saw Florida at every road. I went one way and back another and all down Lake Okeechobee. In winter, I'd gather tomatoes and pick beans and things."

Jacobs-Pollez's research at the Clay County Courthouse shows McKissack buying small, inexpensive parcels of land in Fort Gaines throughout the '30s, fifteen feet of land here, twenty-two feet there, all bordering on the insolvent local bank. In November 1939, he purchased some property from his mother, constructed a small concrete blockhouse on this plot with a detached garage and used it as a rental property, although town historian James Coleman, who actually knew Jeff as a young man, recalled shoddy construction and no attempts made to seal or weatherproof the joints. He seems to have sold all of his property in Fort Gaines for sixty dollars on August 22, 1940, and after that relocated to Jacksonville, Florida.

McKissack in his air force uniform, 1942. *Courtesy Orange Show archives.*

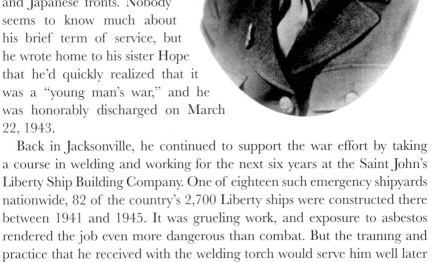

At the age of forty, but still in terrific shape at five feet, eight inches and 153 pounds, McKissack enlisted in the U.S. Air Force at Maxwell Field in Alabama on October 29, 1942, with the United States in the thick of World War II on both the German and Japanese fronts. Nobody seems to know much about his brief term of service, but he wrote home to his sister Hope that he'd quickly realized that it was a "young man's war," and he was honorably discharged on March 22, 1943.

Back in Jacksonville, he continued to support the war effort by taking a course in welding and working for the next six years at the Saint John's Liberty Ship Building Company. One of eighteen such emergency shipyards nationwide, 82 of the country's 2,700 Liberty ships were constructed there between 1941 and 1945. It was grueling work, and exposure to asbestos rendered the job even more dangerous than combat. But the training and practice that he received with the welding torch would serve him well later in life in as-yet-unimagined ways.

After lodging at the Tallyrand Hotel and the Pickwick Apartments, Jeff purchased a house at 890 Melson Avenue in Jacksonville's Woodstock neighborhood. Beatrice Tedeschi, who bought the property from McKissack in 1950, described it to Jacobs-Pollez as "a beautiful house with glass doorknobs and French doors in the dining room," with a cement walk decorated by square tiles. He set up a nursery and flower shop on the premises, went to classes at a beautician's school on the GI Bill and, never averse to exaggeration, invited former classmates to visit him at his "country estate" in the October 1947 issue of his college alumni magazine

the *Mercerian*. Family letters from decades later suggest that he proposed to an unnamed sweetheart in Florida, but alas, she turned him down. Still, after years of slogging around, things seemed to be looking up.

Then, in September 1948, Jeff's mother, Beulah, died. She willed him half of the family house and half of the family store. He almost immediately sold the former to his sister Ruth (who would live there until she died in 1979) and the latter to his brother John Hill (who'd use the upper floor as a funeral parlor until his own death less than a year later; John's son, Herbert, continued to run the store until his passing in 1973). Both buildings still stand.

In their interview with Jacobs-Pollez, Brooksie Barnes and India Wilson said that after he lost his mother, McKissack "went to pieces...His sister Bessie had little patience with Jeff's odd behaviors. The family wanted him to be a calm, high-class, respectable businessman. He 'shook up' the family." His sisters went so far as to have him committed to an unknown mental institution for evaluation. Soon, however, he was released, and with the mood understandably strained in Fort Gaines, he cut his ties both there and in Jacksonville and moved to Houston for a fresh start.

McKissack first landed in the Magnolia City sometime in 1951. It was the beginning of a decade of unprecedented expansion in Houston, with the completion of the Gulf Freeway and the Houston International Airport terminal building, as well as a new crop of mid-rise office buildings downtown, including the Bank of Commerce, the Harris County Courthouse and headquarters for Prudential Insurance, Great Southern Life Insurance and Transco Gas. In 1952, Mayor Roy Hofheinz already had on the drawing board his futuristic Harris County Domed Stadium (later to be famously known as the Astrodome). In 1955, Houston's population topped 1 million for the first time. NASA was established in 1958 and operated out of a converted hat factory until the Johnson Space Center was complete. Quite literally, the sky was the limit.

Acclimating to life in Houston, McKissack went with what he knew, driving a produce truck while staying in downtown hotel rooms. In January 1952, he bought an empty lot at 2406 Munger Street and, while living in the apartment behind neighbor Lew Harrison's house, began to build a place of his own—yet another concrete block dwelling like those he'd constructed in Georgia.

The Telephone Road Place subdivision itself was booming. Originally platted in 1938, most of its homes were built in the 1940s and '50s. The construction of engineer William James Van London's Gulf Freeway from

1946 to 1952 (at the cost of more than $1.5 million per mile) cut directly through it, improving travel to and from downtown but severing the older northern portion of the neighborhood from the newer southern. Even today, only the Telephone Road underpass readily connects the two. The subsequent addition of the Schlumberger Well Surveying Corporation complex to the west in 1953 and the Yellow Transit Freight Lines to the east in 1954 boxed in a narrow sliver of residential neighborhood between highway traffic and industrial usage. Still, Munger Street was only a few miles from the attractions of Telephone Road, then a major thoroughfare that featured the Santa Rosa and Wayside Theaters, down-home eateries like Paul's Ice House and the Tel-Wink Grill and a huge array of motels inhabited by transient workers, with their dazzling neon signs lighting up the night.

McKissack found a job at the post office in 1954, carrying special delivery mail on a route that covered about one-third of the downtown area. But at the same time, he seemed to have his sights set on something else. In November 1955, he took out a $5,000 lien on his property at 2406 Munger from the Ben Franklin Savings and Loan. On December 12, he purchased an additional plot of land at 2401 Munger, a seventy-five- by sixty-five-foot lot catty-corner to his house. In 1956, he plunked down $14.95 for a building permit for a beauty salon and began putting together a concrete block structure at 2401. Apparently, he never got far with the salon, as the address first shows up in Houston's City Directory in 1963, listed as the "American Tree Nursery and Worm Ranch."

McKissack's experience operating nurseries went back more than a decade at this point; he'd launched such enterprises in both Fort Gaines and Jacksonville. With his largely self-taught construction skills, he fashioned a rudimentary foundation and concrete block walls, surrounded by planters about a foot high

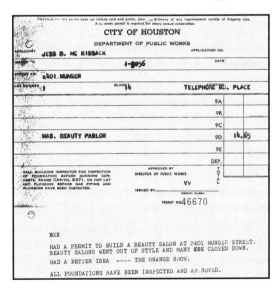

Amended Department of Public Works permit for 2401 Munger Street. *Courtesy Orange Show archives.*

to give customers a better view of his offerings. His neighbor Lew Harrison, a longtime Southwestern Bell man and an amateur gardener himself, was curious about the work and was particularly impressed by McKissack's fine mist propagation system. Years later, neighbors told Caroline Bowles that they remembered McKissack loading up his truck with flowers and plants to take into town to sell at farmers' markets. Perhaps his Munger Street location was a bit too tucked away to generate much on-site business. It was only after he'd decided to abandon the nursery and offered to give away his remaining stock that customers appeared in droves.

Having given up on both the tree farm and the beauty salon, he "was lost for two years," as he told Sims's class. Then, one day in 1968, as he stood outside the concrete block shell he'd constructed, the sixty-six-year-old McKissack had an epiphany. "Two words came to me," he told Martin. "'Orange Show.' That's it. 'Orange Show.'"

Shown Houston's ostentatious Art Deco Shamrock Hotel in the final stages of its construction in the late '40s, Frank Lloyd Wright purportedly turned to his apprentice Fay Jones and said, "That, young man, is an example of the effects of venereal disease on architecture." Whatever the prickly architect's feelings may have been about the Shamrock (with its swimming pool large enough to host elaborate water-skiing displays), its appearance signaled the beginning of a construction boom that would last for more than fifty years. Judge Roy Hofheinz's Astrodome, the so-called Eighth Wonder of the World, was completed ahead of schedule in November 1964, providing a refreshing seventy-two-degree temperature, plush theater seating and a 474-foot, crazily flashing scoreboard called the Homerun Spectacular that taunted visiting teams whenever Astros slugger Jimmy Wynn walloped a round tripper.

Throughout the '60s and '70s, Jeff McKissack watched as the skyline to the north changed dramatically. Down came historic buildings like the Colored Carnegie Library (1962), Memorial Auditorium (1963), the Majestic and Loew's State Theaters (both 1972) and Memorial Baptist Hospital (1977), not to mention block after block of residences and small businesses.

Up went the Exxon Mobil Building (forty-four stories, completed 1963), One Shell Plaza (fifty stories, 1971), One Allen Plaza (thirty-four stories, 1972), the 1100 Milam Building (fifty-three stories, 1973), Two Houston Center (forty stories, 1974), the Philip Johnson–designed Pennzoil Place (thirty-six stories, 1976) and One Houston Center (forty-six stories, 1978). The boom would continue, and even these behemoths would be eclipsed

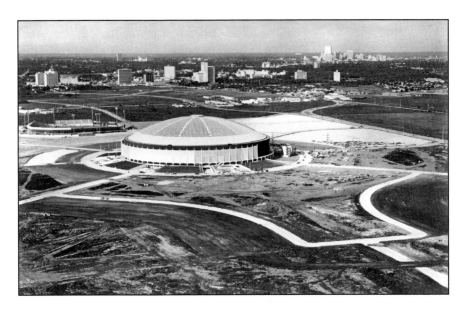

The newly constructed Harris County Domed Stadium set against the Houston skyline, 1965. *Collection of the author.*

and outshined by the seventy-five-story JPMorgan Chase Tower and the distinctive modern designs of Heritage Plaza and the Bank of America Building, all three completed in the years immediately following McKissack's death. In 1976, the *New York Times'* architecture critic, Ada Louise Huxtable, declared Houston to be "the city of the second half of the twentieth century."

As early as the late '50s, on his mail delivery routes and on his days off, McKissack was quietly filling his truck with the debris generated by this extensive urban redevelopment and stockpiling it back at his house for use at the nursery building. While giving filmmaker Ken Hudson a tour of the nearly completed Orange Show in November 1978, he told him, "That tile right there, I got twenty years ago, when they was wrecking the Capitol Theatre back there. They had it stacked there, and the fellow said, 'Well, you can have the whole pile, fifteen dollars.' So I just put it in my car and went and got two, three loads, stacked it up back at my house."

Period photographs of the Capitol Theatre, which once stood at 719 Main Street, show a grand old picture house with an arched, ornately tiled ceiling and a series of decorative secondary apses along each side wall. These architectural details were later hidden by a drop ceiling during the building's second and third lives as the Hammersmith Brothers shoe store and the Three Sisters Clothing Company. But there's something comforting about

the fact that after the wrecking ball leveled the building, its most beautiful bits and pieces were reassembled into the tile banding and proverb murals of McKissack's fantasyland.

McKissack salvaged iron fire escapes from the G.W. Stowers Furniture Building and used them as staircases for visitors to access various levels of his emerging structure, and he scored an obelisk reminiscent of the San Jacinto monument from the Texas State Hotel ("They thought it might fall off and hurt somebody, so they just gave it to me"), which he repurposed as a tribute to orange growers by affixing a small brass plaque at its base. An old photograph of the swimming pool area at the nearby St. Francis Motel, taken circa 1963, shows kids cavorting beneath metal picnic table umbrellas that appear to be an exact match for a festive peppermint-colored parasol that greets visitors outside the Orange Show's front door. One can easily imagine McKissack's delight in happening upon one of these shades tossed out by the curb on the Old Spanish Trail.

He resumed his annual trips to Hot Springs, Arkansas, and along the way picked up the rocks that decorate the exterior front wall and ring the steamboat pond. He'd stop at antique stores and purchase garden statuary: an owl, Confucius, an expectorating frog and a cherub playing the pan flute. "See, as I ran into things, I just bought it," he told Hudson. "Bought, bought, bought, when I saw it. I just bought it on the spot, because if you don't, it's gone. You have to buy it and store it up." He estimated that he'd spent between $30,000 and $40,000 on materials, and he told Bill Martin that "my living room is full of this stuff. You can't wait until the last minute on this kind of thing." Neighbors who caught a glimpse of the inside of his house confirm this. There was barely room to move.

At a display store, he bought for sixty dollars a preposterous clown face, a big, round piece of plywood painted white and decorated with a deconstructionist geometric visage: concentric circles for eyes, a stuffed glob of vinyl for a nose, a pink oval of a mouth with green dimple-dots on either side and exclamation points on each cheek. He wears a darling little pumpkin orange derby with a bow-tied green band. As a surreal ready-made, or as a modern design culture-buster, it fires on all cylinders. Jeff made a sign to go with him that read, "The Clown Said I am alert. I take care of myself every hour every minute of the day. You can too if you will. Clowns Never Lie."

Sometimes Jeff got lucky and picked up something for free, like the Christmas decoration he obtained from a local cafeteria's holiday display. "They had this Santy Claus," he told Hudson. "You know, ho, ho ho. And I

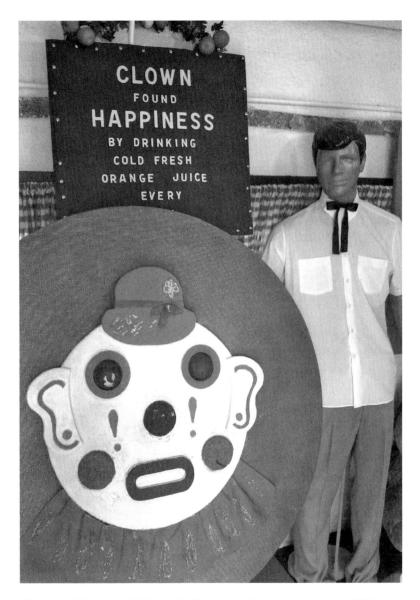

Clown found happiness drinking cold, fresh orange juice every day, August 2011.

took off his mustache, and he looked like a little teenager, a young man, so I called him Santa's son." The plaque Jeff propped on an easel beside him explains his intention to plant a grove in McAllen, Texas, and bring oranges to everyone at Christmas.

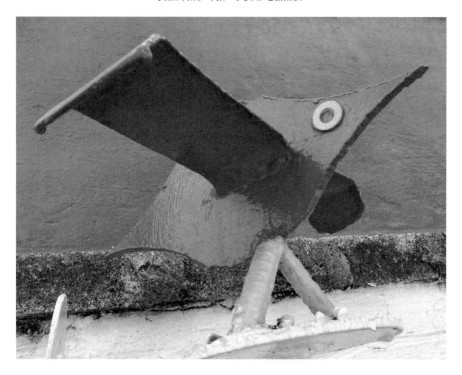

One of McKissack's many hand-cut metal birds, August 2011.

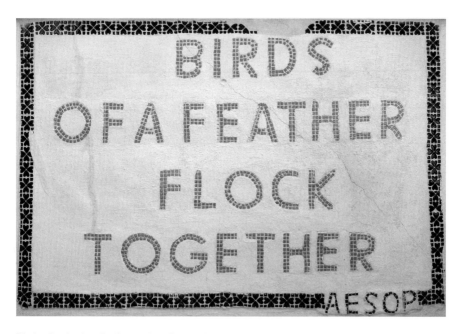

Birds of a feather flock together, September 2013.

McKissack had a knack for manipulating scrap metal, welding together a happy little scarecrow figure who would live in the museum and, with a stuffed bird perched on his head, act out a little moral play about conquering life's fears. After he sold the original *Clockman* to Marilyn Oshman, he created a new clock-faced metal sentry that silently stands guard at the front entrance. In addition to various arrow- and ball-shaped finials, he cut out dozens of goo-goo-eyed birds from scrap metal that he'd then paint in bright primary colors. They'd become signature pieces that he'd later sell to visitors for ten dollars each or simply give away to those he took a shine to. Unfortunately, it's art with a message that has nothing to do with oranges.

"Birds of a Feather Flock Together" pronounces a tile billboard on the rear wall:

> *Blue birds flock together and red birds flock together," he told Ken Hudson as the tape rolled. "Blue birds don't associate with red birds. Fishes of the sea don't associate with each, only like kind. You never see a trout and a mullet associate. You never see a red bird associate with a black, blue bird, a sparrow. Government been forcing people to associate, like black man, white man associate, living and working together, but birds and fishes and beasts of the forest won't do it. You take, rabbits only associate with rabbits, squirrels with squirrels. You never see a rabbit wantin' to associate with a squirrel.*

Watching this clip on YouTube, I suddenly had misgivings about these happy-looking birds, while trying to remember that this man's worldview was established in the post-Confederate household of the senior Jefferson Davis McKissack.

The concrete walls that enclose the Orange Show today are the same ones McKissack constructed in the '50s to contain his nursery. In his landmark book on folk art environments, *Gardens of Revelation*, John Beardsley wrote of the wall's purpose in such sites as "a double-edged device…it plainly shuts out the world, symbolically breaking the conventions of the surrounding landscape and culture. But it also invites inspection, by its very presence drawing attention to the mysteries it might shield." Certainly, McKissack had that conflicting need to keep the world at an arm's length while at the same time audaciously presuming that once invited, most of the country's population would come to call.

"It's built like a fort," McKissack told Martin, as usual drawing the focus of attention back to the orange. "It's got to be! Weak construction would make the orange look weak as a nutrient. Strong construction makes it look strong." It's impossible to know exactly which interior structural elements came first or how quickly they went up, as he was reluctant to admit strangers onto the

premises, although a handful of pictures do exist of McKissack at work, a jumble of cinderblocks visible in the background. In Martin's article, McKissack pinpointed 1968, shortly after he'd retired from the post office, as the year in which he began his work in earnest. He sold his Ford Falcon and took to riding his bike exclusively so that he could channel all available resources (mostly his pension and Social Security checks, not to mention "enough sweat to float a canoe," as he once put it) into the construction of the Show.

Often, he'd lie awake at night, planning his next day's labor. Then he'd get up early, work for a few hours, take a break at 11:00 a.m. ("You could set your clock by it," a neighbor once said) and pedal his bicycle across a knot of busy freeway access roads to his favorite lunch spot, the Dinner Bell Cafeteria at Lawndale and Wayside. He made it a point to get there early, when everything was freshly made, and chained his bike to a light post outside while he ate. A career waitress there told Caroline Bowles in the mid-'80s that, whether seriously or in jest, McKissack once offered to leave everything he owned to the restaurant when he died if only they'd feed him for the rest of his life. After his meal, he'd head home, perhaps picking up a piece of scrap metal somewhere along the way, and then work until sundown. In the evenings, he'd go out dancing to big-band music as often as four or five nights each week, usually at the Sons of Hermann lodge or at Dokey Hall's Clover Ballroom on nearby Milby Street. One photograph on display at the Orange Show pictures McKissack at age seventy-four, ready for a night on the town. His sky-blue slacks are hiked amusingly high, complementing his white collared shirt, striped tie and signature orange-banded fishing hat.

As one would suppose, neighbors began to notice something strange happening. Some decided that he was up to no good and began avoiding his block. Others were merely intrigued. Through the Houston Architecture Information Forum message board, I met a user named "isuredid," who wrote to me that circa 1970:

> My mother used to go down Munger when driving us to school in the morning and I watched that structure take shape. You can imagine that it was a bit puzzling as to what he was building. I remember watching cinder block walls go up and then seeing him welding the wagon wheels and tractor seats. I rode my bike down that street on the way to visit my girlfriend, who lived in the same neighborhood on the other side of the freeway. I stopped and asked Mr. McKissack what he was building once, and he said it was going to be an amusement park. Looking at the size of the lot, that seemed to be a bit delusional and I assumed then he was a bit off.

Of course, the site was irresistible to trespassing kids (and still is). McKissack complained about it in Ken Hudson's film: "Kids comin' over the wall, and they knock out the winduhs, steal my tools, tear up things. They cain't just come in here and look at it; they gotta tear it down." They knocked Confucius off his pedestal and kept hiding him in different nooks and crannies around the property until McKissack locked the Chinese philosopher in place with a bicycle chain. Just before writer Bill Martin's last visit, Jeff had spent two days cleaning up a mess left in the museum by some neighborhood hooligans, who'd splashed paint all over the room and plucked the eye and antlers from one of the stuffed deer heads. "It was three kids from down the street," he told Martin. "I bawled them out, but I didn't say nothing to the parents. Ain't no use to worry them; the kids are worried to death already." To replace the deer's eye, a ping-pong ball did the trick.

The relationship with the neighbors was always a touchy issue. "I knew it all along the neighbors hated me," he told Hudson. "They thought, some of 'em, that they had something I wanted. Maybe they thought I wanted their wives. Hell, I wouldn't want to have their wives in my bedroom if they volunteered to come in there! I wouldn't have 'em at all. But they afraid they might die, and I'd get their wives. Man alive! It'd be unthinkable to get in bed with such creatures."

As Hudson and his film assistant Gary Jones struggled to keep it together, McKissack's commentary suddenly took on a darker tone:

> *Hate, envy, jealousy, lotsa hate in there. Fact is, I been hated all my life, y'might say. But they don't think about it like that. They think I might-could inconvenience them some. In other words, I'm gonna live in the slums, you know, all-uh my life so they won't be inconvenienced? If I didn't have any more courage than that, I'd go and shoot myself through the head. Yeah, that's what it takes, courage to build a show like this. I just cain't understand it myself, why they hate me like that.*

Whatever the neighbors might have thought, the Orange Show was certainly capturing the more positive attention of art students and even Houston's fine art establishment.

Born in Maine in 1932, James Harithas was an army brat who studied art at the Universities of Maine and Pennsylvania before quitting school and hitchhiking his way to New York for more feet-on-the-ground training.

He began his curatorial career at the DeCordova Museum outside Boston in 1962 and developed a knack for attracting a hip, fringe element and raising serious cash anywhere he went, whether at Washington, D.C.'s stuffy Corcoran Gallery or Syracuse's nowheres-ville Everson Museum of Art, where in 1971 he arranged a bona fide blockbuster with the first gallery exhibition by John Lennon and Yoko Ono. In June 1974, he blew into Houston, hired as the director of the Contemporary Arts Museum by Marilyn Oshman, then the CAMH's board president.

Harithas began to upend things immediately with his freewheeling, renegade style, not to mention his unwavering support for local artists at a time when some board members wanted a heavier focus on internationally recognized superstars. His first show at the CAMH was a landmark exhibition of relatively unknown artists from across the state. A cluster of artists working at the University of Houston as faculty or as students, including painters John Alexander and Julian Schnabel and sculptor James Surls, all got early museum exposure thanks to Harithas before they moved on to wider success in the art world at large.

"Jim was instrumental in the promotion of Texas art," remarked Alexander, talking to me on the phone as he sketched in his Amagansett studio. "He was the catalyst." With Harithas's crowd in the house, exhibition openings might be disturbed by fistfights or food fights, and there was the small matter of a flood at the CAMH that destroyed the organization's membership records and over $1 million worth of artwork. But before he wore out his welcome, he discovered McKissack and the Orange Show while out on the prowl in the East End.

"When I first moved here in 1974," Harithas recalled, "I decided to divide up the city and get each member of the staff to look at one area so we could try to develop public contact, find out what our population looked like." He assigned himself the band of Houston's southeast end between the University of Houston and Hobby airport and began driving around the area whenever he could. "That's how I ran into the place," he said, "and I was amazed. I went back and got John Alexander and brought him over there because I thought, 'You've got to see this. This is it—this is our Watts Towers!'"

"I remember the unbelievable smile on his face," said Alexander of his first meeting with McKissack. "He was the nicest man, one of those special individuals who would light up a room—just a really infectious personality. And I remember thinking, 'This is just the coolest thing I've ever seen.' The obsessive nature which he used to put all that together, that's what really captured my imagination. I mean, what the hell is going on here?"

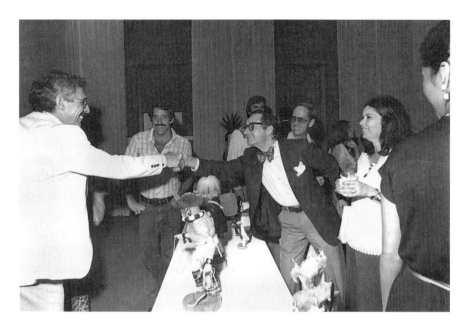

Jim Harithas (left) and John Alexander (second from left), with guests at a fundraiser for the Contemporary Arts Museum Houston, March 1977. *Photo by Frank Martin.*

Harithas and Alexander struck up a friendly relationship with McKissack, and as Harithas put it, "We began treating him like a real artist." Alexander brought him bucket after five-gallon bucket of orange paint "borrowed" from the U of H maintenance warehouse (orange is the university's school color, so there was a seemingly endless supply). They'd stop by every few weeks to check on his progress or to show off the place to a museum trustee, a new girlfriend or a visiting dignitary like pop artist Red Grooms or modern sculptor Salvatore Scarpitta.

Certainly the most high profile of these celebrity visitors was Willem de Kooning, the Dutch American abstract expressionist who's widely regarded as one of the most important painters of the twentieth century. De Kooning came to town in 1976 to visit his close friend Emilie "Mimi" Kilgore, a Houston socialite who taught a class called "Awareness of Visual Arts in Houston" and often brought her own students to the Orange Show for field trips. She charmed McKissack, who told her, "We'll have to go dancing sometime" and gave her a metal heart on a stand.

De Kooning had agreed to give a lecture at Rice University during his stay, but after looking around the campus and seeing exclusively white faces, he asked Harithas, "Don't you have a school here with real people?" The

engagement was moved to the University of Houston, and Kilgore asked John Alexander to show de Kooning around while he was in town. One afternoon, Alexander, Harithas and de Kooning spent over an hour at the Orange Show.

"Actually it turned out very well," remembered Harithas, "because he and Jeff were about the same age, although de Kooning, who'd been drinking seriously for a few years, looked terrible, and Jeff was just the very picture of health. They got along perfectly, the way only people of a certain generation can get along. Jeff was showing him around, telling him about this and that, and de Kooning would nod and say, 'Oh yeah, that orange really works there.'"

"They got along like a house afire," agreed Alexander. "De Kooning really liked the story about Jeff driving produce through the South back in the '30s. He was from Holland, so it was a world he didn't know, the old days in America. He just found Jeff fascinating."

Of course, McKissack didn't have any inkling of who de Kooning was. When Harithas introduced him as "a painter," Jeff responded by suggesting he move to Houston. "There are lots of buildings going up around here," he told one of the world's most famous fine artists. "You can probably find yourself lots of work." De Kooning, who just two years earlier had sold his painting *Woman V* to the Australian National Gallery for a record-setting $850,000, roared with laughter and embraced McKissack like an old friend.

It was a classic moment (and Alexander regrets that he didn't bring his camera), but Harithas unknowingly helped preserve McKissack's life's work for decades when he introduced him to Marilyn Oshman. "I'll bet you don't know the greatest artist living in Houston," Harithas told her one day. How could that be, wondered Oshman, who in her position at the CAMH had come to know just about every significant artist in the city. "Well, I'm not going to tell you who it is," he teased, "but if you get in the truck, I'll take you to meet him."

"Here I thought artists were painters and sculptors," said Oshman. "The truth is, I was overwhelmed by the medium of this huge environment that seemed to just ramble on." As Harithas introduced her to McKissack, she stepped into a space in transformation with some of the older walls already falling apart, some areas freshly built and a huge open sandpit where the steamboat pond would one day exist. It was a strange, magical place that reminded her of the time when as a girl she'd stumbled on the ruins of an abandoned off-season Barnum & Bailey circus encampment, with its toppled stone elephant guardians.

Oshman had become interested in contemporary art in 1960 during her senior year at Finch College in New York City. She took classes with the esteemed critic and gallery owner Ivan Karp just up the block from the Leo Castelli Gallery, where she saw early shows by Jasper Johns and Andy Warhol and went to "happenings" staged by the pioneering installation artist Allan Kaprow. "It was a magic moment," she said. "It made some kind of sense to me, what people outside of Houston were doing and thinking that was radically different." For $110, she bought her first piece, a figurative painting by the contemporary artist Bob Thompson, on a $10-per-month layaway.

Also in 1960, she married Alvin Lubetkin, a Harvard-educated broker who would leave Wall Street to move to Houston and help run Oshman's Sporting Goods at his father-in-law's request. Under Lubetkin's leadership, the business underwent decades of massive expansion, including a public stock offering in 1970 and the acquisition of several smaller chains, as well as the Abercrombie & Fitch trade name. Marilyn's interest in art only grew, and she volunteered to serve as president of the CAMH's board of trustees from 1972 to 1978, a turbulent time in the museum's history with the culmination of a massive building fund drive, the ouster of its embattled director Sebastian "Lefty" Adler[2] and the hiring of James Harithas, who called it "the poorest and most ambitious museum in the state" when interviewed upon his arrival by *Texas Monthly*.

"I knew it was a *something*," Oshman said of her first visit to the Orange Show. "But I didn't know what it was. After I left there, I thought about it, and I thought about Jeff. He seemed excited to meet someone from the museum world, but it was clear he didn't think of any of this as art." It was beautiful, though, and it struck Oshman as a metaphor for Houston's own nonlinear growth and its stubborn insistence on individual freedom. From then on, she, too, made the Orange Show a must-see for visiting friends and artists. After all, she felt as though it was every bit as interesting as anything shown in any of the local museums.

Eventually, she even got Jeff thinking about his work as a saleable commodity. One day, she asked McKissack, "These little birds you have, would you sell me one for my garden?" He demurred, saying that he wouldn't know how much to charge. He promised to think it over, and the next time she came by, he wondered, "Would five dollars be too much to ask?"

"I said, '$5? You should charge $25, $50, $100 for these birds!'" said Oshman. "He looked at me like I was a lunatic. 'I couldn't do that,' he said, 'I'd be cheatin'!' Then he started to tell me about how little the metal cost. That

Marilyn Oshman and McKissack at the Orange Show, circa 1977. *Courtesy Orange Show archives.*

was very endearing to me, and I think it's an important part of understanding people who do things like this."

The Orange Show also drew visitors from the De Menil–supported Rice University art program as well, including art history professor Dr. Bill Camfield ("I remember the place being a bit higgledy-piggeldy," he told me, "like the way you'd add on rooms to fit a growing family"). Camfield, in turn, had been brought to the Orange Show by his friend Dadi Wirz, a cultural anthropologist and visual artist who'd served on the faculty at the Basel School of Design and Rio de Janeiro's Museo de Arte Moderna before coming to Houston to teach printmaking at Rice. Before his term was up, Wirz purchased fourteen metal birds that he later donated to the Collection d'Art Brut in Lausanne, Switzerland. In an e-mail, he wrote: "After also receiving from me a series of slides of Jeff's 'Iron World' they placed those painted iron birds on top of that museum's roof, I presume that they are still there. Monsieur Michel Thévoz, the museum's director who is now retired, even mentioned that one should eventually make an exhibition in Lausanne of Jeff's activities as an outsider artist."

Wirz can recall an unusual, free-standing structure on the property across the street alongside McKissack's house: "Jeff showed me a tiny building which was to be the bedroom for the president of the United States, who would come one day for a visit." It's hard to imagine the Orange Show holding much appeal for Lyndon Johnson, Richard Nixon or Gerald Ford. Even Jimmy Carter, himself a produce man who grew up only fifty miles away from Fort Gaines in Plains, Georgia, only made it as close as the De Menil–commissioned Rothko Chapel some years after his term in office had ended (in 1986 and again in 1991).

The Swiss kinetic sculptor Jean Tinguely visited Houston in March 1969, about five years before McKissack connected with the city's art scene. It's a shame the two men never met because the pair of iconoclastic tinkers undoubtedly would have gotten along swimmingly. Tinguely arrived to participate in an exhibition titled The Machine as Seen at the End of the Mechanical Age at Rice University's art gallery; first he made the rounds of the city's junkyards in search of scrap metal with which to build his ten-foot-tall assemblage *Water Machine No. 4* especially for the exhibit. Period photos show the artist hard at work on the piece, welding together an array of machine parts, the most prominent of which is an oversized metal buggy wheel.

Like Jeff, Tinguely was loath to consider his work "art." "The word 'art' is bullshit," he remarked in *Kinetic Cosmos*, a documentary film produced by John and Dominique de Menil's son, François. "The [ancient] Egyptians, the Indians, the Chinese—none of them had the concept of art. It was just guys doing things." Tinguely's mechanized contraptions, some of them as big as the Orange Show itself, were imbued with a healthy dose of humor and playfulness. "I'd prefer to show my work in amusement parks," he said, expressing his admiration for the Palais Ideal[3] and poetically opining, "Dreams are the best organizers. A kind of trance with the mixture of dreams, intuition and unconscious yielding, the chemistry of enthusiasm… others might call it craziness."

There's no evidence to suggest that Jeff ever met the Houston-based sculptor Jim Love either, but there are obvious similarities between McKissack's work and that of the self-taught Love, who with fellow artists Roy Fridge and David McManaway charmed the Texas fine art establishment with fanciful assemblages made from industrial scraps and found objects. They called such cast-offs "jomos" and perceived them as serendipitous gifts from the universe, sent to spark their imaginations. Love referred to his sculptures made from gears, plumbing fixtures and machine parts as "put-togethers," and he even made some cut-metal birds early in his career, although they didn't look anything like McKissack's. "I might have something that can be called a bird," Love once wrote, "and still the most rewarding thing about it for me is what I have talked the steel into doing. Something not ordinarily asked of it."

Ty and Ginny Eckley were newlywed art students at U of H when they first came across the Orange Show in 1974 or '75. "I was a sculpture major," Ty told me as we sat in the spacious studio behind his house in Kingwood, a few miles north of Houston.

*I was just trying to figure out what the landscape of art was. You've got Simon Rodia's Watts Towers. You've got classical sculpture, and what happened to classical sculpture from the Italian futurists to Impressionism until you hit Duchamp, and the ability that all those people had to find their work so engrossing, that they could eat, drink, sleep, breathe it, was the connecting element. So there Jeff is, able to give up any interest in the rest of the world, and not even be interested in art. How can that be? What does that mean, in terms of being an artist, being a sculptor, to wrassle with the world, and have what you end up with resulting from your efforts, affect it? What are the pieces that comprise that? Which ones come first—which ones come later? How do they pass from one stage to another? What the hell's going on? What's life? So I borrowed some money and moved in next door.*

For $19,000 ("Huge money for us at the time"), Ty and Ginny bought the house at 2412 Munger. "We just thought it was so cool," said Ginny, "with the bayou at the end of the street. You could walk to U of H. And we looked out across at the Orange Show and thought it was just totally fun." They appreciated McKissack's work in a way other neighbors couldn't, and unlike others, they found it positively charming that he'd play Linda Ronstadt's "Blue Bayou" on his record player at full volume as often as twelve times in a day. But that didn't mean that they had any easier time getting to know the man. "He was not interested in being studied," said Ty. "He was not interested in talking to anyone, unless you were a woman."

On this point, according to Eckley, McKissack was a ladies' man of legendary proportions, as counterintuitive as it may seem. "The hottest thing about Jeff was that he had a twinkle in his eye that could power a small city," Ty said.

Ginny and Ty Eckley, 1981. *Courtesy Ginny and Ty Eckley.*

*Women from all over the planet would stop in to see him, and he could thrill them. He had this Victorian idea…he told me, "If you want to keep a lady happy, you buy her a Cadillac and give her a $100 bill every once in a while, and she'll be happy." He was thoroughly convinced about this, which just goes to show you why he stayed single all that time. But on a Saturday? There'd be as many as ten, twelve women coming by to see him. Women from all over the world, who'd come to Houston once every two or three or five years, and they'd make a point to stop by on their way to the airport to see Jeff. He just charmed the socks off these super-wealthy globetrotters. He'd just mow 'em down.*

After rebuffing Ty's offers of help for years, McKissack eventually deigned to accept from him some watermelon slices on a hot day. "And that was, like, a big deal," Ty remembered. "He wouldn't let anyone work with him. Once in a while, he'd pick up a bum he knew, over on Harrisburg, to help him lift or carry something, but he wouldn't let me do anything." With Ginny, it was a different matter. "See, that's because you're a woman," pointed out Ty, sitting across the table from her and raising his eyebrows. Jeff knew that she specialized in fabric and fiber arts, and consequently, he'd call on her from time to time to, for example, sew a dress for his museum's mannequin bride (who represented the purity of the orange: "The orange is absolutely pure," reads a sign beside her; "it grows right out of the bloom—protected by the rind") or to repair the pants of his axe-swinging woodsman ("Spare that tree," commands a mounted verse by G.P. Morris; "touch not a single bough"). McKissack would always offer to pay Ginny for her work; she would decline, and he would insist and give her the money anyway.

In the years since, Ginny has made a career creating remarkable quilts depicting natural scenes often interfacing with encroaching urban life. Ty seems to have made out well as a real estate developer in the '90s, with a spacious home in suburban Kingwood and a glistening green Jaguar in the driveway. But he still indulges his artistic side, crafting elaborate jewelry and attending the annual Burning Man festival.

As much as Ty liked McKissack and admired his efforts, he understood that with his grandiose ideas, Jeff was only setting himself up for disappointment. "I really felt kind of sad about it," he said. "I mean, it could never be as big as Disney World, like he expected. I just hoped some people would come."

"It was such a grass-roots and optimistic and open kind of place, which were the qualities of the city at the time," said Lynn Randolph, another of the many emerging local artists introduced to McKissack and the Orange

The orange is absolutely pure, August 2011.

Show by James Harithas. "This was part of something everyone was proud of, as we're all expanding and growing culturally."

"These were amazing times in Houston," she continued, placing McKissack's creation within a larger context.

> *When Harithas came, nobody had ever paid any attention to Texas art, in New York or Los Angeles or anywhere else in the world. And he simply got in his car and visited the studios of every artist he could find and came back and announced that Texas art was as good as any art that was being produced anywhere else. And that needed to be said. Even if it wasn't true, it needed to be said because it encouraged people to have confidence in what they were doing. What was respected was being independent and not having to look over your shoulder all the time. And what Jeff McKissack was doing was a huge part of all this. So I called my friend Bill Martin and told him he should go over there and write "The Miracle of Munger Street."*

Martin would visit the Orange Show twice in preparation for his *Texas Monthly* article. Back then, he was a Harvard-taught associate professor of sociology at Rice University and an instructor at the Houston police academy. I found the avuncular, mustachioed educator at his office at Rice's stately James A. Baker Institute for Public Policy, where he holds the position of "Senior Scholar." He specializes in the areas of sociology of religion and criminology, in particular the failures of the war on drugs; in fact, he retrieved his notes on the Orange Show from a drawer where they sit alphabetically between files on "Needle Exchanges" and Houston televangelist "Joel Osteen."

Looking back, the writer remembered that Jeff seemed genuinely excited about being the subject of a magazine article. "At the time I did it, I had no idea the Orange Show would still be around this long," Martin admitted. "It was just a story for *Texas Monthly*, and it didn't seem like something that would still be around in five years. I wasn't sure if it would ever get finished or if anyone would ever take note."

Martin's article, "What's Red, White, and Blue…and Orange All Over?" was based on one of only four known recorded interviews with McKissack, and unfortunately, the original tapes vanished during a move some years ago. Now all we have is the piece itself, which is all the more interesting since it describes the Orange Show when it was still a work in progress. In his article, Martin introduced it as "a razzle-dazzle piece of American folk art—an amusement park sideshow that looks like a topless castle designed by a committee composed of Alexander Calder, Rube Goldberg and Mad King Ludwig."

"Ask him why he began or why he continues his work and he may or may not be able to say," Martin wrote. "If he gives an answer it may sound like more of a convenient dodge than a logical reason. He is not easy to understand or to categorize. But letting him tell you about his art, whatever he may choose to call it, is a fine way to spend the day."

"I love it," McKissack told Martin. "I started working on it in 1968 and I work on it every day. Every time I do something, I feel like I am creating. Everything you see is based on my creativity. You could take a hundred thousand architects and a hundred thousand engineers and all of them put together couldn't conceive of a show like this."

"I think he was genuinely pleased with the article," Martin told me. "He was all for getting publicity. He saw it as a commercial project, and it was not his aim to labor in obscurity."

I walked out of the plush Baker Institute, with its marble floors and varnished wood paneling, and drove north to C&D Hardware in the

Houston Heights, less than a mile from my house. It's where I found Tom Sims, who also interviewed Jeff McKissack while teaching a film class at the University of St. Thomas in the fall of 1979. After years at the Rice Media Center and its offshoot, the nonprofit Southwest Alternative Media Project (SWAMP), he became waylaid by cataract surgery and settled into a less creative but more straightforward career selling tools, plumbing supplies and garden hoses. ("I do enjoy leaving my job behind when I punch out at the end of the day," he admitted.)

We adjourned to a local watering hole just a few blocks south of the hardware store for a couple of beers and a flashback to a very strange visit to the Orange Show. One of Sims's students, his name long forgotten, had befriended McKissack and proposed a documentary film project. Sims joined a team of three or four students for about an hour of recording on Super 8 video cartridges. The delicate tapes have long since deteriorated, but fortunately, the audio tracks were transcribed and reproduced in the March/April 1991 edition of the *Orange Press*, the Orange Show's newsletter.

Recorded just months before he died, there's a sense of urgency in McKissack's tone: "I'm 77 years old and don't even have a decent place to stay…I'm trying to make enough money somehow or another to build a new house so I can have friends come to have coffee with me, something. At the present time I can't have nobody even come in my house, it's filthy. I built it for 'bout three, four thousand dollars 'bout thirty years ago…and it's all falling in. I'm trying to get off the poverty level."

After proudly showing Sims's team every nook and cranny of his show for an hour, detailing the cost and source and purpose of almost every item on display, McKissack suddenly remembered a previous visit that had rubbed him the wrong way, and he changed his tone abruptly:

> *People come out here and try to get everything I've got. This other feller came out here, he's a guy takin' motion picture of my show, done take everything! He says sign this, fill out a contract. It was beautifully typed…says, uh, uh, "standard artist's contract" and then the artist's signature. But I didn't fall for that. Every time I signed a contract I lost like hell…I guarantee you one thing, nobody else is coming out here and making any motion pictures and nobody's going to get me to sign no contract. So goodbye!*

Even if he shooed away Sims's film class, he certainly did have hopes of being a motion picture star. He modestly told filmmaker Ken Hudson, "I'm going to try to have Paramount Pictures make a picture, *A Genius Is Born.*

You know that picture *A Star is Born*? This'll be *A Genius Is Born*. They'd have a picture they can show all over the world—Japan, China, South America, Asia, Europe—and make millions of dollars."

He wasn't just whistling "Dixie," either. The Orange Show Foundation has retained McKissack's personal Rolodex, a recipe-type metal file box containing several hundred annotated three-by-five cards on which he typed the names and addresses of visitors to the show and dozens of others who might be helpful someday. There are governors, electricians, potential sideshow performers ("Face full of hair—wild looking," reads one. "Can play organ") and several movie producers, including Michael Douglas, on whom he seems specifically to have set his sights for help with his "motion picture" after being impressed with his work on *The China Syndrome*.

McKissack thought that he'd attract as many visitors as the Astrodome. He foresaw thousands lining up on opening day. "We asked him where everyone was supposed to park," said pianist Robert Pearson, who was in John Alexander's painting classes at the University of Houston in the late '70s when he, like many other art students, visited the Show to peek over the walls and sometimes hang around with its creator. "He just ignored the question, though, like he didn't even hear us."

It's estimated that about 150 people dropped by on May 9, 1979. There seems to have been no formal press coverage of the event, in advance or afterward. In fact, John Alexander remarked that most of the attendees were people involved with the local art scene and the CAMH. "Had that art world presence not shown up en masse, there wouldn't have been many people there," he said. "I remember thinking what a strange phenomenon, to have these museum people and these River Oaks socialites, and among them this strange little man—I mean, this brilliant, obsessive man—and that, well, this might work."

Glenn Carman, another of Alexander's painting students (and now a tool and die specialist down by the Gulf in La Porte), was there and remembered only about fifteen or twenty people milling around at any given time. McKissack had installed a large rotating dais for performers in the sideshow, and when he invited Carman up onto the stage with him for a test ride, the combined weight of the two men promptly burned out the tiny motor. Even if the day was a mixed success, McKissack remained upbeat, smiling, reveling in the long-awaited moment. Some special visitors received orange juice squeezers. Another guest's daughters were given little plastic oranges filled with juice.

The newly organized Houston Women's Caucus for Art held its first fundraiser, the "Black and Orange Ball," at McKissack's fantasyland on

October 26. Lynn Randolph arranged the event, and while she can't recall what McKissack charged her to rent the Orange Show, she does remember a lively party with refreshments and a band, as well as McKissack himself again mingling with Houston's finest painters and sculptors and its savviest collectors and museum administrators.

But these special events were exceptions; after the grand opening, activity slowed to just "a mere dribble," in the words of neighbor Lew Harrison. The Orange Show was a hit with Houston's art scene, all right, and friends and fans continued to drop in, just like always. But where were the vacationing families he expected to stream in from all corners of the country, spinning his bicycle-handlebar turnstile all day long?

"He thought there was hope," said Ty Eckley, but he allowed that Jeff "was perplexed, he was just really confused" when thousands of people failed to line up outside the Orange Show. With his life's work virtually completed, and few guests to entertain, what was left to do?

"There was no life," suggested Eckley, as he began to act out McKissack's inner thought processes, "except for: 'I need to go stick this thing with that, and I'm missing this, so I've got to go find it, and I've got to get somebody to…no, I don't, I can cut it apart there. Or maybe I can get another one. I'll go look.'"

"In art, we call it being a shop person, or a studio person," he continued. "You go in, and you've got this work station and here's all your tools and you do this, you do that, then you put it over here and you look at it, then bring it over here and do your drawings over there, and then bring it back over here to spray paint it…you get in this loop where there's always lots to do ahead of you. It's very comforting, just really addicting. Jeff had that one down. He had made his own little universe, and puzzling it out, parsing it out, was enough, maybe just enough to make life bearable."

In a letter to his nephew Alex Hurst written on December 13, 1979, thanking him for the gift of a box of dried fruit, Jeff sounds alternately hopeful and dispirited. He was still working out the mechanics required to get his steamboat to run and remarked, "People who are interest[ed] in art come to the show. All say it is art. I am an artist in steel…Have two (2) goals. One is to build a new house and the other is to live to be the oldest man that has ever lived in Houston." Then, immediately reversing direction, he wrote, "It is all over for me. Will be 78 on January 28th. It is too dangerous to get out at night in an auto. 595 people have been murdered this year in Houston."

When McKissack suffered his stroke and fell to the floor of his bank on Wayside Drive in late December 1979, the damage was severe, and he'd

never make it back to his beloved Orange Show. He spent three weeks bedridden and inarticulate at Southern Methodist Hospital.

"I went and visited him," remembered Ty Eckley, "and I had picked up a little tile heart that was part of something that he had mudded into a wall there, and I put it into his hands—big, strong hands. He knew what it was and knew what it was from and closed his hand on it. And I got it. He was freakin' trapped in there, and that was really bad. And for some reason, I was drawn to rub his feet, I guess to help get his wiring going; it just seemed like the right thing to do at the time. Two, three days after that, he was gone."

A small, private service was held at the Show, where Eckley gave the eulogy and Alex Hurst scattered McKissack's ashes. "I do not like the idea of being buried," Jeff had presciently written in his letter to Alex little more than a month earlier. Hurst sold McKissack's run-down house (including his tools and clothes) to Eckley, and Ty demolished it as per Jeff's wishes. McKissack didn't want its shabby workmanship seen by future visitors to the Orange Show.

"I didn't have two nickels to rub together because we were trying to be fancy-shmancy artists. But I bought it and tore it down. It took me a year and a half! And I mean, we killed ourselves, we did it rude boy style," Ty admitted. "We tore stuff apart, hauled cement all over the place, put a little in the trash can every week. We burned the rest of it behind the façade we left standing so people couldn't see the flames, though we must have had flames thirty feet in the air. The neighbors were kind of pissed, but they didn't say anything because I was making it go away!"

For three months after McKissack's death, Oshman met frequently with Hurst, a retired Federal Bureau of Investigation special agent who lived in Southern California and had been reading up on the Watts Towers, as well as with SPACES' Seymour Rosen in order to put together a plan for the purchase and preservation of the Orange Show. Rosen had been instrumental in rescuing the Towers from periodic threats of demolition, and in fact, he eventually codified his experience into a proprietary and rather practical method for folk art environment preservation. Having grappled with these issues for years, he wrote with unabashed frankness in his workbook, "What's the problem? Artist old, dead, artist wants to sell property, no relatives, relatives who want the property, area being developed…lack of local interest?" It's a grim checklist, but yes, in the case of such environments, usually one or more of the above apply. Later, he advised, "Remember the

words 'cultural destination' when talking to politicians or business people." Oshman took dutiful notes during her three days with Rosen, at the end of which he told her, "Now you've got the benefit of learning from all of my mistakes."

Oshman knew that the city wouldn't properly maintain the site, but in the spring of 1980, she approached the University of Houston about taking on the monument as part of its art department. The timing was certainly right. After the departure of its chancellor of thirty years, Philip Hoffman, the university had a new staff in its front office and a refreshed outlook on the importance and possibilities of community outreach. The new chancellor, Barry Munitz (who'd later serve a term as the CEO of the J. Paul Getty Trust), and Assistant Chancellor Andy Rudnick both liked the idea of being the Show's custodian, but in the end, Rudnick convinced Oshman that it would be a mistake to give them, or anyone, the Orange Show to run. Priorities and attitudes always change from one administration to another, he explained, and he pointed out that something as unconventional as the Orange Show could easily get lost in the shuffle.

Hurst had initially asked for $50,000, with the hopes of offsetting McKissack's medical bills. As the summer wore on and it became obvious that there was little competing demand for the property, his asking price slid to $25,000. On September 15, Oshman bought the Orange Show for $10,000 plus closing costs on behalf of an eclectic consortium of arts patrons including Rudnick, Dominique de Menil and Menil Foundation chief financial officer Miles Glaser, Texas Art Supply founder Louis K. Adler, Magnolia Petroleum heiress Nina Cullinan, ZZ Top guitarist Billy Gibbons, building supply magnate Carl Detering Jr., trial lawyers David Berg and Robert Sobel, writer Joe Lomax and Main Street Arts Happening chairwoman Diane Rudy. On December 3, the Orange Show Foundation was incorporated, and all twenty-one supporters donated their shares of the property to the new entity.

The foundation's first order of business was to preserve and, to a lesser extent, restore the monument itself, which had already begun to decay before its opening day. It had sat empty, locked and choked with weeds for months. McKissack's friend Barry Moore, a specialist in preservation architecture, worked together with the Walter P. Moore engineering firm and the contractors Craig and Sheffield to carry out a structural analysis of the site and to stabilize and repair elements that had deteriorated. (When Barry Moore went to the city to secure a building permit, the clerks remembered McKissack and his Show. "Oh yeah, that pile of junk," they snorted.)

Water pooling in an alley running behind the Show had caused significant shifting in the rear wall, so a concrete foundation was poured, and vertical steel I-beams were sunk around the structure's perimeter to hold it in place. Concrete ceilings built around plywood instead of rebar were reset and buttressed with galvanized pipe (during restoration, other surfaces were found to contain as filler such items as old paint cans, a steering wheel and the license plates from McKissack's truck). Missing structural elements were replaced, and every detail of the site was catalogued and photographed. In all, $130,000 was raised for these early stabilization efforts, which commenced in September 1981 with the tedious scraping, priming and repainting of each rusting piece of metal.

Above all else, Rosen implored Oshman to get on the right side with the neighbors, which in the case of the Orange Show proved relatively easy to do. Oshman reached out to the neighborhood civic association early on and sent representatives door to door to explain their intentions for the site, and even today, the foundation hosts a block party cookout every year.

After a year of labor, Houston mayor Kathy Whitmire cut the ribbon to unveil a freshly repainted Orange Show on Saturday, September 25, 1982, kicking off a two-day fundraising party. The official public "unpeeling" followed on October 9, with a day of magic shows, dance performances and bagpiping. After an abbreviated season of tours and a few activities, the Show closed in December for continued maintenance, while Oshman recruited a team to create and implement a more serious plan of community-oriented programming. In January 1983, she recruited as the Orange Show's first programming director Susanne Demchak (now Theis), who had come from Canton, Ohio, to study American cultural history at the University of Houston before graduating and working as the program coordinator in the chancellor's office.

Seeing the Orange Show for the first time, "I didn't know what to think," Theis admitted, and she asked herself, "What would I direct?" Having seen the collection that Oshman kept at home, though, she trusted her. "What I cared about most was the opportunity to create a space where art was about real people," she said. "It was an open laboratory for me to try all kinds of things to see what people would respond to. It was anti-elitist, which attracted me very much."

"What I understood from Marilyn," continued Theis, "was that the idea was to preserve this place, but really, as much as preserving it, was to make it be a vital part of Houston's cultural landscape and to integrate it into the fabric of our cultural life. That was incredibly exciting to me."

She joined Oshman's first hire for the foundation, Sharon Kopriva, a sculptor, former public school teacher and a protégée of James Surls and John Alexander at the University of Houston. ("In her A-frame dress and her necklace with a bone on it, I could tell she was different," remembered Theis.) Working with an annual budget of just $60,000, the two women set up an office in a spare bedroom at Oshman's house and began devising a season of fun, community-oriented programming. Theis and Kopriva enlisted their collective community of friends from U of H and Lawndale to help with ongoing maintenance and to comprise the performers and audience for most of the Orange Show's early events. They told their friends, and those friends told their friends.

Theis kicked off her debut season with the First Annual Easter Orange Hunt in March 1983, during which kids searched the monument for oranges and other healthy treats rather than Easter eggs. In the months and years to follow, the foundation hosted polka dances, new music concerts and tap recitals by neighborhood youngsters. There were outdoor movies, theatrical productions and puppet shows, as well as a particularly memorable beauty contest for eighty outrageously decorated Barbie dolls in June 1989. There were celebrations for Christmas, Halloween and Cinco de Mayo. "We made a festival about everything," sighed Oshman. "And it was festive, and it was beautiful."

Theis recalled a night in November 1983 when University of Houston art students Jack Massing, Bert Samples and Mary Cullather performed a graphic score-based piece that used the Orange Show as an instrument. "They stood in the pond and played the Orange Show. That was the night I really understood," said Theis. "We tried all kinds of things that didn't work. A classical chamber group didn't work. But having the Orange Show utilized by contemporary artists as a work of art to respond to—that really worked."

In 1984, the foundation commissioned Houston artist Jackie Harris to decorate a worn-out 1967 Ford station wagon donated by board member Carl Detering, giving her a budget of $800 for paint and plastic fruit. Reborn as the "Fruitmobile," it was then auctioned off at the next Orange Show gala. It fetched $4,200 and was then donated back to the organization, where it became its "roving ambassador of good will." Theis's June 1986 exhibition Road Show featured the Fruitmobile and about a dozen more "art cars"—ordinary automobiles made extraordinary by painting, decorating or sculpturally altering them so as to, in some cases, render them almost unrecognizable as motor vehicles. "We had been calling them art-mobiles," said Theis, until someone realized that people would have an easier time remembering a term with one fewer syllable.

In conjunction with the New Music America Festival that same year, Orange Show friends Rachel Hecker and Trish Herrera joined New York City–based cellist Tom Cora to organize a parade of about twenty music-making art cars and floats. With a soap bubble–blowing Theis behind the wheel of the Fruitmobile, the procession rolled down Main Street until it arrived at a John Cage concert celebrating the dedication of the Cullen Sculpture Garden at the Museum of Fine Arts, Houston.

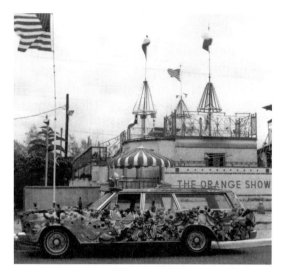

Jackie Harris's Fruitmobile. *Courtesy Orange Show archives.*

When New Music America's host organization, the Houston International Festival, called on Theis and the Orange Show to help produce a more formal art car parade in 1988, she jumped at the chance. Theis estimated that maybe only two thousand scattered bystanders saw the parade in '88, but nevertheless it attracted the attention of Harrod Blank, a writer and documentary filmmaker who's one of the pioneer figures of the art car movement. He helped to "connect the dots" by encouraging artists he knew from all over the country to drive their art cars in massive caravans to join Houstonian artists for subsequent events. In 1989, the parade's audience swelled to more than ten thousand. In a single day, the foundation connected with three times as many people as it had previously been serving in a year.

In the decades since, the annual parade has become by far the largest and most widely celebrated of its kind, with more than 250 vehicles from twenty-three states and a live audience of more than 250,000 spectators. It requires a massive fundraising effort each year and an equally massive logistical undertaking, yet it's still doggedly organized and administered by the Orange Show's tiny staff and an eager contingent of volunteers. In fact, the parade's profile both in Houston and beyond prompted *Houston Chronicle* arts writer Lisa Gray to call it a "tail-wagging-the-dog outreach event that [has] nearly overshadowed the monument."

Bryan Taylor has designed several art cars, including his current ride, a beat-up old Honda covered in Santa Claus figurines and topped with an enormous fiberglass Santa hat. He might be better known locally, though, for his annual restaging of the attack on Pearl Harbor, reenacted with Santas (yes, actual human beings dressed up like Santa Clauses) representing each warplane and battleship. With his ample girth, long gray hair and snowy beard, he projects a Santa-like presence himself—that is, if jolly Saint Nick decided to quit delivering presents and instead spent his time partying with roller-derby girls. Taylor first came to the Orange Show as a visitor in the mid-'80s when he was working as a bouncer in what he will only refer to as a "men's tavern" and as a DJ on Houston's community radio frequency, KPFT.

"There was this guy at the station named Art Gnuvo," said Taylor. "He told me that he had a gig where he'd be beating on pots and pans with some avant-garde band. I asked him where could you possibly get a gig like that?" Soon after, he drove by to get a look at the place for himself, and finding it locked and deserted, he climbed the wall to get inside. Having just waddled into Chicago's Italian Beef and wedged himself into the booth we're sharing, he noted the look of skepticism on my face and admitted, "Yeah, I couldn't climb a wall these days if I had a rocket strapped to my ass."

Once inside the Orange Show, he gawked incredulously. "I'm standing right by the stage, and I'm looking around, and a little voice inside said, 'Dude, you're home.'" He stayed there for hours until after the sun went down, exploring the candy-colored labyrinth and listening to the flapping flags and spinning whirligigs. He began to make a Sunday tradition of arriving at the Show in "various stages of...enlightenment, shall we say," bringing along a supply of comic books to read up on the observation deck.

Theis noticed that Taylor was hanging out constantly and attending nearly every event, and she encouraged him to volunteer, which led to an actual paying gig as site manager in 1988: sanding, patching cracks and painting ("lots and lots of painting"). He got into the programming end of things as well. "Susanne was angry at me one day," he remembered, "and she said, 'I should make you staff this place for twenty-four hours straight.' I, thinking that would be an incredibly cool idea, came up with twenty-four hours of consecutive programming." From midnight to two, visitors stargazed through a telescope on the upper deck. Then, a local theater troupe did a dramatic reading of Dylan Thomas's *Under Milkwood*. "There were seven of them, and there were five in the audience," said Taylor. "This was at four in the morning." At six, there were donuts and orange juice to go with the sunrise.

"Judy" the lion guards the steamboat pond, September 2013.

Things at the site were off to a flying start, but the foundation itself had continued to operate ten miles away out of Marilyn Oshman's home in the affluent River Oaks area of Houston. Its property owners' association was not pleased with the arrangement, and Oshman agreed to relocate the organization. With grant monies from Minute Maid Orange Juice and from other private donors, the foundation bought property at 2402 Munger, directly across the street from the Orange Show, in May 1988. The new location provided obvious advantages in terms of access and oversight of the monument in a then dodgy neighborhood (the Eckleys moved away in 1983 after Ginny was held up at gunpoint in their own driveway). The house that was now the new office was a mess, and it fell to board member Barbara Hinton to act as general contractor and repair the property on a slim budget.

When the foundation celebrated the tenth anniversary of the Orange Show's original public opening on May 9, 1989, some of McKissack's wildest dreams were finally realized. A crowded house of people sipped juice while a "beautiful lady" played the organ on a rotating sideshow stage. The refurbished steamboat paddled its way around the pond (powered by an air compressor rather than the resident boiler), ferrying its cargo of cotton

bales. The staff wisely decided to edit from the display the intended "colored man" doll and the cannon shooting at Native Americans, but just as Jeff had pictured it, battery-operated monkeys rode along, crashing cymbals. If you squinted your eyes enough, you just might have thought they were real.

As late as it may have been in coming, the Orange Show finally began to receive the recognition, attention and affection that McKissack had always counted on. In fact, his work has been acknowledged by the art establishment in ways he never imagined. A state-shaped metal cutout emblazoned with plastic letters spelling out "I love Texas" was displayed during Rolywholyover: A Circus, a citywide multimedia exhibition mounted in 1994 by the Menil Collection and posthumously "curated" by John Cage via the throwing of the *I Ching*. McKissack's metal birds were displayed at the American Visionary Art Museum in Baltimore in 1995 when Theis organized a show there entitled The Wind in My Hair, as well as in a 1997–98 exhibit called Spirited Journeys that premiered at the Blanton Museum in Austin before traveling on to Dallas, Houston and San Antonio.

Jeff became the subject of academic inquiry in 2001 when University of Houston graduate student Rebecca Jacobs-Pollez arrived at the Orange Show to look through the foundation's papers and compile the first proper biography of the man. Not since 1983, when Caroline Bowles reached out to surviving McKissack family members for photographs and anecdotes for the Show's informational poster display, had anyone looked so seriously into uncovering the historical details of Jeff's life.

Jacobs-Pollez first became interested in the Orange Show after seeing a news segment about the Eyeopener Tours. Years later, she wrote a brief paper on the monument for a grad school class in local history. "I decided it would be a good chance to learn more about Jeff McKissack," she said. "I was interested in women's history, and as you know, Marilyn Oshman created the foundation, Susanne ran it for years, the staff was always predominantly female. So, having written about Jeff already, I decided to write my thesis on the organization."

She was impressed with the team, from top to bottom:

> *I found most of the staff to be professional, creative, and especially during art car week, they put in some of the longest hours of any group I know. The volunteers, especially the dedicated ones, are also hardworking, creative people. I was impressed with the support the staff gives to artists and people like me who just walk in with questions. I've volunteered at lots of places in Houston, and the Orange Show treats their volunteers better than any other group I know. You know you are appreciated.*

Building on the research that Jacobs-Pollez gathered for her thesis, Theis worked with other foundation members to prepare and submit an application to have the Show added to the U.S. National Register of Historic Places. Said Theis, "For me, it felt like I couldn't leave before it was done. Jeff deserved that official recognition." But she explained that there was a more practical concern, as well. "Being identified with a single patron has a lot of inherent danger. It makes the organization fragile and vulnerable. This has been talked about within the Orange Show, with Marilyn, since the beginning; [there was] always the idea of a succession plan, always the idea of how you strengthen the organization so you can survive."

At first, the bureaucrats at the Department of the Interior told Theis that the Orange Show wouldn't qualify. ("And it wasn't just no," she said. "It was hell no.") They pushed on regardless, and after an initial rejection and subsequent revision of their materials, the Orange Show was USA bona fide on November 21, 2006, joining such other nationally recognized sites as Simon Rodia's Watts Towers in Los Angeles (1985), Edward Leedskalnin's Coral Castle south of Miami (1984) and Samuel Dinsmoore's Garden of Eden in Lucas, Kansas (1977). A photo on the Internet shows Marilyn Oshman, Barbara Hinton and Susanne Theis with wide smiles at the unveiling of a brass plaque applied to the exterior wall upon the monument's seasonal reopening in March 2007.

"She did it," said Oshman. "Susanne was amazing. She and I were tied together; we acted in concert for many, many years. Susanne is the mother of this, the mother of the programming. The structure, I gave it. The programming, she gave it."

By September of that year, Susanne had eased out of her position at the Orange Show after twenty-five years of service, having been offered a job as the first programming director of Discovery Green, a twelve-acre urban park in downtown Houston (she has called it the "city's backyard"). Built at the cost of $125 million, it was opened to the public in April 2008 and welcomed more than 3 million visitors attending more than eight hundred events in its first three years. While in terms of career advancement it would seem to be a huge leap forward, it's a testament to her dedication to the Orange Show that she had to think twice.

"It was one of the hardest decisions I ever made," she told me one day as we sat at a table outside Discovery Green's solar-paneled administration building, with grounds crew scurrying about to prep for the day ahead. "Looking back, it seems so right. It was a good move for me, a good move for the Orange Show. But it was incredibly hard."

At the park's edge in the distance stands *Monument au Fantôme*. It's a hulking red, white, blue and black fiberglass sculpture by the French iconoclast Jean Dubuffet, who coined the phrase "Art Brut" for the visionary work he championed and collected by self-trained artists working outside the establishment. "Art made by professional specialists, I find it uninteresting," Dubuffet pronounced in his 1948 manifesto *In honor of savage values*. "It is the production of art emanating from persons foreign to the specialized circles and elaborated by those shielded from any influence, in a completely spontaneous and immediate way, that interests me." As one of the first major pieces of public art in Houston, Dubuffet's whimsical monument lived for decades at the foot of the 1100 Louisiana building, but it was moved to Discovery Green right around the time that Theis did.

The search for Theis's replacement found Houston's Robin Koch Howard, a fundraiser and arts administrator with ties to the University of Texas Health Science Center and the Museum of Fine Arts, Houston. Her brief term ran from January to June 2008. She was succeeded by Lynette Wallace, who had served for thirteen years as the executive director of the Bayou City Art Festival, a weekend-long art fair held twice annually. Each year, the Orange Show throws another ritzy gala; hosts a season of small, eclectic events at the shrine; conducts a few Eyeopener Tours; and administers the increasingly well-attended art car parade, all following the template carved out by Theis in the 1980s.

It's no overstatement to say that the Orange Show has become one of the city's most cherished cultural institutions. When the American Association of Museums held its 105th annual conference in Houston in May 2011, its theme was "The Museum of Tomorrow," and the art car parade was chosen as the expo's opening event. Shortly before his death, Dr. Peter Marzio, the pedigreed director of the Museum of Fine Arts, Houston and the conference's chairman, remarked to the *CultureMap* website that "the idea of museums is to make your life better—we wanted to convey a little bit of the naughty spirit that makes Houston so enlivening."

Site maintenance continues to be a constant struggle, and it always will. (As Oshman is fond of saying, "Rust never sleeps.") Alternating periods of standing water and baking heat have caused the ground to shift. By early 2011, the rear wall had begun to bow out again, bulging as much as a quarter inch over the course of five months. It may not sound like much, but it's more than enough to cause significant breakage. What's more, one of McKissack's windmills anchored directly to the wall has produced a constant vibration that has weakened its structural integrity. The concrete

itself is porous, endlessly absorbing water and then drying out, leading to cracks and crumbling.

The summer of 2011 was especially harsh on the Orange Show, as Texans suffered through the most severe drought in a century. With the water table becoming gradually depleted, the ground sank and caused huge cracks in the stucco-slathered walls. Additional supports have been installed to shore up the perimeter walls, and the back alley has been regraded to draw off rainwater. But as a structure wide open to Houston's torrential rainstorms, blazing sunlight, blowing grit and oppressive humidity, there's only so much that can be done, and only for so long, short of enclosing the entire site within some kind of exterior structure.

"But you can't do that," said programs and preservation manager Ruben Guevara as he took me on a detailed tour of the property. "If we put a structure around it, it wouldn't be the Orange Show." Waving at the assortment of swirling metal weathervanes and anemometers, he said, "We restored all of these. They used to be so rusted they couldn't move. Now when there's a good wind, they all move. There's a sound, the squeaking of all these lazy Susans. The flags flapping. That's the Orange Show. We do treat it like a living entity. Sometimes it's bleeding. Sometimes it's just a little scratch, and we have to mend it, take care of it. We have to nurture it."

Guevara came to the Orange Show in 2003 for the first time when a pal was DJ-ing at a special event one evening, and he struck up a conversation with program manager at the time, Adrian de la Cerda, also known as "Mr. Bristle" in his concurrent life as a street artist. Soon after, Guevara began guiding tours as a docent, and he eventually began helping with preservation and stepped into De la Cerda's position when he left the organization in 2010. Although it was his engineering background as a student at U of H that had impressed De la Cerda, he's become just as intrigued with the artistic side of site preservation.

"Here, I'll show you one of the first things I restored," he said as we walk past Mike and Judy, the twin stone lions that guard the steamboat pond. During his downtime as a guide, he enjoyed sitting on the rectangular benches in the Oasis, a small covered alcove opposite the chemical converter display area, decorated with small Grecian statuettes and outfitted with a water fountain—the perfect shady hangout spot on a hot, sunny day. It bothered him to see the benches' blue-green tilework crumbling away, and while he waited for the show to open each day, he collected the broken pieces from the ground and studied up so he could properly reset and recaulk the surface.

Ushering me into the museum, Guevara showed me a particular focus of the most recent restoration effort. The air conditioner clicks on, disturbing the quiet in which the room's occupants had been patiently waiting. "This is what we've been working on since December of last year," he said. "We restored just about everything in here. The signs were in bad shape. The

The freshly restored inhabitants of McKissack's museum wait in silent vigil, August 2011.

mannequins were just in awful condition." Scavenged by McKissack in the '60s when they were thrown out by a department store, they are delicately constructed from papier-mâché coated with shellac. Ravaged by heat and humidity, by the late 2000s, their faces had become cracked and pasty-looking, like dummies from some low-budget haunted house diorama. As conservators prepped them for repainting, they found that they were stuffed with New York–area newspapers from 1954. The team used Bondo putty to fill out deteriorating hands and facial features, and each figure was given a fresh coat of paint and outfitted with a new uniform. "Now they look exactly how they used to look," Guevara said with pride.

For sure, the woodsman is robust and handsome as he wields his new hatchet. His female companion, glancing coyly away from the stuffed deer's head mounted behind her, looks smart in her lime green pantsuit. In the corner, the bride radiates a sense of virginal purity with doe eyes and a faint Mona Lisa smile. The friendly looking bear, ostensibly the wooden Indian's arch-nemesis, has been cleaned and re-stitched and his big blue eyes touched up with paint. All of the signs look brand new. Replacement tiles along the edges of the display platforms are marked with a small orange dot in the corner, so as to indicate that they aren't McKissack's original work.

"Now, I think we've got the right kind of mindset," Guevara said. "In the past, people might just have gone out to Home Depot to get something close to the right color. Now we're a little more careful to go back to original photographs, documenting exactly what kinds of colors were used, what kind of paint was used."

There's a never-ending list of work to be done. The ground has shifted so much over the summer that the men's room door is jammed halfway open. A leaking plumbing pipe caused a corner of the structure to deteriorate so badly that it recently had to be cut out and removed. A brick planter out front is being pushed apart by a fir tree planted as a sapling by McKissack (or possibly by Mother Nature) decades ago but is now a mature sixty-foot behemoth with roots to match. In the weeks prior to our conversation, an unsightly crack had worked its way down a tile mural near the entrance proclaiming the site (not entirely accurately, considering the San Bernadino facility) the "World's First Orange Show / A Jeff McKissack Production." Within the walls of the Orange Show, a small crack always becomes a larger crack. By the time one crack is patched, two new ones appear.

Where previous restoration efforts have occurred during "off-seasons" between December and March and during the excruciatingly hot month of August, Guevara sees the need for a shift to year-round small-scale

restorations and maintenance. "There's no way to keep up with it, otherwise," he said. "We're never going to win that way. We're not going to be able to do much more than to repaint what we painted the year before. Again, for now, preservation is more our goal than restoration."

However, the Orange Show is on the brink of its most detailed and professional restoration effort ever. With financial support from the National Endowment for the Arts, the foundation hired SWCA Environmental Consultants to perform a complete assessment of the site and to develop a plan for both immediate repair and long-term maintenance. In turn, SWCA contracted structural engineer Patrick Sparks of Sparks Engineering and art conservation specialist Joe Sembrat from Conservation Solutions (who'd previously worked with such artifacts as Saturn V rockets and large chunks of the RMS *Titanic*). In February 2012, members of the team reported their preliminary findings at the Divine Disorder Conference on the Conservation of Outsider Folk Art, hosted by the National Center for Preservation Technology and Training on the campus of Northwestern University in Natchitoches, Louisiana.

Despite high hopes, the structure is inherently unstable, and its lifespan is inevitably limited. When I met with former site manager Bryan Taylor, he spoke with the resignation of someone discussing an elderly loved one: "There will be a day when there's no more Orange Show. Even the best-built buildings eventually crumble. And this isn't one of the best-built buildings."

But for now, more than fifty years after its construction began (and thirty years after its completion), the building does survive. Its visionary creator never gave up on his dream, and a succession of caretakers in the years since his departure has fought hard to keep the monument in the best condition possible, improving the lives of countless Houstonians along the way.

In McKissack's museum, there's a smiling ceramic frog sitting beside a butter churn. "It's for the kids, the children," McKissack told Bill Martin for his *Texas Monthly* piece. "You gotta have something for everybody." The sign behind the display reads:

> TWO EAGER-TO-LEARN FROGS FELL INTO A CHURN.
> ONE FROG CROAKED, "I CAN'T MAKE IT. I CAN'T MAKE IT."
> THE FROG QUIT KICKING AND DROWNED.
> THE OTHER FROG CROAKED, "I CAN MAKE IT. I CAN MAKE IT."
> HE KICKED. THE FROG KICKED. HE KICKED AND KICKED.
> FINALLY, A CAKE OF BUTTER FORMED.
> THE FROG CLIMBED ON TOP AND SAVED HIS LIFE.
> MORAL: NEVER GIVE UP. KEEP A'KICKING. KEEP A'KICKING.

Snickered at by the townsfolk of Fort Gaines and his neighbors on Munger Street, committed to a mental institution by his own sisters, jilted by his mysterious Floridian sweetheart, called out by Thomas Edison and kicked out of Columbia and with his beloved Orange Show largely misunderstood or ignored in his lifetime, McKissack kept a'kicking.

"I suspect Jeff McKissack made up that story," wrote Martin. "If he didn't, it's clear he got the point."

Chapter 2

# THE BEER CAN HOUSE BY JOHN MILKOVISCH

When there's a breeze, you can hear it before you can see it, especially if you head north on Malone Street away from Memorial Drive and into the re-gentrifying Rice Military neighborhood, or what's also known as Houston's "West End." It's not the cloying bell-like tone of your typical wind chime; it's more of a gentle metallic tinkling. Pleasant. Subtle. To those of us from the North, it might suggest sleet pinging daintily off a tin roof. Then you see it—what might otherwise be an unremarkable mid-century bungalow sandwiched between two monstrous, three-story townhomes. Except this bungalow looks like it's been heavily draped in Christmas tree tinsel. Next, you notice the fence and the repeating circular shape of the streamers dangling from the eaves. Oh my God, those are all cans. That house is covered entirely in beer cans. Well, it is, after all, the Beer Can House.

Working from 1968, when he was fifty-six, until shortly before his death in 1988, John Milkovisch covered his one-tenth-acre yard in intricately decorated concrete and clad his house in an armor of flattened aluminum cans. He linked their tops and bottoms with wire hooks and hung them like chain mail curtains from the house's gabled roof, and he also surrounded the property with a picket fence studded with marbles that allowed sunlight to pass through with an iridescent glow. Was Milkovisch a maverick architect or some kind of smarty-pants conceptual artist? No, he was just an upholsterer who spent his life working on railroad cars, a practical man who decorated his house intuitively on his days off and after his retirement—a man who told anyone who asked about his creation that he did it because he hated mowing

the lawn and painting the house. But he loved to drink beer, whatever was on special.

Over the past thirty years, the Beer Can House has become a pop culture icon. It's been featured in the *Ripley's Believe It or Not!* syndicated comic strip (in fact, the Ripley's people once sent a representative in a fruitless attempt to accurately count the cans) and in numerous "roadside attraction"–themed books and websites. MTV even arrived at the height of the network's popularity to film an on-location report. After John's passing, his widow, Mary, became a minor celebrity, appearing on daytime game shows *To Tell the Truth* and *You Bet Your Life* and starring in a TV commercial and a glossy magazine ad for trash bags made from recycled milk jugs.

Mary moved to an assisted living facility in 1997, and shortly before her death in 2002, the house was purchased from the family by the Orange Show Center. Since the completion of a meticulous restoration in 2008, it has been open to the public most weekends. Before he cut an orange ceremonial ribbon festooned with can tops, Mayor Bill White declared the Beer Can House to be an example of Houston's "fun, quirky alter-ego to the high-architecture downtown skyline" and recognized that "often what some regard as strange at the time turns out to be the most memorable aspect of a city or culture." To wit, whenever Houstonians are invited by a website or the local paper to name their favorite local landmarks, the Beer Can House always makes the list.

"I think he'd be shocked," said John's son, Ronnie, standing in the backyard at 222 Malone and assessing the expanding legacy of this carefully preserved monument as guests stream past us on a Saturday afternoon. "He would probably say something like, 'People really don't have a lot to do, do they?' You know, he told somebody once that he wouldn't walk around the corner to see this place."

"He tried to take this very lighthearted," Ronnie continued, looking around and reacquainting himself with his father's remarkable labor of love. These days, he comes in from his home in northwest Houston to visit three or four times a year, sometimes to help with some minor maintenance on the property or just to stop by and reminisce. "I do think it was important to him," he told me, "but I don't think he really cared if it was important to you. And the fact that so many people do care, I think would surprise him."

"The art students come here and call it art," Milkovisch told the *Houston Post*'s art critic Mimi Crossley in 1980. "But I say 'no way.'" Yet it's hard not to see a relationship between Milkovisch's work and that of, say, the California conceptual artist Tom Marioni, who has created several sudsy

works, including his 2000 piece, *Golden Rectangle*, which consists of a set of shelves containing 119 neatly arranged Pacifico beer bottles. Then again, there are skeptics who question whether Marioni's work is really art, and Milkovisch certainly made no such claims for himself. Inside the house, which has been emptied of its furnishings and converted into a tiny museum displaying his early experiments with beer cans, his work bench and his customized tools, appliqued to the wall, signal his attitude clearly: "This curtain idea is just one of those dreams in the back of my noodle."

John Milkovisch's father, also named John Milkovisch, was born in March 1885 in the city of Hornstein, in what was then the Austro-Hungarian empire. He moved to the United States at the age of twelve with his own father, an Old World craftsman, and his stepmother. They settled in Philadelphia, where the elder John met his future wife, Marie, about a decade later, as a boarder at her parents' property. John's nephew, James Kachtick, said that the first John Milkovisch "was a dandy back then, you know, mustache, high collar and tie." When he was in his mid-twenties, and Marie only fifteen, the sweethearts eloped, wed and hopped a ship to the port of Galveston, which was still struggling to rebuild from the devastating hurricane that leveled the city in 1900. They moved inland and settled in Brunner, a small community established on the western outskirts of Houston that was already becoming engulfed by the growing city just as they arrived. A son, John Martin Milkovisch, was born on December 29, 1912, in the family's small apartment near the intersection of Washington Avenue and Shepherd Drive, behind Schot's Bakery.

While John was still an infant, his parents purchased property a few blocks to the southwest, on the corner of Malone and Kent (now Feagan), where they built by hand a modest house for themselves and their growing family. "Not quite a shotgun house," said Kachtick, "but a typical cottage for this kind of ethnic neighborhood." In August 1914, John's sister, Louise, was born. Before long, the elder John was operating from the rear of their domicile a thriving furniture refinishing business, specializing in pianos. There was plenty of work. Little more than a decade after the Spindletop gusher, new oil money was flowing into Houston and helping to establish affluent neighborhoods just south of Malone Street. "He must've refinished half the pianos in River Oaks," said Kachtick of his great-uncle.

"All the wealthy homes were on the bayou," remarked eighty-seven-year-old John Siml, "and we didn't understand why you'd want to live down there—you could get flooded out so easy!" Siml was born at 221 Malone in 1925 and still

Young John Milkovisch with sister Louise. *Courtesy Ronnie Milkovisch.*

lives next door today. In fact, his family once owned much of the property on his side of the street, which was built on the periphery of what had been Camp Logan, a World War I encampment that's best known as the site of a tragic race riot and a severe outbreak of the Spanish flu. By the time the younger John Milkovisch was ready for school, the camp's hospital had been converted into a makeshift schoolhouse on the corner of Washington Avenue and Birdsall Street, where John and Louise began their education. Later, he'd switch to Stevenson School on Radcliffe and finished the eighth grade at George Washington Junior High.

"Johnny, his sister Louise and my sister, Margie, they all went to school together," said Siml, describing a neighborhood worlds away from modern-day Houston, where kids ran off to fish and swim in Buffalo Bayou[4] and hunt and trap rabbits in the woods. West of Knox Street, in what's now Memorial Park, there was a pasture good for kite flying, and Mrs. Skiff from up the street would walk her cow there to graze every morning. Siml can even remember the block party held in the early '30s in celebration of the paving of Washington Avenue, now one of the city's most historic thoroughfares. In fact, many of those fancy homes did flood back in 1935, when the bayou rose so much, Siml recalled, that "there were houses where you could just see the chimney!"

"My cousin who lived down here on the corner, Johnny Hoiden—he and Johnny Milkovisch were about the same age," continued Siml. "They'd run

around together. Fact is, they had a bet. First one that got married had to give the other one a dollar. They wrote it down, and I've got it in one of these old albums somewhere."

When the young Milkovisch completed the eighth grade, he left school in order to learn a trade. From connections made caddying at the Memorial and River Oaks golf courses, he picked up a few landscaping jobs and even hung drapery in the enormous houses coming up throughout River Oaks, including the luxurious Ima Hogg estate just south of Malone at the junction of Memorial Drive and Westcott Street. Johnny Hoiden's father ran an upholstery business downtown on Rosalie Street, and during the Depression, John found steady work there as an apprentice. At nineteen, he showed off his sharpening skills with the creation of a cedar chest inlaid with the hearts, spades, diamonds and clubs of a deck of playing cards.

John's father impressed on him the importance of responsibility, hard work and job security. Kachtick remembered the elder Milkovisch as a "tough guy" who "intimidated my uncle to some extent." Meanwhile, he described young John as a "fun-loving dude" and a flashy dresser who sported a straw skimmer hat with a flat brim and crown. He was a thin, good-looking fellow who drove a Chevy with a characteristic whine that would announce his impending arrival.

By the end of the Depression, John was cultivating a love affair with a young lady named Mary Hite. Mary was born in Idaho in 1916, and her father, a Railway Express agent, moved his family of six kids to Houston from Solvang, California, when Mary was in her teens. She graduated from Sam Houston High School, but when the rest of the family returned to the West Coast, she stayed behind to enjoy her friends and a well-paying job at Gordon's Jewelers. Then, she met John at a party, who wasn't the only one who was charmed. "Whew, she was one of the original Valley girls," chuckled Kachtick, who remembers their courtship well. As the oldest of John and Marie's grandkids, he said, "I was just in love with her. She was a princess."

John continued to live with his parents until he and Mary wed on May 19, 1940. They moved first into a duplex at 636 Harvard Street in the Houston Heights and then briefly to a three-room house back in the West End at 319 Birdsall. John's sister Louise had married a man named Walter Kachtick and was living with him and their young son, James, at the small gabled bungalow that the elder Milkovisch had just built at 222 Malone, two blocks south of the family home, as a rental property. When the Kachticks moved out of the neighborhood later that year, John and Mary moved into number

John Milkovisch and Mary Hite, circa 1940. *Courtesy Ronnie Milkovisch.*

222. John bought the house from his father in 1942 and lived there for the rest of his life.

For more than a quarter century, things around the Milkovisch household were pretty typical of the blue-collar Rice Military neighborhood. John and Mary had three kids: Marcia, born in 1941; Ronald, born in 1942; and Guy, born in 1946. Kachtick was a frequent visitor to the household and remembered John as a "tough father" who "probably intimidated Marcia as much as anyone." Or, put another way, "If I was having dinner there, and he told me to finish what was on my plate, you'd better believe I did it."

John had gone to work as an upholsterer for the Texas and Louisiana Line Railroad (later to be renamed the Southern Pacific Transportation Company) in 1935, working on passenger cars and Pullman sleeping coaches. Never one to remain idle, he worked his trade at Brookmay's Piano, at the Myers-Spalti Furniture Manufacturing Plant and back at Hoiden Upholstery during strikes and layoffs. Pictures from the family album show an increasingly rotund and balding man in a work shirt kicking back after a long day on the job, maybe resting on the couch or perhaps sitting with friends at the kitchen table, always with a beer in hand.

Despite his working-class roots and his rough-and-tumble demeanor, John enjoyed opera and classical music. He'd sit in the yard with a cold one and listen as his extensive collection of 78s blared on his oversized stereo cabinet. He went for long, daily walks on the advice of his doctor, east on Memorial Drive all the way to downtown and back, or along a two-mile

Milkovisch family portrait, circa 1960. *Clockwise from bottom left*: John, Ronnie, Marcia, Guy and Mary. *Courtesy Ronnie Milkovisch.*

loop on the north side of Memorial Park. Politically, although his nephew, James, characterized him as "a bit to the right of Atilla the Hun," his son, Ronnie, contended that as a labor union man, his dad almost always voted for Democrats like Adlai Stevenson or for Independent candidates. He drove solid, American-made cars—a 1937 Plymouth and then a 1950 Chevy, both handed down from his father. "He wasn't a touchy-feely guy," said Kachtick, "but he knew what he liked and enjoyed every minute."

Number 222 Malone before the addition of beer can siding, circa 1968. *Courtesy Orange Show archives.*

The years went by happily, full of hard work and Friday night drive-in movies over on Post Oak Boulevard. John and Mary were the first ones on the dance floor at Van's Ballroom on Shepherd and Alabama and at the Sons of Hermann Hall on Yale Street (where Milkovisch and Jeff McKissack might have brushed elbows unknowingly), and of course, there were frequent get-togethers at the house. "So much fun," sighed Kachtick. "Beer drinking, laughing, music, barbecues…the house always smelled like good German cooking. I think John was always flabbergasted that Mary had married him. He just adored her."

As the kids grew, so did the house, with a new back bedroom featuring art glass stained windows and a kitchen extension in 1957. ("We're amazed at how five of us sat down at the dinner table—it was so small," says Ronnie now.) John's father died in 1954, but his mother, Marie, lived the rest of her long life on Malone Street, playing dominos and pinochle with the Simls on their front porch and remaining a significant presence in the day-to-day activities of her son's family.

John was an eager craftsman, always up for a project; for example, he worked with John Siml, who'd become a tool and die man, on a little table-and-chair set for Siml's daughter. Siml made the chair out of wrought iron, and Milkovisch did the upholstery. At Mary's request, John installed

linoleum flooring in the kitchen, bath and front and middle bedrooms in the house, creating eye-catching patterns of marbled browns and greens from scraps brought home from Southern Pacific. He also tried his hand at a geometric wooden inlay on a kitchen countertop and upholstered most of the furniture in the house, as well as the headboards to the beds. He made a leather holster with a metal star for young Ronnie and fashioned a stylish periwinkle blue leather jewelry case for his adoring wife.

Ronnie had plenty of chores, including painting the house and applying creosote oil to pipes and lumber underneath ("My sister always says we're lucky to be alive with all the stuff our dad brought home," he jokes), but he never really worked on projects with his dad. "He was kind of a perfectionist," Ronnie said. "I'm not sure he would have been such a great guy to work with."

In the mid-'60s, Mary began working at Foley's, Houston's massive department store on the 1200 block of Main Street, as an advisor in the cosmetics department, from which she'd bring Siml's daughter a steady supply of miniature perfume samples. By all accounts, Mary was a fun-loving gal who played the ukulele, dressed like a black cat every Halloween and filled every square inch of the house with knickknacks.

In the Foley's cosmetic department, Mary became friends with a young woman named Donita Burkett Hollander, who lived only a few blocks away. An old snapshot shows Donita and her husband, Dennis, sitting at the Milkovisches' kitchen table, smiling widely and sharing a beer with Ching, their Lhasa Apso they'd brought along for the visit. Dennis recalls countless afternoons and evenings at 222 Malone between June 1965, when Donita and Mary met, through May 1969, when the Hollanders divorced and moved out of the neighborhood. "They were down-to-earth and enjoyable people to be around," said Dennis. "I can remember talking for hours on end with both John and Mary about their life, family and dreams."

By 1968, John had finally paid off the mortgage on the house, and he used some of the extra money to buy a metal patio cover to shade the rear section of the backyard. The heat of the summer in Houston can be withering, and a man needs a shady spot to sit, relax and sip a beer. Milkovisch always had at least a half-dozen cases on hand, which he'd pick up at one of the nearby mom and pop groceries like the Lucky 7 at the corner of Birdsall and Lacy or Pizzitola's on Feagan and Birdsall.

"John did love his beer," said Dennis, "and he did indeed buy whatever was on special. I can't ever remember going over to his house where he didn't have a cold beer in his hand or one close at hand to share with you.

He was never drunk nor lost his composure in any way. Drinking beer didn't seem to effect John's coordination in the least bit."

Around the very same time Jeff McKissack began toiling on his Orange Show on the other side of downtown, John went to work on his patio with the same skill and precision that he applied to upholstering railroad cars. Behind the newly mounted patio cover, he built a fence of redwood slats, about four inches wide and six feet tall. With a drill, he bore five-eighth-inch holes in complicated patterns and filled them with glass cat's-eye marbles from his extensive collection, forty to ninety of them per slat. The effect was brilliant, and Mary once remarked, "When the sun would come up in the morning, the light would shine through the holes and the marbles would sparkle in multi-colors."

For a solid floor beneath the metal awning, he arranged rectangular twelve- by twenty-four-inch concrete pavers in an alternating pattern and then painted them in pastel shades of red, blue, orange and green. He filled the spaces between with square blocks of poured cement, in which he embedded starburst patterns of marbles, all with rectangular brass pieces at their center, except for one that boasts a doorknob engraved with the year "1968." Not content to leave it at that, he created a curving sidewalk leading from the patio to the driveway and to the backdoor of the house. He painted these pavers, as well, and decorated the concrete in between with more marbles. He had plenty at his disposal, ever since he bought out the entire stock of a failing dime store and carted them home in his wheelbarrow.

Gaining momentum, he began to pour his own concrete blocks in a variety of shapes—squares, rectangles, circles, diamonds, shields and flowers—embedding in the wet concrete rocks in various shades of brown and black, as well as bricks, shells, wire mesh, chipped ceramic, bits of broken glass and hundreds of marbles from his collection. He'd work after he came home from the rail yards, on weekends and on holidays. By the end of 1971, he had covered virtually every inch of his property, to the front, back and sides of the house, with decorated concrete.

"I can remember when John first started working on changing his home into the artistic showplace that it eventually became," said Dennis Hollander. "He would sometime work intensely for several days on this and then relax for a few weeks to enjoy his labor before starting up his task again. It was very much like a strong passion with John to do this. He never could really explain to me why he was doing it except to say that it kept him busy, and the more he did, the more he wanted to do. I think Mary had mixed emotions

Detail of inlaid cement surface, July 2011.

about this change in the beginning, but eventually she began to get as much involved with his dream as John was."

"He'd mix the cement by himself," said John Siml one summer afternoon as we gazed across the street at the Beer Can House, twinkling in the sun. "And the rocks in there, he went out here on the other side of Memorial

Park, to the railroad tracks. That's where he got the rocks, and the metal that would fall off of box cars, he'd just haul it all back." Sometimes he'd take along the wheelbarrow he'd inherited from his father to transport his finds or sometimes just a heavy canvas satchel, and then, upon arriving home, he'd dump out their contents under a tree beside the door of the garage at the end of the driveway. John never put his car in the garage; he called it "the shed" and used it exclusively as his workshop and for storage.

By this time, Ronnie was in his late twenties, had graduated from the University of Houston and was embarking on a long and successful engineering career with Schlumberger. But he and his wife, Brenda were at the house frequently, and Ronnie kept his father company while he was toiling on the driveway for hours at a time. "He's putting these patterns of bricks in one day," he recalled, "just picking up whatever he wants and just layin' it out. And I came up with a design, and he said, 'Son, you just sit there in that chair and drink that beer; this is my project.'" Today, as a fourth-generation craftsman, Ronnie admits that he readily identifies with the urge to protect one's work from the well-meaning "help" of others. Even back then, he said, he got the point: "I never made another suggestion to him after that."

John's work became increasingly detailed and imaginative. The birth of Ronnie and Brenda's son is commemorated by the inscription "Mark 1971" within a trio of sun-shaped impressions in the concrete beside the door to John's shed. The pair of bricks, one red and one white, that form a perpendicular "T," with their round center holes filled in with marbles, is a nice touch. Later on down the driveway, John sunk two particularly eye-catching slabs announcing the house's address. Just about a third of the way up the drive, "222 Malone" is inscribed in small black stones on a slab polka-dotted with marbles. At the top of the driveway where it joins the sidewalk, "222" is written in marbles against a background of black and tan rocks pressed into the wet concrete.

On a small brick-and-concrete pedestal just to the south of this marker, Milkovisch mounted a tricone rotary rock drill bit, a device featuring three rotating cutters that ground quickly through rock. Invented in 1933 by Houston's Hughes Tool Company engineer Ralph Neuhaus, it revolutionized the drilling industry.

"We used to work on those," said Siml. "We did work for the oil companies and Schlumberger, and that one got left behind on a job, so I thought Johnny might like it. I don't know if you noticed over there on the cement work between the sidewalk and the curb, there were a bunch of plastic washers I

gave him, a quarter, five-sixteenth thick, with a hole in the middle. They were scrap, but I brought 'em over, and when he was working on the sidewalk, he'd push them into the cement. Now I think the holes are still there, and most of the plastic is gone."

Having jumped the sidewalk and extended his work all the way to the curb, there was nowhere to go but up. He built long, rectangular planters, about a foot high, along the driveway, the north border of the property, and along the sides of the sidewalk leading to the front door. These were made of more concrete slabs decorated with alternating patterns of black and tan stones (and even "signed" with his initials) and then topped with wooden boards inlaid with marbles.

Left with excess dirt and concrete at the end of the day, Milkovisch sculpted conical mounds, first in the front yard, then in the back and along the south side of the driveway. Each has a different character. A low mound in the northern side of the front yard is decorated with heavy slabs of garnet-colored iron ore and a toppling pancake stack of soapstone impaled on a steel post staked through its core. A much larger mound to the south is festooned with pieces of broken bottles, ceramic mugs and bits of wire mesh and topped with an aboriginal (or tiki?) fringe of delicate ribbons cut from beer cans that stirs in the wind. A mound in the backyard is capped with a large, oblong rock stood on end.

Some consider his finest individual piece to be the concrete and metal arch, completed by 1972, that stands in the backyard, decorated with bamboo reeds, slivers of delicately folded metal and a cowbell at its apex. "Yeah, he must've been in a real zen kind of mood when he did this," said Ronnie, peering up at it and grasping hold of its brightly painted concrete supports, which John molded from cardboard tubes and then studded with washers and wooden pegs. To me, it looks like a tribal relic from out of the Pacific Northwest.

With every inch of soil now entombed in cement, John was looking for the next thing. In 1976, he retired from Southern Pacific as the last upholsterer remaining on its payroll. He was rewarded with a handsome brass plaque ("in recognition of 41 years of injury-free service"), and at sixty-five, he settled into retired life on Malone Street. After so many years, he'd had enough of the upholstery trade anyway. Ronnie recounted a story wherein Guy asked his dad to redo a leather stool for him. John took out his wallet in response and told him to go buy a new one. "He just totally lost interest in the needle and thread," said Ronnie, "the whole business."

John did enjoy spending time in the yard, which with its giant pecan tree and assorted other plants he called "Little Africa." He placed plastic parrots in the trees, as well as hanging planters made from coconut husks spilling Spanish moss. He collected birdbaths and garden statuary. He dripped paint on his workbench in a winking imitation of Jackson Pollock's action paintings. He built a wishing well (which eventually filled up with excess can trimmings) and fashioned a delicate abstract sculpture atop one of the backyard mounds from sticks, pull-tabs and yarn. He hung a few beer can tops, as well as the plastic rings from his now daily six-packs, from the trees. The latter blew down easily in the wind, though, or quickly biodegraded in the rain. Ronnie recalled an attempt to melt down the rings, tint the resulting goop with paint and apply it to the house with a brush. The idea went nowhere after the material quickly dried, cracked and fell off.

Between 1968, when he began his project, and 1972, when he'd completed the majority of the concrete work, John consumed a lot of beer. Like many who made it through the Depression, he was loath to throw anything away, and he was fascinated by the ingenious design of the seamless aluminum beer can. "While I was building the patio, I was drinking the beer," Milkovisch told writer Joseph Lomax some years later. "I knew I was going to do something with them aluminum cans because that's what I was looking for." He estimated that he'd saved seventeen years' worth of cans, stacking bundles of them in the garage, in his attic and in the attic of his mother, who still lived in the same house on the corner of Malone and Feagan.[5]

It's tough to pinpoint exactly when he began working in earnest with beer cans as a decorative medium, as no photographic evidence exists of him actually attaching them to the house. A photograph dated 1972 shows the house with no can work. The next available picture, from 1976, shows a quilt-like screen of interlinked Budweiser can labels forming an arch over the driveway. Two years later, a similar screen, flanked by can-top garlands, is seen hanging from the eaves and shading the south side of the house. When Joe Lomax visited and interviewed the Milkovisches in 1983, John estimated that he'd begun working with cans about the time he retired. "I would say around seven or eight years ago."

The basket-weave screens, while attractive, proved to be unsuitable for outdoor use. "A strong wind took care of that," Milkovisch told the *Post*'s Mimi Crossley. But he was really on to something with the garlands, cannily exploiting the subtleties of the bungalow's shape and design. "The wife doesn't want me to do too much to the trees," he told Crossley. "She thinks it will kill them." By 1979, he'd hung streamers made from can bottoms

Ronnie Milkovisch and his son, Mark, with beer can screen and curtains, 1978. *Courtesy Orange Show archives.*

prominently from the two pointed gables at the front of the house. Along the north eave, he strung delicately tinkling curtains made of the cans' pull-tabs and, to the back, garlands of linked diamond shapes made from forging together two squares cut from flattened cans, the larger's edges ingeniously folded over the smaller's. Other streamers used can tops separated from, but still framed within, their rims, allowing them to pivot, spin and rotate.

Drawing from his seemingly endless supply of flattened empties—Shiners and Lone Stars and Pearls and Texas Prides and Falstaff 96s and Budweisers and Buckhorns and Dixies and numerous others (including the occasional 7 Up or Sprite soda can)—John had perfected a method of creating panels two by four feet in size, and in about 1980, he began to attach these to the house like sheets of siding, with aluminum tacks carefully clipped to the proper size. He went row by row, starting from the bottom.

"Now then, I would say—you take this bottom part around the windows," he told Lomax. "I did that first. After I had gone all the way around the

house below the windows, it didn't take me no more than seven months to get the rest done." Winking at Mary, he continued, "I was soft peddling her in the meantime. See, giving it to her slow."

"He didn't know if he was going to get to do it," Mary chimed in, "but finally he did it all before I knew what was going on." She'd get on the bus to go to work at Foley's, and when she arrived home in the evening, there'd be another row of cans on the house. Freshly applied, the panels popped with vibrant reds, yellows and blues in a seemingly haphazard patchwork pattern.

"I thought he was off his rocker," Mary said later. "I also worried what the neighbors would say." But in the spirit of matrimonial compromise, she and John struck a deal. John could continue to do whatever he wanted to on the outside of the house. But the interior was Mary's. No beer cans inside the house, please.

John did construct a macabre tableau on the kitchen wall, where he pinned up the carcasses of dead bugs and left them until their legs and antennae would fall off. This gave Mary license to step into John's territory. In about 1980, she fashioned an adorable little tree from a metal bottle rack hung with small plastic juice containers shaped like lemons and added it to John's outdoor display.

Needless to say, this tinkling, twinkling house attracted considerable attention. Now retired and largely finished with the most time-consuming parts of his work, John had plenty of time to sit on the front porch and talk with neighbors and curious passersby.

"This is where he'd sit," said John Siml, pointing to the edge of the front stoop, "right next to this post. Every morning and every afternoon. I had a few beers with him right there, yep. He had lawn chairs, but he'd sit right there."

Milkovisch was often asked whether he'd emptied all the cans on his own. He was a beer drinker of heroic proportions, with a belly to match, but the fact is that Mary helped, as did their kids, their kids' spouses and the family's many friends and neighbors. John would also pick up littered cans while on his daily walks, and after a while, some admirers began tossing empties over the fence. Milkovisch appreciated the materials as he worked his way up toward the eaves.

"My father taped these together," said Ronnie, running his hand along the surface of the house. "He'd have five beer cans across and three down, which was a panel of fifteen, and he did 'em upside-down and overlapped 'em like shingles, taped 'em down, and then he punched it with an icepick and put these handmade rivets in them and punched 'em in with a hammer from the backside. Some of them squashed the cans, and they fell off, so he

had a lot of errors with that technique, but usually they lasted long enough for him to get them in place on the wall and tack them up, with felt paper behind there as a moisture barrier."

By 1982, the house was completely covered with flattened cans. John's shed, too. But with a restless creative spirit, he couldn't help but add to, and alter, his work. In 1983, John came across a cache of Bicentennial Falstaff beer cans adorned with the face of George Washington, fashioned a screen from them and hung it from the lower front gable. The cans were made of steel, though, not aluminum, and they turned quickly to rust. A second, identical screen survived somewhat intact and remains as part of the interior display today.

While the rest of the city gawked at Spanish artist Joan Miró's whimsical fifty-five-foot-tall sculpture *Personage and Birds*, installed at the foot of the JPMorgan Chase Tower and dedicated in April 1982, John felt inspired to create a breathtaking piece of modern art of his own. In 1983, he sank one end of his father's prop ladder into a diamond-shaped, marble-studded concrete slab. He colored it with yellow paint leftover from another project, and from the top, he dangled from long wires a moon and stars cut from beer cans. He entitled the sculpture *Ladder of Success* (although Mary preferred to call it the "Stairway to the Stars"), and he painted the third rung black to indicate that it can be a difficult climb and that, as he put it, "most people don't make it." Two years later, he attached a sign to the very top, emblazoned with one word: "Amen." Mind you, while Mary was a weekly churchgoer, John always stayed home.

Also in 1983, John erected a sign hung from a framework of plumbing pipe that announced the house's address in Roman numerals cut from aluminum: "CCXXII Malone." To the pipes he attached two faucets. John and Mary went frequently to the beach in Galveston, forty-five minutes away. Arriving early in the day, John liked to sink a faucet-topped pipe into the sand and then sit back in his beach chair to watch confused beachgoers attempt to draw water from the tap. Two years later, he added a second sign to his home, commanding its viewers to "Live by Golden Rule." Both set silver letters on a green background, in imitation of the reflective signage erected up and down Houston's freeway system.

John's original fence that stood behind his backyard patio blew down in August 1983 during Hurricane Alicia. It was the worst Texas hurricane since 1961, and besides knocking down John's marble-studded fence, it caused $2.6 billion worth of additional damage while killing twenty-one people. The cans held up relatively well, though, and have done so during other such

meteorological incidents. When Joe Lomax asked Mary what the can-top curtains sounded like in a hurricane, she replied, "Well, wild!"

Over the next few years, John constructed a high fence along the property's south side made from wooden slats, beer bottles and, of course, more cans, as well as a lower fence on the property's north side. In 1985, he built two large planters clad in flattened cans and placed them between the sidewalk and the curb in front of the house. He decorated the sides with stars and odd phrases spelled out with letters cut from cans: "ME YOU SHE," "HE IOU IT AM" and "OK NO GET." While countless visitors and passersby have scratched their heads while attempting to decipher their meaning, it was all just another of John's put-ons. "He just did that so people would ask," Mary once said.

Likewise, a small placard that reads "BAD CAT" in hand-cut lettering was attached to the fence beside the driveway in response to the "BAD DOG" sign that John Siml put on his lawn across the street. Never mind that neither the Simls nor the Milkovisches owned a cat or a dog. It simply tickled John's taste for the absurd.

Toward the end of his life, John retired his trusty wheelbarrow, planted flowers in its basin and attached to it a sign with his now-trademark cutout letters that shouted "CULPRIT." This is the same wheelbarrow that had once belonged to his father and with which John was sent as a boy to collect bricks and stones along the railroad tracks for a driveway and footpath for the family home. Over the decades, John put it to use gathering materials for his beloved Beer Can House, and clearly he understood it to be the catalyst for a lifetime of hard work.

There wasn't much left to do but sit back, pop open a couple of cold ones and continue to watch the passing cars screech to a halt. "Then they get embarrassed," Milkovisch guffawed when interviewed by the *Chronicle*'s Donna Tennant in 1980. "Sometimes they'll drive around the block a couple of times. Later, they come back with a carload of friends."

Occasionally, they even came by the busload. On August 12, 1986, a luxury coach squeezed down Malone Street as the twelve-member crew of MTV's *Amuck in America* program rolled up to tape an on-location report hosted by VJ Alan Hunter.

When Susanne Theis, Sharon Kopriva and Caroline Bowles helped to launch the Orange Show's inaugural Eyeopener Tour in September 1986, the Beer Can House was one of its most popular stops. As usual, John and Mary were patient and gracious hosts. But that didn't mean John had any reciprocal interest in the Orange Show monument. When Ronnie drove him

over to Munger Street one afternoon, his father wouldn't even get out of the truck. "Okay, now I seen it," he barked. "Let's go."

After John suffered a debilitating stroke in the spring of 1987, he was confined to a wheelchair. He died at home less than a year later, on February 24, 1988, with the official cause of death given as cardiovascular thrombosis. Marks Hinton, who would go on to research the site in detail and write its visitors guide, posits that once John was no longer able to work on his house, he simply died of a broken heart. Like Jeff McKissack, John was cremated, and fittingly, his ashes were scattered on the grounds of the Beer Can House during a small private ceremony.

Susanne Theis had met John and Mary in 1985, after she, Kopriva and an early Orange Show supporter named Susan Stem visited the house during an impromptu tour of unusual sites they'd heard about by word of mouth. Despite the pouring rain, they found John hard at work, clipping cans in the shed. "He was so completely charming and self-effacing about what he was doing," Susanne remembered. "Susan was the only one of us that day who had known Jeff McKissack, and she remarked later on how different he and John were—how proud Jeff was of his creation and, by contrast, how humble John was. I have long thought he must have been proud of what he was doing, but he was uncomfortable with it being called 'art.'"

The Beer Can House continued to be the star attraction on many of the early Eyeopener Tours, and Theis's friendship with the Milkovisches deepened as she brought artists, collectors, writers and gallery owners to visit whenever they came to Houston. Everyone, it seems, was quite taken with the humble upholsterer and his shimmering creation.

Of all the elements that composed 222 Malone, Theis's favorite was the cowbell arch: "The top part had pieces of bamboo from the backyard, and straightened pieces of beer can rims, which I was always fascinated by, because of how utterly time-consuming and complex the process was, and how utterly simple the effect was."

Marilyn Oshman had recently returned from India with a traditional wedding arch decorated with tiny sculpted metal figures. "When I saw Mr. Milkovisch's arch," Theis said, "I thought of Marilyn's, and I asked him whether he was thinking about arches as a traditional symbol of two people coming together. He just laughed—thought it was a bunch of hooey."

But a few years after John's passing, when Susanne met her future husband, David, and they decided to wed, she thought again about the arch. "I thought about John and Mary, too," she said. "They seemed to me to

have one of the great marriages that I knew of. They were such a team. Mary was like apple pie, just the most wonderful, gracious woman, and for her husband to spend all of his time making the Beer Can House, you can imagine it required some patience."

When Susanne asked if she and David could have their wedding in the yard, Mary was enthusiastic. David was happy to go along ("In fact, it was a condition for her to marry me," he joked), but not everyone was as excited. "That sounds so tacky," complained David's mother when he told her about the wedding's location. "It's much nicer than it sounds," he countered. "It's actually kind of spiritual." When he pushed his luck and asked that the Beer Can House be mentioned by name on the invitation, well, that was too much for mom. "Forget it," she said, putting her foot down. "'In the lovely garden of Mrs. Mary Milkovisch' sounds much nicer."

The simple ceremony took place on December 6, 1990, with Barbara Hinton fashioning a walkway from a roll of white plastic, and Greg Harbar and his band the Gypsies providing the music. Susanne and David couldn't find a Catholic priest who'd deign to participate in a wedding at a house clad in beer cans, so the ceremony was officiated by a young Episcopalian priest named Bill Miller, himself an admirer of the Orange Show who was working on a country western demo. Inspired by the surroundings, Miller urged those gathered to seek "holiness in that which is common—bread, a beer can, a human being."

"I was just dumbstruck by what he wrote," Susanne said, "because it was the perfect explanation for why I felt so passionate about places like the Orange Show and Beer Can House. He connected the idea of the moment of grace to the moment where something is transformed into something else by a loving creator."

In the years after John's death, Mary continued to welcome visitors and videographers and became something of a minor celebrity around Houston and beyond. It was the perfect human-interest story, tailor-made for the five o'clock news on a slow day: "Viewers, meet the charming old lady who lives in the whimsical Beer Can House."

In the spring of 1991, Mary appeared on *To Tell the Truth* opposite host Alex Trebek and guest judges Kitty Carlisle, David Niven Jr. and Dr. Ruth Westheimer. In 1992, she was flown to Philadelphia to tape a segment of the game show *You Bet Your Life* with Bill Cosby, but she found the experience so unpleasant that she stuck to local activities after that. She picked some of her favorite tunes with the Houston Forum's Swinging Strings Ukulele Band, and she took up tap-dancing.

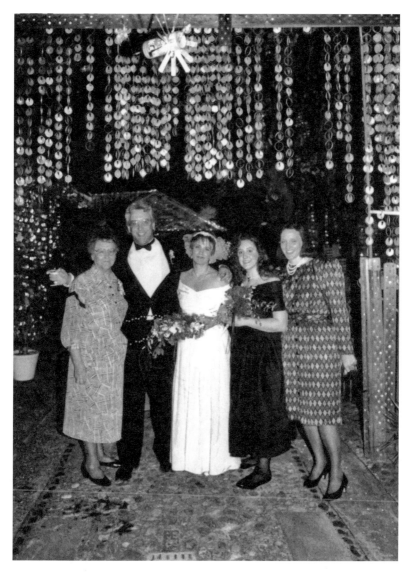

Susanne and David Theis wed at the Beer Can House in December 1990. *Photo by Janice Rubin, courtesy Susanne and David Theis.*

She posed in front of the Beer Can House seated in a yellow lawn chair beside her little lemon tree for a photographer from the Martin Williams ad agency; a resulting portrait was used in a national magazine ad campaign for Ruffies, trash bags made partially from recycled milk jugs. ("It's a unique recycling story," company spokeswoman Rhonda Iannacone said of the

Beer Can House in the *Chronicle* at the time.) The ads appeared in *People, Good Housekeeping, Parents* and other magazines appealing to the twenty-six- to fifty-four-year-old female demographic. She filmed a TV commercial for Ruffies, too. "Mary Milkovisch made a house with recycled beer cans," comments an unseen narrator. "Ruffies made a trash bag with recycled milk jugs." Mary deadpans the punch line at the spot's end: "Maybe we'll drink more milk."

Throughout the '90s, Ronnie was Mary's primary caretaker and companion. "We bonded," he said wistfully, "and became best friends." Mary liked being the public face of the Beer Can House, while Ronnie enjoyed visiting, fixing her lunches and making repairs. Not only did Ronnie maintain his father's work, he even built onto it as the need arose, first adding a privacy fence and driveway gate made from stacks of unflattened beer cans in the front in 1989 and then in 1996 replacing the rear fence that had blown down thirteen years earlier during Hurricane Alison. Ronnie's beer-and-wine bottle showpiece forms a back wall beneath the patio cover, resplendent with multicolored glass and marble-studded slats whose pattern Ronnie worked out on his computer.

Guy also redid two backyard planters in 1996, decorating one with a huge insignia shaped like the state of Texas and topping the other with poured concrete bricks incorporating a new generation of found objects: push-button phone keys, coins, circuit board fragments and a brass plaque not too much bigger than a postage stamp engraved with the names of the three Milkovisch siblings along with those of their parents. John's wooden wishing well (which had a beer can roof, of course) wasn't salvageable, unfortunately. Mary's relatives from California had at one point sold John on the durability of redwood as a building material. However, what lasts in the dry climate of Solvang deteriorated quickly in Houston's humidity wherever John used it. Today, Mary's lemon tree sits on the spot where the wishing well once stood. The original *Ladder to Success* weathered badly as well, and when Ronnie replaced it in the late 1980s, he "signed" the new piece with his father's initials and his own by pressing metal furniture tacks into the wood.

Continuing through the front yard, Ronnie pointed out a decorative arch on the lot's north side supporting a wire grid of rusting soup and vegetable cans that he constructed in 1994. He burned off the protective plastic coating on each can with a propane blowtorch so they'd corrode more rapidly in the elements. It's an eye-catching element of the yard that often finds its way into photo sets taken by wandering tourists. In fact, several were gathering around us then, snapping pictures of the designer with his arch. "My mother never liked this," Ronnie said with a soft chuckle. "She thought it didn't fit

View of backyard with patio, planters, rock mounds and lemon tree, July 2011.

or something, but she didn't want to hurt Ronnie's feelings and she never told me." When Marcia told him many years later of his mother's dislike, he offered to redo it for the foundation with beer cans, but, he said, "They're not interested; they like it the way it is. Art people like it because it looks more natural. That's why I did it, actually."

John's shed had deteriorated badly, and Ronnie and Guy demolished the original structure in 1996 and replaced it with a new outbuilding featuring an arched ceiling with stained-glass skylights and, of course, an epidermis of beer can armor.

By 1997, Mary was eighty-one, suffering from Parkinson's disease and struggling to make her way over the uneven concrete blocks surrounding the house. "My father just didn't plan for that," said Ronnie. "It's not that he didn't care; I'm sure he just didn't think of it. It had been the same way back when his own mother would come to the house. She always came in through the front because she had trouble getting over this stuff. John didn't think of it, and if you ever pointed it out to him, he sure didn't want to hear it."

Mary moved to an assisted-living facility, and while her sons gamely continued to do their best to keep up the house, she held out hope that the Orange Show might step in and do something to preserve the property. A board retreat was organized, and what Theis described as a "philosophical rift" developed between its members. Some wanted to purchase the Beer Can House, resell its valuable lot to developers and move the house and its yard elements to a vacant parcel of land on Munger Street; others felt strongly that the house needed to be left in place. Susanne herself was torn. Her heart told her that it should stay put on Malone Street, but her responsibility to keep the Orange Show organization on solid financial footing forced her to consider the house's removal to cheaper land. "In my twenty-four years there," she said, "that was the most difficult decision the board ever faced."

In the fall of 2001, Orange Show board members John and Stephanie Smither worked closely with Marilyn Oshman and with Houston philanthropist Mike Stude of the Brown Foundation to raise the money. "It was such a somber meeting in the period right after 9/11," remembered Theis, "and the only time anyone smiled all day was when they approved the funds to buy the Beer Can House. Up until then, there had been a lot of 'hurry up and wait,' but once it happened, it happened very quickly."

In November, the Orange Show Foundation officially bought the home from the Milkovisch family for $197,000, and after what Theis called "a deep soul-searching conversation by the board," they began to formulate a plan to restore and preserve the property in situ and eventually to open it to the public. Mary died fewer than five months after the sale, on March 18, 2002, at the age of eighty-five.

Theis convened a Beer Can House steering committee and spearheaded a three-year fact-finding effort during which she consulted with experts about conservation and restoration needs and techniques, capped by a 2005 retreat involving artists, architects, preservationists and civic leaders. Ronnie created a detailed set of notes and mechanical drawings outlining John's techniques for making garlands and can panels, had them trademarked and then donated them to the foundation. Instructor Jim Arnold and fifth-year architectural student Kimberly Radich of U of H's Workshop for Historic Architecture documented the property to Historic American Building Survey standards, and copies of their photographs now reside at the Library of Congress. Funding for the project, $202,000 in all, came from the Cullen Foundation and the Houston Endowment.

Ultimately, it fell to a young architect named Julie Birsinger to formally manage the restoration efforts. She'd been with the firm W.O. Neuhaus and

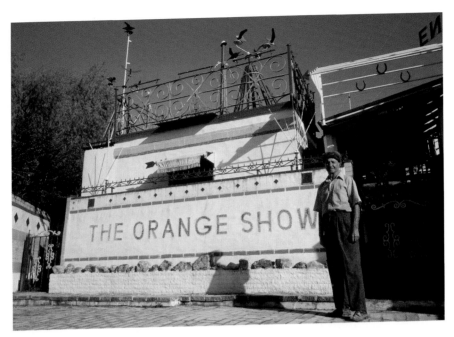

Jeff McKissack and the Orange Show in November 1976. *Photo by Geoff Winningham.*

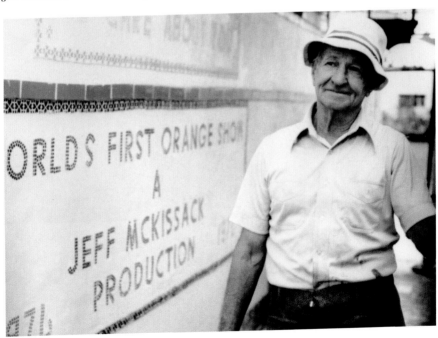

Jeff McKissack at the Orange Show, circa 1979. *Photo by Marilyn Oshman, courtesy Orange Show archives.*

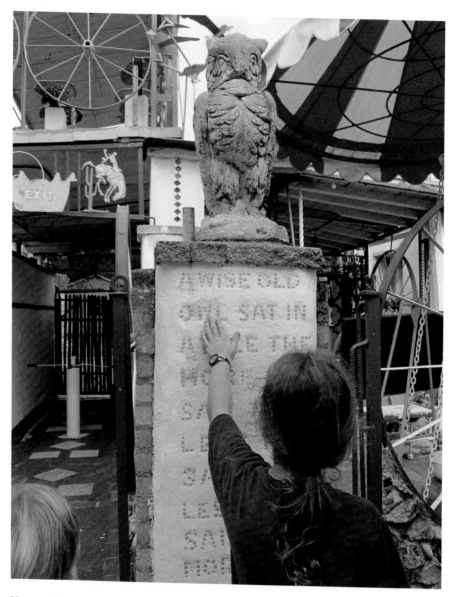

Young visitors approach the wise old owl, September 2013.

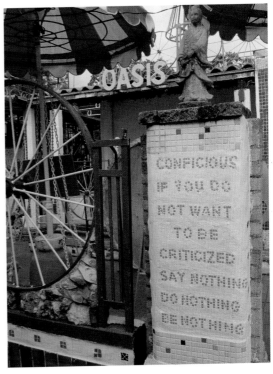

*Above*: Detail view of McKissack's "chemical converter plant," August 2011.

*Right*: If you do not want to be criticized, say nothing, do nothing, be nothing, September 2013.

*Below*: The Orange Show still under construction in 1978. *Photo by Don Francis, courtesy Orange Show archives.*

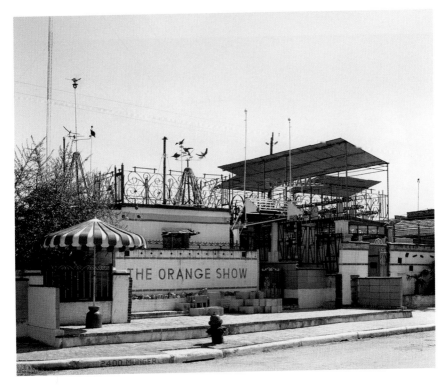

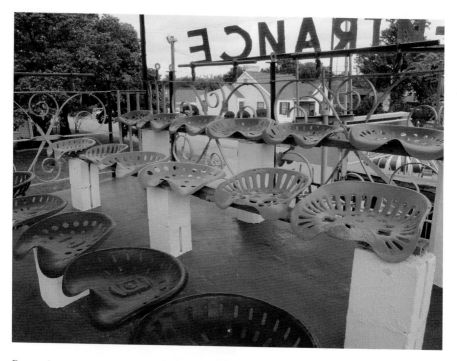

Rows of tractor seats look down on the sideshow stage, September 2013.

Today, the Orange Show is frequently used as a venue for offbeat concerts, dance performances and film screenings.

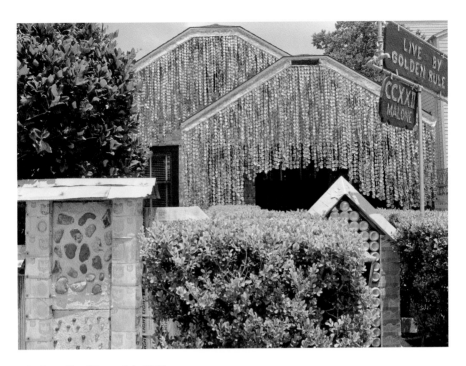

The Beer Can House, July 2011.

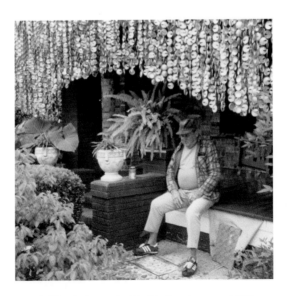

John Milkovisch, perched in his favorite spot, 1986.
*Courtesy Orange Show archives.*

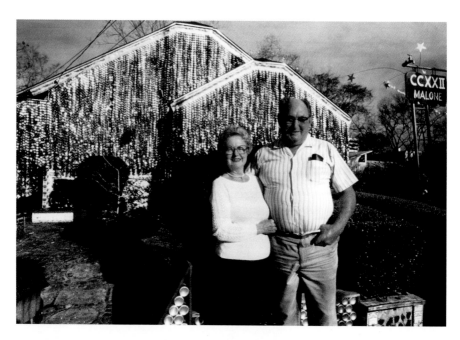

John and Mary Milkovisch at the Beer Can House in 1987. *Photo by Ben DeSoto, courtesy Orange Show archives.*

Detail of beer can siding, July 2011.

*Above*: Can curtain detail, July 2011.

*Right*: The *Ladder of Success*, July 2011.

"Culprit," July 2011.

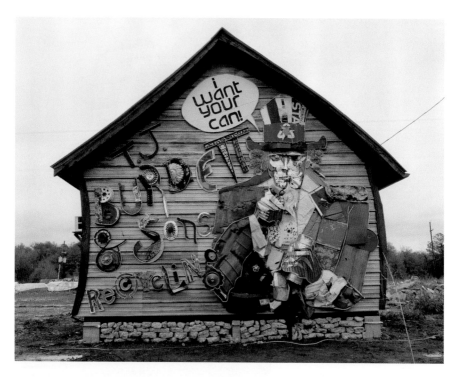

Matt Gifford's exterior design for the office building at T.J. Burdett & Sons Recycling, January 2012.

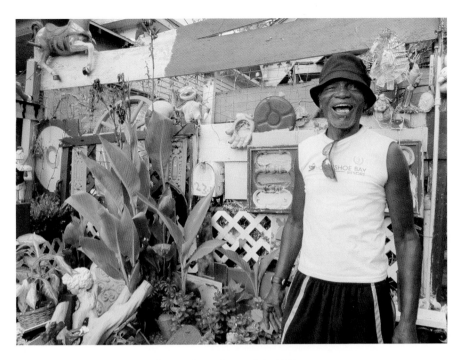

Cleveland Turner outside his Francis Street house, July 2011.

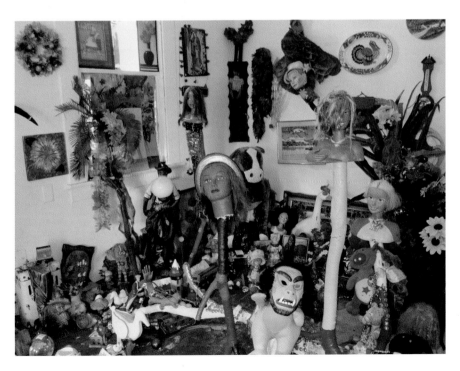

Interior of Turner's Francis Street house, July 2011.

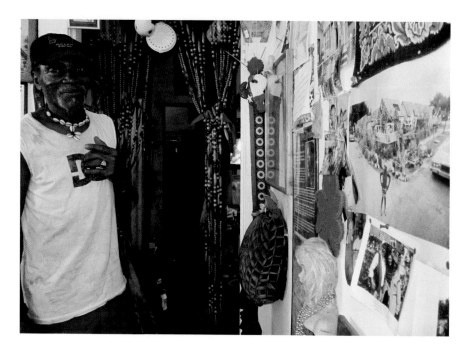

Turner in his Francis Street house, September 2011.

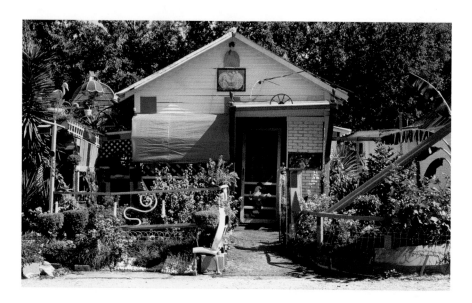

Turner's house at 2311 Sauer Street, 1987. *Photo by Paul Vincent Kuntz.*

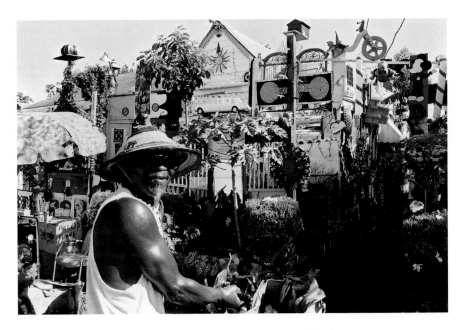

Turner at his Sampson Street home, circa 1990. *Photo by Larry Harris.*

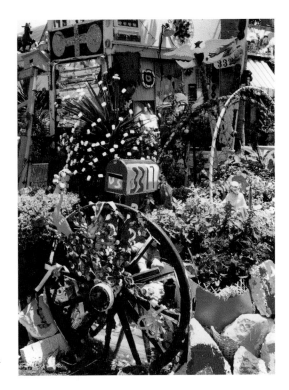

Detail view of Turner's Sampson Street house. *Photo by Tom Lafaver.*

Stephanie Smither at work on the Smither Park memory wall, February 2012.

Detail view of the Smither Park memory wall, September 2013.

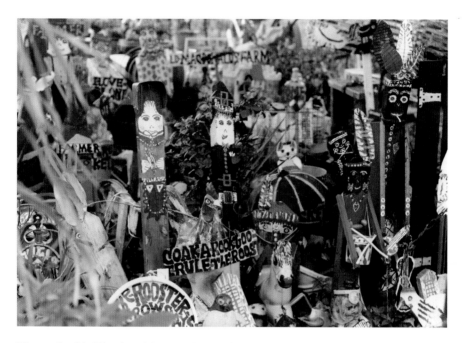

The yard at Ida Kingsbury's house. *Photo by Tom Lafaver.*

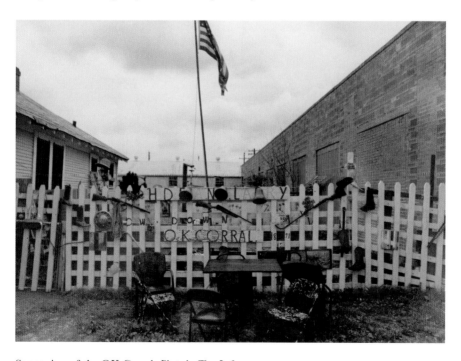

Street view of the OK Corral. *Photo by Tom Lafaver.*

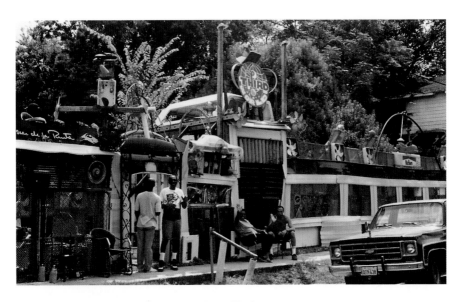

Street view of the Third World. *Photo by Larry Harris.*

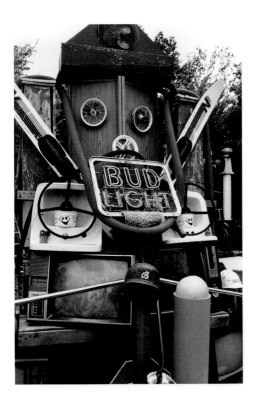

Detail view of the Third World's interior. *Photo by Barbara Hinton.*

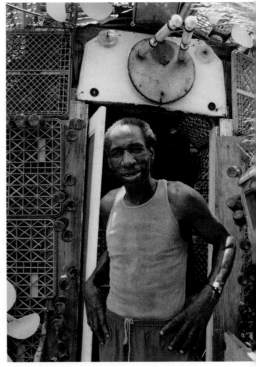

Bob "Fan Man" Harper at the Third World, circa 1990. *Photo by Tom Lafaver.*

Pigdom, 4208 Crawford, late 1980s. *Photo by Tom Lafaver.*

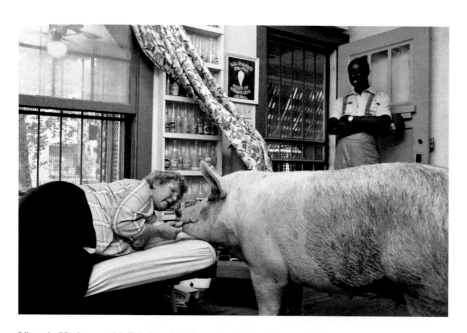

Victoria Herberta with Priscilla the Pig and neighbor Roosevelt Gunnie, April 1986. *Photo by Paul Vincent Kuntz.*

*Above*: Interior view of Notsuoh, August 2011.

*Below*: The Phoenix Commotion's Tree House in Huntsville, January 2012.

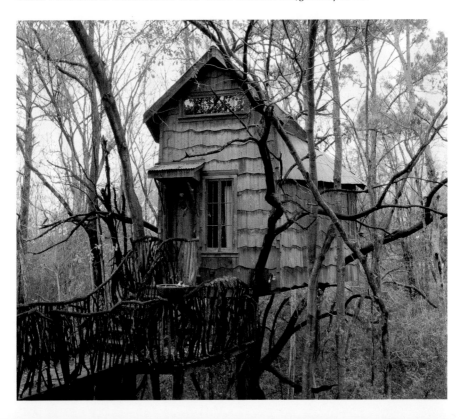

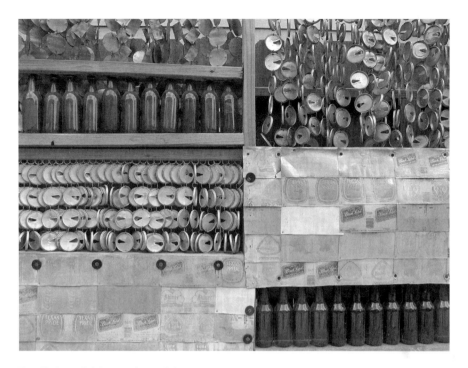

Detail view of driveway fence, July 2011.

Associates, and her work on several "adaptive use" projects—for example, a former Nabisco Bakery repurposed as a medical office—made her a natural fit for the endeavor. Birsinger's boyfriend (and now her husband), Brian "Visker" Mahanay, is one of the stars of the art car movement in Houston, and through his associations with the Orange Show, she offered to help with the Beer Can House restoration and in doing so satisfy the community service component of her state licensing requirements.

"It wasn't in the best shape," said Birsinger of the site as she found it. "John was continually working on the house, and he wasn't so concerned with longevity. He wasn't making a museum piece. If things would fall over and blow off, then it was his opportunity to do something new. It's just kind of the nature of the space that it requires continual maintenance. And while we were trying to figure out what to do with the house, that wasn't happening." Fences were sagging, garlands were breaking and weeds were poking up through cracks in the pavement, which was beginning to lose its marbles.

Mark "Scrapdaddy" Bradford, another well-known art car artist (who in addition to building his metallic-scaled "Carmadillo" also made news with

an enormous catapult he dubbed the "Refrigerator Throwing Machine"), was enlisted to move into the house with his wife and young daughter to ward off potential vandals and to prevent the elements from getting a foothold. If a piece of the fence or a garland blew down, he'd seal it inside a scrupulously labeled Ziploc bag and put it aside for the restoration team.

"To an extent, it seemed almost silly to apply the secretary of the interior's Standards for the Treatment of Historic Properties to a house covered in beer cans," Birsinger admitted, "but we took the project very seriously. The project was not registered with the National Register of Historic Places, as it was really more about the beer can artwork than the actual house. However, we used their guidelines as reference."

She started by making a detailed assessment of each element of the structure, including the materials and methodology used in its assembly, as well as elevation drawings of the house itself, which was still in great shape for a sixty-year-old cottage. However, the wood used in the fences had begun to rot; years of sunlight had leached the reds, yellows and greens from the can labels, leaving a shiny surface dominated by grays and blues; and the steel wire with which Milkovisch painstakingly connected can tops and bottoms had rusted and discolored the dangling curtains. "You can look at that two ways," she pointed out. "You could say that they didn't have their shine anymore, or you could say, hey, that's patina. But it was different from what it looked like before. It just looked tired."

Birsinger and the rest of the restoration team puzzled over a wide range of unusual considerations. Should a protective coating be applied to the fading beer can siding, the rusting garlands or to the delicate concrete work covering the driveway and lawn? Or would such a coating do more harm than good? Should visitors be permitted to walk on the artwork? Or only in certain areas? Or only with certain kinds of footwear? Or should everyone just relax and allow sightseers to enjoy the site to the fullest while it lasted?

One of the first tasks at hand was to repair garlands that had come apart, their bits and pieces having been collected in a wheelbarrow parked in one of the now-vacant bedrooms. Beer cans had changed in size and construction since Milkovisch was at work, and vintage empties were needed to replace pieces that were damaged or missing. Theis and Birsinger appealed to can collectors for help, and Ken Knisely, president of Houston's Grand Prize Chapter of the Brewery Collectibles Club of America, answered the call. His group rounded up some eight thousand cans for the project, the bulk of which were donated by Knisely himself.

"It worked like this," Knisely said. "Someone would contact me and ask me if I wanted to buy their beer can collection. Beer cans from the '70s are worthless as collectibles and many times are viewed as a plague on our great hobby. Out of the two thousand or so cans for sale, only a handful would be of interest to me. Despite that, I would buy the whole collection, keep the few interesting cans for myself and donate the remainder to the Beer Can House for the tax write-off."

Naturally, the conservation team wanted to keep as much of the original material as they could. Birsinger tried various solutions for washing rust from can tops and bottoms (they were made of aluminum and didn't rust, but they became stained when galvanic action transferred oxidation from the steel connective wire). A lemon and water mixture was a miss, and some cleaners she tried proved too corrosive, but a mild truck-washing product did the trick. To prevent future discoloration, the garlands were completely rewired.

It was a tall order, and through word of mouth, Theis and Birsinger solicited volunteer assistance from the art car community, from the University of Houston's student body and from the Rice Military neighborhood at large. As many as thirty helpers would assemble for weekly "happy hours" and drink donated beer while they donned heavy work gloves and cut apart cans with razor blades. "It was a bit of a challenge to get everybody's work to look the same," Birsinger said, "and make it as precise as John's was."

John's Dadaist planter boxes had degraded badly, and one suffered the indignity of being used as a wastebasket by John's shed in the back. Birsinger's team reconstructed new ones that are virtually indistinguishable from the originals and placed them back on the curb to welcome visitors. One surviving vintage planter panel ("Yes We Kit") now hangs on an interior wall, as does an early basket-weave screen made of cans and the sheet of bicentennial-themed Falstaff labels that once hung from the front gables. John's workbench and tools were set up for display in one bedroom. Early craft projects, old photos and even an exhumed time capsule containing who knows what reside in a vitrine in another. A selection of family snapshots is tacked to the wall in the kitchen. John's shed was repurposed as a visitor's center and gift shop stocked with Orange Show and Beer Can House T-shirts and memorabilia, including bumper stickers that announce, "My Other Car Is an Art Car."

The work proceeded in fits and starts as volunteers were drawn away periodically to help with art car parades and Orange Show galas, but by 2008, the Beer Can House sparkled anew and was ready to receive visitors.

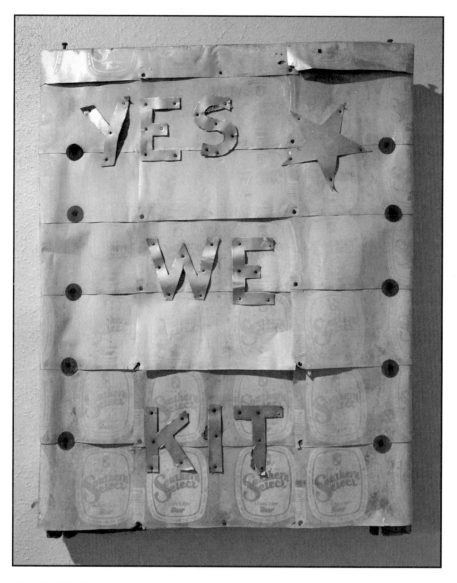

"Yes We Kit": John's enigmatic planter box message.

At the ribbon-cutting ceremony, Mayor Bill White presented Marilyn Oshman with a framed commendation proclaiming March 6, 2008, as the "Beer Can House Day." From the front porch, standing in the same spot where John Milkovisch liked to sit and watch passersby do double-takes, the mayor commented that "most people who take the lead in doing something

truly innovative are considered a little bit crazy," and he praised the late upholsterer for "the hard work of generating all those beer cans."

It's a good punch line, yes, but I really do enjoy gazing at John's creation and thinking about how each individual can represents a visit with friends, a quiet afternoon in the yard or an evening spent watching his grandson playing on the kitchen floor.

"They say every man should leave something to be remembered by," this backyard beer Buddha once remarked. "At least I accomplished that goal."

# THE FLOWER MAN'S HOUSE
# BY CLEVELAND TURNER

Almost as soon as the city of Houston was established in 1837, its founding brothers—John Kirby Allen and Augustus Chapman Allen—set up a "ward" system of political subdivisions from which the city's aldermen would be selected. The formal ward system was abolished around the turn of the century, but certain areas have retained their designations informally. The region southeast of the downtown skyscraper district is still known as the Third Ward today.

Stephen Fox, Houston's leading architectural historian, has referred to the nineteenth-century Third Ward as "a silk stocking neighborhood of Victorian-era homes," but things began to slip after the construction of Union Station in 1910. The appearance of hotels catering to passers-through in the 1910s and '20s, the slicing and dicing of highway construction in the '50s, the political unrest of the '60s and the blockbusting of the '70s accelerated the trend, and by the oil bust years of the 1980s, the once proud hotels and Victorian residences had deteriorated into a grim landscape of vacant lots and crack dens. It's still the kind of place where entire blocks seem to be abandoned, caving in or recently set ablaze and where the sound of gunfire occasionally interrupts the chirping of cicadas on a hot summer evening. But there are signs of hope, like flowers growing up through cracks in the pavement.

Head two blocks south of Emancipation Park[6] and the historic El Dorado Ballroom at the corner of Elgin and Dowling and take a right on Francis. There, on the right, interrupting a monochrome streetscape of weathered

brick and peeling paint, is a place positively bursting with color. A modest bungalow built in 1949, bowed but unbroken, is painted an electric lemon yellow and trimmed in a deep forest green, but you barely even notice the house behind a high perimeter fence of multicolored plywood boards hung heavy with bedraggled baby dolls, stuffed animals, ready-made sculptures of wood and plastic, ceiling medallions, pinwheels, Christmas lights and bouquets of plastic flowers. Rocking horses are frozen in midair as they appear to leap triumphantly over the barrier. A mannequin around to the east side raises its arms in a sun salutation as it faces back toward the property. With their red-and-orange blooms, Pride of Barbados erupt from raised flowerbeds made from painted bricks and slabs of concrete; a yucca plant blooms year round with a piece of packing popcorn impaled on the sharp point of every leaf.

If you show up at the right time, you'll meet the homeowner responsible for this festive display. His name is Cleveland Turner, but he insists that you can just call him "the Flower Man." A wiry seventy-seven-year-old with cocoa skin, graying hair and an easy, wide smile that gleams with gold-capped teeth, he's the very embodiment of Will Rogers's old saw about strangers

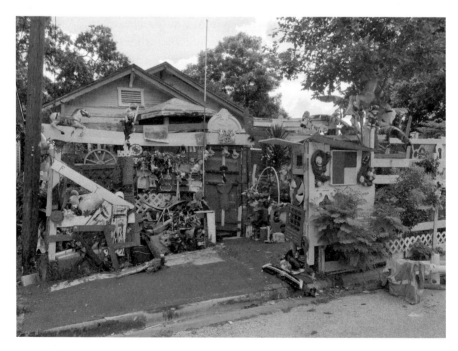

Street view of Turner's Francis Street house, May 2013.

104

only being friends you haven't met yet. The first time I walked up to his doorstep, he was climbing off his bike, its baskets laden with plastic flowers and a cornucopia of cast-off objects he'd picked up on his morning's ride. "Cleveland Turner!" I called as I approached. "The Flower Man!"

"YAY-uhhh!" he shouted in reply, his eyes widening as if surprised by the arrival of his oldest, dearest friend. "You found the Flower Man, you sure did!" Within ten minutes, we were sitting together on his front stoop with his pet bunny, already deep into his life story, wherein after seventeen years as a homeless alcoholic, he had a near-death experience in the gutter in 1983. Then, a divinely inspired vision of a whirlwind of colorful junk prompted him to devote the rest of his life to brightening his neighborhood and the lives of countless visitors with the deft arrangement of colorful refuse.

Pictures taken over the past thirty years depict a constantly evolving display of yard art at three different addresses, although having been settled at 2305 Francis for twelve years now, the sheer volume of accumulated objects seems to have increased substantially. These days, it's hard to tell the art from the piles of raw materials. Things come and they go. "People come take things right off the fence here," he says. "But that's OK. It ain't mine, anyway; it's just junk."

As he shows me around the property, he points to a hole in the latticework at the base of his front porch. "I spent the night in there when Hurricane Ike came," he told me. A large tree had fallen on the house during the particularly devastating storm in late September 2008, caving in part of the ceiling. As Ike barreled through, the crawlspace underneath the porch seemed like a better bet than the living room. "Wasn't it wet down there?" I asked. "Hell yeah, it was wet," he answered, grinning, "We was having a hurricane!" His display was wiped out almost entirely, but in the wake of the storm, the Orange Show Foundation rallied volunteers to help Turner replant and rebuild.

I'm not sure about the accuracy of everything the Flower Man told me during my frequent visits over the summer and fall of 2011, but I do think he's one of the most generous and forthcoming men I've ever met. "All this is for you," he told me, waving his hand at his swarming creation. "I'll tell you anything you want to know. Just ask."

Cleveland Turner was born in Vicksburg, Mississippi, on May 25, 1935, the same day Babe Ruth hit his final home run and Jesse Owens set three world records for track and field. Turner's family, descended from slaves and Sauk Native Americans on his father's side and Cajun stock on his mother's

side, lived on the property of a white farmer and then on land of their own after his father, James, found respectable work with the railroad. Cleveland's mother died when he was three. "I barely could picture her, just barely," he says today, squinting and cocking his head. He had a photograph once. "I did have one; I got that picture off my sister's mantelpiece, and when I went out on the skid row, I kept it for years and years in my wallet, but I lost it, it got wet or lost or something."

James remarried, and the family moved to Brandon, about eleven miles outside Jackson. But he worked far away as a Pullman porter and was rarely home. Cleveland and his ten siblings were raised by their stepmother, Rosie, who a few times a year would dress the kids in their best clothes and line them up along the tracks at the train station to catch a glimpse of their father as the train flew by. James would wave and toss a note, weighted with a rock, out the window to his family. And then he was gone again, disappearing into the distance. In 1946, when Cleveland was eleven, his father was killed in a head-on train collision in Ohio, and Pullman provided a regular stipend and a forty-acre plot for his survivors.

Life with Rosie was okay, remembered Cleveland. "Well, she had to get along with us because the railroad was payin' her to raise us 'til we got grown after my daddy got killed. If she whooped us, we'd just leave and she wouldn't get the money, see?" Young Cleveland didn't care much for school and stopped going after the second grade. Instead, he'd head into the woods to pick, dry and roll rabbit tobacco. "I sold my cigarettes two for a nickel to the other kids when they came out of school," he said. "That's why I didn't learn nothing." But clearly, he figured out how to make a buck, even if he's never learned to read or write much more than his own name.

"I drove a mule out in the country," Turner remembered. "I had fourteen head'a hogs. See, I wouldn't go down to your office looking for a job, cause I knew better. I'd go out on the farm lookin' for a job." On his own land, he grew corn, sorghum and sugarcane and picked cotton "until my hands were tore up. You'd get so sore you couldn't even eat at night."

After the rest of his family dispersed to Michigan, California and elsewhere, he continued to work the family farm, drove and cooked for a well-to-do doctor in Jackson (a typical meal that still counts as a personal favorite: collard greens, okra, cornbread and baked potato), and for two years, he managed a juke joint called the Blue Goose. He had a pretty good racket going at the Goose, bootlegging the leftover booze in the backroom after hours, off the books. He drove a 1955 Bel Air Chevrolet[7] and carried a thick wad of cash in his pocket. But the local banks wouldn't guard his

money, and he couldn't even drive down the main street in Brandon. This was the Deep South of the late '50s, and the white population of Jackson epitomized the backward thinking of racism and prejudice.

"You mighta heard about this black boy named Emmett Till?" he asked. Of course I have, I told him. Everyone knows the horrifying story of fourteen-year-old Till, who in 1955 was mutilated and murdered by Roy Bryant and his half-brother, J.W. Milam, after having been accused of winking at, whistling at or probably simply looking at Roy's wife, Carolyn, as she sold him bubblegum at Bryant's Grocery and Meat Market. This happened in Money, Mississippi, only about one hundred miles north of Jackson, which was about to explode as the epicenter of the civil rights movement. "Yeah, those were the hangin' days," he said. "We were just lucky we had our own place out on the farm. Mostly they'd just leave us alone."

It was 1962 when Cleveland hopped onto a bus bound for California with forty-two dollars in his pocket. His sister Ethel's brother-in-law was going into the army, and she had arranged for Cleveland to take his job on the line at a car manufacturing plant in Los Angeles. He left on a Friday night and thought he'd go by way of Houston. He'd been moving cows at a "sell-barn" and wanted to see the Texas longhorns he'd heard about. The plan was to leave home on a Friday, stay over with his friend George in Houston and leave on Sunday so he'd be on the job in time for Monday's late shift.

Toad met him at the bus station as planned. George was his real name, you see, but everyone called him "Toad." He brought with him a funny kind of wine that Cleveland had never seen before in Mississippi. It was called "Thunderbird." They started drinking, and before the weekend was over, Cleveland had spent his forty-two dollars. On Sunday, Toad drove him up to the bus station so he could cash in his ticket and buy more wine.

Sitting on his front porch almost fifty years later, he laughed, leaned toward me and said:

*I ain't never got to California yet! I drank that money up, and it was just a mess. And talkin' about sick? Maaaaan. Now I had never drank steady like that. Oh, maybe off and on, like if I was getting ready to go to a dance or somethin', I'd take a drink. But not steady like I did here, all day and all night. And then when I got sober enough to realize I had sold my ticket, the weekend done passed. It was Tuesday, and my sister had the man waitin' on me out there in California, on the job. You talk about a sick dog? Man, I was sick. Bad hangover. And my sister didn't speak to me for two years! I mean, she okay now, well, she sickly*

*now, but we got back in friends. But that's the way I got to Texas, just meanin' to come through.*

Without a bus ticket or any money left to buy another, Cleveland had to make the best of his situation in Houston. But then again, there was a bar on every corner. He found work at Wyatt Steel, driving a forklift, or as he calls it, a "tow-motor." "I was so little, up on that big machine, they used to call me the little black bee," he said, giggling. He'd work there for seven and a half years, and his hard work and knack for efficient processing of steel sheeting eventually led to an offer of advancement from his supervisor, Mr. Witty.

"My boss man Mr. Witty and I got friendly," he said, "and he was a white man, I was a black man, and that kind of friendly love is real cool. He was gonna make me a foreman and put me in an office. And I told him, 'Now, you know I can't read!' and he said, 'Don't you worry about that. I'll put a boy in there with you that *can* read and do your paperwork.' But I don't like to be no boss if you got friends on the job, cause you know you're gonna lose 'em. I'd rather have the friends than be the boss."

In any event, his drinking was picking up, and his days driving the tow-motor were numbered. Cleveland used to drink coffee every day out of a thermos, or as he calls it, his "stomach jug." However, over time, he stopped filling it with coffee and started filling it with Thunderbird. One day, Mr. Witty grabbed Cleveland's thermos expecting to pour himself a quick shot of joe. Instead he got a cup of cheap wine. "Oh man!" Cleveland exclaimed. "I was picking up some scrap steel, and I froze. He came over and told me to hang up my stuff and go [home for the day]. I mean, he said it in a joking way, but he meant it. And that's the first letter I ever got on the job. It got worse and worse from there. And I drank myself down to one day a week."

Cleveland started making up stories. He told people that his aunt had just died. Then he told them his sister had just died. His co-workers would always take up a collection to send him home for a nonexistent funeral, and he drank the money away immediately. Once his boss spotted him staggering drunk down the middle of the road when he was supposed to be back in Mississippi grieving with his family.

"You know, people ask me why I started to drinkin' the way I did," he said, "and yeah, my mama died and my daddy died when I was young, and some people think that must be the reason, and I guess that'd be a good story, but I'd be lyin' to you. I just drank because I liked the taste of that wine, and I liked the high. And that way, when I tell you that, you know I'm tellin' you the truth!"

Drawing of Cleveland Turner as a young man.

The drinking got worse and worse. He'd trade in his dwindling paychecks for bottles of Boone's Farm directly. One morning, he woke up unclothed ("Naked as the palm of my hand!" he told me, laughing) and lying by the side of the highway forty minutes away, a few miles outside Galveston. He managed to flag down a passing trucker, who wrapped him in a tarp and drove him back to Houston. He only worked at Wyatt Steel for three or four months after that. "I just drank that good job down the drain," he said, shaking his head ruefully. "And that Mr. Witty always went outta his way for me."

"Man, I was so uncivilized, I wouldn't even talk to you," he said, leaning forward with a penetrating gaze and furrowing his brow. He'd drink a half gallon of Thunderbird in a night, then wake in the morning and crawl to the next bottle. He lost his apartment and began living on the grounds of the then abandoned Merchants and Manufacturers Building on Buffalo Bayou or in a makeshift tent in the rail yards near Lyons Avenue where the conductors of passing trains would sometimes toss him the leftovers from their sack lunches.

"Yeah, I had a whole lotta skid row," he said. "I stayed out there for seventeen years drinkin' that Thunderbird wine. Sleepin' in the weed patch,

under bridges, eating out of the Church's Chicken dumpster. Now I didn't stand out there on the corner, like I see these guys today with their hand out. I found my own meals out of the dumpster before I'd stand on the corner like that."

He was actually quite enterprising, and even in troubled times, his innate likeability led to brushes with legitimate employment. One day, when he was out pushing a shopping cart full of deposit bottles and pieces of valuable lead pipe he'd cut from abandoned buildings for scrap sale, he met a man overseeing some road work. "You know how to work construction?" he asked. Sure, said Cleveland, and he jumped up into a forklift to demonstrate his ability. He was given a job and told to show up sober. He earned the man's trust and eventually started working around his house, preparing meals and driving his wife around town. The man was James Overton Winston, his wife the Houston socialite Ella Botts Rice, an heiress to the fortune of financier William Marsh Rice and earlier, from 1925 to 1929, the wife of a handsome young inventor and aviator in Houston named Howard Hughes. Cleveland liked James and Ella and enjoyed the work. Then, he slipped, getting drunk with some friends. He was cited for driving under the influence after crashing Winston's car into a ticket booth. "That was just my life," he sighed. "I lived out on that skid row until it just nearly killed me."

One afternoon in early 1983, a passing motorist noticed Cleveland lying facedown in a ditch on Chenevert Street. She called an ambulance, which took him to St. Joseph's Medical Center. "I don't know when I fell or how I fell," he said, "but I woke up in the hospital. Ain't no telling how long I was out. Ain't no telling the last time I 'et or had something to drink. This time I was so low that I fell and couldn't get up; they tell me by the look of me I'd-uh been laying out there for three or four days. I was so forgone crazy I didn't know my name or what state I was in or the president's name, anything."

They administered eight IVs from his toes to his brain in an attempt to save his life. "I didn't know where I was," he said, "but the walls were so clean. And there was a lady. I asked her where I was. She was a nurse, and she told me, 'You're in St. Joseph's hospital, you been in here for two weeks and a half.' She said, 'Mister, you like to die? You start drinking again, and you ain't even gonna make it into here next time.'"

It was at this point that Cleveland had the vision that would change the course of his life:

*I knocked on the wall and turned to the good Lordy and said, "You keep the taste of wine outta my mouth; you give me the power to keep it outta my*

*hands." Two nights passed, and I had this big, pretty vision, this vision comin' from junk, just goin' way, way up in the sky, so pretty! And people from all around was there lookin' up at it, and I said to the good Lord then, "You keep me sober, and I'll make that vision for you." You seen a whirlwind, right? Well that's what this vision was. 'Cept this vision wasn't leaves; this was junk. It was just picking it up, like on a belt, rollin' it up, you know, but pretty, pretty, pretty, pretty! And this is how I formed my way of makin' all this, that vision. And I didn't know what all this was about or where this was comin' from or that it would someday turn into art.*

At St. Joseph's, Sister Amelia Shannon took an interest in him and gave him a job delivering plate lunches to the other nuns in exchange for room and board. He struggled to remain sober. Just a few months off the wine, he took a young lady out on a date. She ordered a drink. "They call it Champale," he said, "classy little wine in a green bottle." When the waitress returned to their table, she said, "Mister, you mean to tell me you're letting this young woman drink by herself?" After a few brief slip-ups, the Flower Man has been sober since May 23, 1983, a date commemorated by a certificate taped to his wall.

One day, a social worker at St. Joseph's named Miss Elaine asked, "Cleveland, you ever go out and thank that lady for having you picked up?" She looked up his admission form and found the name of the woman who'd called the ambulance and brought him out to her house in the posh, leafy West University neighborhood just north of the Rice University campus. He stood shuffling on the sidewalk as Elaine rang her doorbell. The woman was incredulous. "But that man was dead!" she exclaimed. "I remember her pretty white hair," Cleveland told me. "And I thanked her."

Before he knew it, she'd offered him a job tending her yard. Neighbors followed suit, until eventually Cleveland was working nine properties on a weekly basis. From these odd jobs, he saved up thousands of dollars, kept in a jar buried in the yard of an abandoned house nearby while he continued to live and work at St. Joseph's. "I didn't have to pay no rent," he said, "and I was stacking that money. And I wouldn't spend it. I said I'm either gonna die with this money or I'm gonna die with me a home."

Soon, he found a place to rent—a tiny, weathered row house at 2311 Sauer Street in the Third Ward. It was a world away from the gardens of West University, but it was better than being on the streets. For the first time in well over a decade, Turner had a place to call his own. He remembered his vision, as well as his childhood spent planting flowers with his stepmother and aunt

Interior of Turner's house at 2311 Sauer Street, 1987. *Photo by Paul Vincent Kuntz.*

back in Mississippi. "I always said back then that when I became a big man, I was gonna have me a house with pretty flowers." And he did it.

First he painted some antique tools he'd hauled back from the farm in Mississippi in a friend's pickup, and he set them out front on weekends. It wasn't long before they were stolen while he was off mowing yards. Then he started to gather small items—dolls, toys, bricks, holiday decorations, broken pieces of decorative latticework—and began painting and arranging them artistically, first brightening up the inside of his house and then outside, until they flowed out to the sidewalk and beyond. He produced a mangled yearbook from a pile of papers and showed me how a photography student at the University of Houston named Paul Kuntz documented this house in a two-page color spread while chronicling the residents of the Third Ward. The yard is in its earliest stages, more flowers than junk, with a middle-aged Flower Man hoisting a coffee mug, wearing a Hawaiian shirt and a wide smile.

Still, Turner wasn't completely comfortable with his newfound stability. "I didn't know whether I wanted to go back out on the skid row or not," he confessed. "I wasn't used to this life. I had just started goin' to AA, and it was like they were speakin' Spanish to me. I just didn't understand it sometimes."

In about 1986, somebody came to the Orange Show office and told Susanne Theis, "You've got to know about this guy over on Sauer Street." After a few misses, she finally caught him at home. Before he met Theis, he

explained, the yard display "was just something I did. It was Susanne who taught me it was art. She told me that not everybody's art is the same, and I said, 'Okay then, it's art!'"

This completely un-self-conscious attitude is common among self-taught artists, and in some cases, it's possible that the art is the result not of the maker's efforts but rather of the folk art bird dog imposing his own aesthetic judgment on the materials at hand. When questioned by researcher William Arnett about her assemblage made from piles of logs, empty milk jugs and an old broom, an elderly Alabama woman named Dinah Young admonished, "How many times I got to tell you. I'm just piling up old junk. I'm doing not a damn else thing." When Arnett pressed and asked, "Don't you care how they look?" she snapped back, "I don't make no design of them. I don't be making *anything*."

But Turner did care about how his displays looked, and he took to his newfound role as an artist with relish. He and Susanne became fast friends, and Turner's house made its debut on the 1987 Eyeopener Tour. Then, trouble.

"I remember it vividly," said Theis. "It was Labor Day 1988, and there was a story in the *Houston Chronicle* about the folk art sites. I went over to see Cleveland and show him the article, and his place had been brutally vandalized. And later I found out he had done it himself. Somebody had tried to set fire to the house, and he became so angry and distraught that he tore up his own garden."

As Turner told it, he'd awoken one night to hear a girlfriend shouting from the street, "Flower Man! Flower Man! Your house is on fire!" Cleveland is sure he knows the culprit: his pyromaniac neighbor, Walter. "Old doper who lived out back'a me," he growled. "What do you call people who set stuff on fire? What, arsonist? Yeah, that guy gets his nut busted settin' stuff on fire." Once before, through a crack in the door, Cleveland had spied him "settin' fire to mah drawers" as they hung on the clothesline in the backyard. He stomped out the flames, chewed him out and thought that was that. But this time, it was serious.

With his property ruined, Cleveland was forced to find a new place and rebuild. This time, it was a lot on the corner of Sampson and Francis, a couple of blocks south of Elgin Street and less than a mile west of the University of Houston campus. With the help of Theis and artist Jack Massing,[8] he carted over what remained of his previous display on Sauer, and Orange Show volunteers donated plants and labor. Once the Flower Man was planted, the new house bloomed.

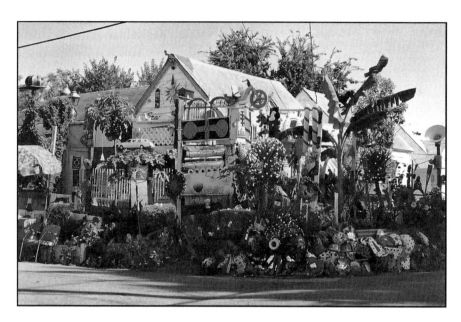

Turner's Sampson Street home, circa 1990. *Photo by Larry Harris.*

The application of buckets of red, white and blue paint gave the new place a patriotic feel. He started a fresh garden: hibiscus, impatients, pansies, Mexican heather, ginger, mums, geraniums, marigolds and cotton plants. From the farm in Mississippi, he retrieved more family heirlooms and oddments dating back to his childhood: a kettle, an old water pail, a mule harness that he'd used as a boy, a skull from a cow he knew and loved and dusty jars of peach and pear preserves canned by his mother back in the 1930s. A photograph in the May 1993 edition of *Texas Highways* magazine shows a well-cared-for folk oasis, profuse yet manicured, with a wooden Mickey Mouse cutout and bird statuary neatly in place. A stuffed squirrel mounted on the roof represented Turner's emerging interest in taxidermy (even today, Cleveland can't resist the urge to bring home roadkill to cook up the meat and tan the hides; he took me into what he calls his "hobo kitchen" to show off some work in progress, skins stretched out on wire coat hangers and hung on the wall with his pots and pans).

From his presence on multiple Eyeopener Tours, and after befriending Massing, Marilyn Oshman, James Harithas and others who brought visitors and spread the word, people from around the world began to catch wind of his first-class yard show and came to call. In the 1990s, he garnered write-ups in all the local papers and even the *Los Angeles Times* (headline: "Houston

Home Is Garbage, Literally"). His smiling face beamed within slick coffee table books on folk art. He became a neighborhood celebrity and enjoyed sharing his story of transformation with an increasing stream of social callers, although not all of the attention he received was positive.

One morning in May 2000, as Turner sat in the shade of his curbside umbrella, a Public Works van drove past, stopped and then turned around and parked in front of Turner's house, its front wheel running up off the road and crushing one of the flower beds.

"I knocked on the winduh," Turner remembered, "and I tried to be nice. I said, 'Say, boss, you gotta get your car up off my flowers, man!' but the fella acted like he didn't even hear me. He just kept his window up, just flat-foot ignorin' me." Turner knocked again. Then the man "cracked his glass and said, 'I'll move it when I get done writin' you up, and not a minute before.'"

When the newspapers inquired later that week, the inspector, Cruz Hinojosa, contended that while he had been well aware of Turner's house for years, it was only after a complaint was filed that he was compelled to issue a citation. Turner wouldn't take it, nor would he accept the certified letter that came in the mail a few days later. "If they want to fine me, I'll just rot in jail," the Flower Man told the *Houston Chronicle*'s Allan Turner at the time. "They can bring a bulldozer and just level the place for all I care. I'll just live in jail."

Many of Turner's neighbors were outraged. "I don't know who's complaining about Mr. Cleve's house," one told the *Chronicle*. "It makes the neighborhood nicer. It's not stopping me from driving down the street." Another argued that the attention attracted by the artwork actually made the street safer. "These used to be drug houses. The man is creative, and we appreciate him. It's an honor to live next door to him." She wondered why the city was wasting time bothering the Flower Man instead of fixing the sidewalks and pursuing absentee landlords who don't keep up their properties.

In fact, Turner had become an unwitting victim of the Community Urban Rehabilitation and Building Minimum Standards ("CURB") ordinance, championed by Houston councilwoman Helen Huey ("the human wrecking ball," as she's been called). It passed in 1993, ostensibly to require city property owners to properly maintain their buildings. In practice, some contend that it has been too often used to harass low-income residents like Turner. Public Works deputy director Bea Link, in particular, earned for herself a reputation as CURB's outspoken and uncompromising storm trooper. "I enforce the laws; I don't make them," Link said in a *Houston*

*Press* article about a perceived vendetta against kids' treehouses. "I deal with hundreds of complaints on a daily basis."

Just get Turner started talking about Link and then stand back: "She came out the next day, 'Ooooo, what is all ah this? What is all ah this?' She walked all around talkin' shit, and I said, 'Who are you, anyway?' Whew, she was rough, man. She said she was gonna shut me down and bring her bulldozers out. I said, 'Yeah? I'll be waiting!'"

The matter was turned over to the city's legal department, and Turner was given until July 26 to remove his art and flowers from the city property or to formally request a variance from the city's Joint Referral Committee. Theis appealed to the press for help, and Katie Dorfman of Texas Accountants and Lawyers for the Arts donated her professional support during the Flower Man's tangle with the city.

Turner had another advocate in Rick Lowe, an artist who in 1993 had founded a community-based organization called Project Row Houses, which purchased and renovated blocks of historic shotgun homes in the Third Ward and used them for installations, community art studios and affordable living spaces. It was a creative and quite practical way to bring art into the community while making it clear that the organization wouldn't be just another slumlord. "We became close," said Lowe of his relationship with the Flower Man. "In fact, I became his savior in an almost irrational way."

Lowe approached Houston's Municipal Arts Commission (as well as Bea Link directly) and argued that folk art sites should be categorized as cultural treasures and therefore be exempt from standard building permit requirements and city ordinances. "Just like you wouldn't hold a piece of sculpture up to the same permitting process as a building," Lowe pointed out. While they were unsuccessful in getting exemptions for such sites formalized, Lowe remarked that "it became enough of a conversation piece and we built enough energy around it, and enough media attention, that the city said, 'Okay, just keep his stuff off the sidewalk, and we'll leave him alone.'"

When a large group of tax-delinquent homes went up for sale in the Third Ward in late 2000, Project Row Houses bought the properties, in some measure due to Turner's presence nearby. The Flower Man pitched in; he decorated a cottage and mentored high school students, and Row Houses anointed him its "artist-in-residence."

"His vision is that everything has some beauty, just like everyone has some value," Row Houses' then executive director Andrew Malveaux told the *Los Angeles Times* in 2001. "Cleveland had already started the process of affecting change in that neighborhood. We're just piggybacking off him."

In fact, Lowe—who grew up in the former Chattahoochee steamboat stop of Eufala, Alabama, in the '60s and came to Texas in 1984 to study at Texas State University under the pioneering African American painter and muralist John T. Biggers—subscribes quite explicitly to German installation artist Joseph Beuys's concept of "social sculpture" and his related notion that "everyone is an artist."

For the 2005 article entitled "High on Lowe: How One Man Changed the Face of the Third Ward Forever," Lowe told Keith Plocek of the *Houston Press*, "If we think of the world as this big piece of sculpture, every day we're changing it…we can either change it in a way that's responsible and high in social and aesthetic value, or we can change it in ways that are not. So it kind of puts the responsibility on everybody who lives in the world and says, 'Look, think about everything you can do as being something that has a huge impact on what the world looks like, what it feels like and what it is.'"

No doubt about it: the Flower Man is a perfect reflection of this concept, and his relationship with Lowe deepened. "I started helping him learn how to keep his money somewhere other than an old sock," said Lowe, who eventually went so far as to become his legal guardian to help him qualify for disability checks. "I helped him get a deposit box at the bank, stuff like that. He started to travel with me to Alabama to visit my mother. He actually became very close with her. We were like family."

Row Houses began to develop Dupree Sculpture Park on the corner of Francis Street and Dowling, "bouncing off of the Flower Man's aesthetic," said Lowe, "trying to create a better context around what he was doing and hoping people would understand it better." Meanwhile, Turner was becoming dissatisfied with his corner rental, and he still fantasized about owning a home of his own. Opportunity knocked in 2003 when a property adjacent to the park became available.

With money he'd saved from his landscaping work, he split the costs with the Project Row Houses organization on a $40,000 house and property at 2305 Francis Street. It was the perfect location, right in the thick of the Row Houses campus. Two blocks to the north is the restored El Dorado Ballroom, the mid-century stomping grounds of Duke Ellington, Ray Charles and B.B. King, with downstairs suites now incubating an art gallery and a community newspaper, as well as a sculpture garden in a lot to the side featuring the beloved Houston artist Bert L. Long Jr.'s *Field of Vision* (consisting of fifty concrete pedestals topped with concrete eyes representing a panoply of ethnicities). Just to the south are the Row Houses' administrative offices and upward of forty associated affordable

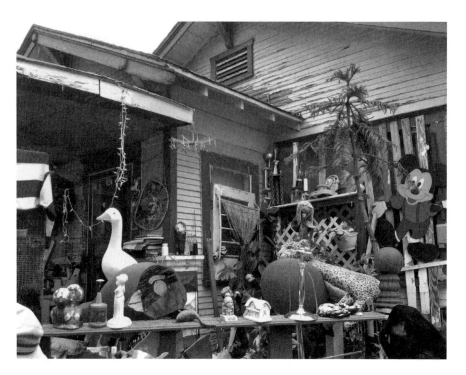

Turner's Francis Street house, July 2011.

housing units, some occupied by members of the Young Mothers Residential Program.

According to Lowe, "The original deal was that we would own the property as Project Row Houses. He would be a permanent artist-in-residence, and that way he wouldn't have to worry about the taxes; he wouldn't have to do anything, and he could just be there. And as far as I know, he was okay with that."

Things started to go off the rails when Row Houses hired a new groundskeeper, and the older, somewhat stubborn man immediately fell on the Flower Man's bad side. In the past, if Cleveland spotted a couch tossed out on the curb in West University, he'd call up Row Houses, and it would send out a truck to help him pick it up. The new groundskeeper would have none of it. "Flower Man started telling me that this guy was 'evil,'" said Lowe, rolling his eyes and shaking his head, "and I'm like, Flower Man, chill out, I can't fire this guy, and we can still get stuff done for you. But the situation started getting worse and worse. It was then he started talking about the deed."

Cleveland's name appeared nowhere on the deed to the house. From a legal standpoint, 2305 Francis belonged to Project Row Houses. The more the Flower Man thought about it, the more he felt like he owned a whole lot of nothing. "I just threw my $20,000 in the hole," he said, shaking his head. "And I'd been savin' this money ever since '83!"

"I was glad he started talking about the deed," said Lowe, "because it was something of a liability issue for us. When it was in our name, we had full responsibility for that building. Insurance? We had to do all kinds of things to keep people from seeing that building, or they wouldn't insure it. We had to make sure it was wired properly, everything. There was always something. Flower Man, you can't use all those extension cords like that. Flower Man, you can't build an addition on your house using a tree as one of the corner posts. I'm still scared to this day of what might happen over there."

Lowe went to the PRH board, contending that the only reasonable thing to do was to come to an arrangement with Turner and let him have the property. The Row Houses organization would be off the hook for the liability issues, and Lowe pointed out that as a senior citizen owning a home, Turner might qualify for tax exemptions. "And the board said, 'Fine, let's deed it to him.'"

One of Turner's employers in West University helped him hire legal representation, and the two parties eventually came to a formalized arrangement wherein Cleveland's name now appears exclusively on the deed. Still, any sale would require the approval of both Turner and Project Row Houses, and in the event of Cleveland's passing, the house will be ceded to the Row Houses organization. "That's when I die," Turner said. "Who cares? I don't have no wife, no kids to give it to. I didn't buy it to sell; I bought it to die in."

It was a win-win situation for both parties, but while Lowe clearly still feels affection for Turner (at the time we spoke, he'd just recently left some pecans and a jar of his brother's homemade slaw at his doorstep), the Flower Man just as obviously continues to suffer emotional wounds from the rift. He won't set foot in Dupree Park. For years, he refused to ride his bike past the Row Houses office. He looked suddenly nervous when an eager young photographer mentioned that he had come by to take pictures at the suggestion of the Row Houses staff. After the visitor's departure, he confided that he worries they'll someday send a confederate to come inside and fake an injury in the hopes of filing a lawsuit and reclaiming exclusive rights to the property.

"I worry about Cleveland," admitted Susanne Theis, pursing her lips. "As he gets older, he seems to be getting more…paranoid."

In the spring of 2009, Turner and Lowe were both among the featured artists in a groundbreaking exhibition of the city's site-specific work at the Contemporary Arts Museum Houston. Toby Kamps—who is now curator of modern and contemporary art at the Menil Collection but was then the senior curator at the CAMH—conceived of and assembled the show, entitled *No Zoning*, with freelance critic Meredith Goldsmith. Having moved to Houston in 2007 after stints at the Walker Art Center in Minneapolis and San Diego's Museum of Contemporary Art, Kamps had the ability to look at the city with fresh eyes, and he was amazed by what he saw. "This laissez-faire approach [to urban planning] was the first thing we had to wrap our heads around when we started living and working in this thoroughly disorganized yet mysteriously charming town," Kamps and Goldsmith cowrote in their introduction to the exhibition's catalogue.

"We began to think that we should try to talk about what we came to call 'extra-institutional art' in Houston," Kamps told me. "Another colleague, Alison de Lima Greene, who's the curator of contemporary art and special projects at the Museum of Fine Arts, told me that she has always thought that Houston is an especially art-permeable city. And that got me speculating about the reasons why that might be the case and then talking to artists like the Flower Man and thinking about how they might fit into the picture."

Asked what he admires about Turner's work, Kamps responded, "What's not to like? He's got a direct pathway to a very deep place in him, and it's not filtered. I think the world for him is full of mysteries and surprises. The things we would drive by and not even look at, he's there, celebrating. He lives life to the fullest, and that exuberance comes through in his work."

The show featured the fruits of eighteen art-producing entities—individuals, collaborations and collectives—ranging from the Art Guys' marriage to a live oak sapling to Mel Chin's "Fundred Dollar Bill Project" calling attention to lead contamination in soil to the spindly, Seussian "pop-up" public sculptures of Lee Littlefield. But how does one curate that which had previously resisted curation? "Yeah, that's exactly the problem," said Kamps. "These things are so wild and raw and fresh. How do you put these things into a museum without it bombing? That was the big question."

Whatever concerns he may have had were allayed by enthusiastic public support. In fact, the May 9 opening is said to have been the most well attended in the CAMH's history. Guests arrived to find the handrails leading to the entrance and even the reception desk itself covered in a colorful cozy crocheted by Magda Sayeg and the other urban yarn-bombers of KnittaPlease. Benjy Mason and Zach Moser, cofounders of the Third Ward community center

Workshop Houston, stood poised to begin work on a nineteen-foot sailing skiff with the assistance of show attendees. Artist and writer Bill Davenport reconstructed Bill's Junk, his Houston Heights thrift shop, from which he peddled found art, discarded ceramics and other curios.

Kamps remembered arriving at Cleveland's house to drive him to the exhibit's opening gala. The normally lively, upbeat Turner seemed distressed, out of sorts. Was the Flower Man nervous about his first big show? "Toby, I just had to pull my own tooth," he said, rubbing his jaw and grimacing in pain. It didn't stop him from cutting a rug at the party, however.

While the other participants displayed, performed or in other ways manifested their work inside, Turner's sculptures and assemblages filled the museum's front lawn, alongside a small metal shed, where Turner often spent the night during the duration of the exhibit. "He ended up becoming a living presence in the show," said Kamps. "He was there every day that he could, just loving the attention and the opportunity to make a few bucks by selling things."

It's clear that Turner looked at *No Zoning* as a turning point in his career as an artist, providing a measure of official recognition of his efforts. It was also around this time that, at the encouragement of artist Jesse Lott and others, he began to produce work for sale: cheerful sculptures made from painted tree branches decorated with beads, trinkets, toys and baby doll parts.

Turner supplemented his diminishing yard-tending income by tapping into the rich and ancient tradition of root sculpture, which crossed over into the contemporary art world in the 1990s in the work of self-taught African American artists from the Deep South, including Ralph Griffin, Lonnie Holley and Bessie Harvey. But Turner's creations don't evoke the same sinister mojo. Instead of contorted, hissing figures that could have slithered from the darkest depths of the bayou, Turner's pieces tease the viewer with a whimsical flair and a naïve, off-kilter recasting of pop-culture artifacts. They're actually much closer to the surrealist sculpture Alexander Calder built in 1938, *Apple Monster*, a brightly painted apple tree branch from which a small piece of wood bobs, attached by a wire spring.

For fifty dollars, I bought a piece from his table at an art fair at Discovery Green in 2011. Twenty-four termini of a twisting tree branch are capped with shiny purple orbs, plastic dice and, in one case, the torso and head of a smiling, brown-skinned Barbie doll. The orange wooden base on which the branch is mounted is also a roost for a quizzical cast of characters: an expressionless scarecrow, a prancing horse, two cloaked and masked action-figures and a sleek, cyborg quadruped. As we perused the rest of his stock, the Flower Man

led my six-year-old from sculpture to sculpture to try to learn the names and stories of other toy figurines he'd incorporated into his work.

"It's just stuff people throwed away," he told me one day, bending low and tenderly caressing a small wicker turkey as if he was back on the farm in Mississippi. "I can't pass by nothin' that halfway kinda looks like something. It's got to have no kinda look to it at all for me to pass by it! But that's me. And I got to say thank God that I can pick up that stuff and stay sober."

Even now, it still helps? "Yes sir!" he exclaimed. "Yes, sir, it still makes a difference. Sometimes that ole memory starts to creep in. It starts back in my brain here somewhere, if I set 'round too long, it starts to play tricks on me, I start to thinking about taking just one drink. But I catch myself, and I start doin' something, movin' something, makin' something, getting out on my bike to find something."

I can't help but think back to Calvin Trillin's article on Simon Rodia, which references one of the earliest printed accounts of the Watts Towers, entitled "Glass Towers and Demon Rum," in which it is written that Rodia's construction was "something he turned to after giving up drinking—sort of a therapeutic hobby."

I also recall a quote from *The Last Folk Hero*, a real page-turner of a nonfiction novel about artists Thornton Dial, Lonnie Holley and their unlikely Svengali, the collector-dealer-promoter Bill Arnett. In it, author Andrew Dietz interviews movie star and folk art aficionado Jane Fonda, who told him, "These artists pick up objects that the rest of us throw away and give them a second chance. In a way, these materials give the *artists* a second chance."

# Chapter 4

# THE LOST ENVIRONMENTS

<span style="font-variant: small-caps;">M</span>ost art is fragile," remarked the minimalist sculptor (and part-time Texan) Donald Judd, "and some should be placed and never moved away." If only things worked out that way. In fact, the stuff that folk art environments are made of was never built to last, and all too often, once their creators are gone (or even before), their artwork is tossed onto the rubbish heap by uncaring property owners, begrudged family members or clueless bureaucrats. The history of such sites is littered with sad stories of needless destruction.

Pelham, Georgia's Laura Pope Forester built more than two hundred statues from concrete and scrap iron in her yard between 1919 and her death in 1953—with subjects ranging from the founders of the Red Cross to the first woman to fly across the Atlantic and the first woman to be granted a legal divorce in Georgia. The site survived for years as a museum and tourist attraction, but in 1981, a subsequent owner of the property (in fact, a family friend who'd been by Forester's bedside as she died) hired a crew to destroy the figures with sledgehammers, and within forty-eight hours, they were reduced to a pile of broken body parts. Fortunately, an ornate concrete and marble gateway remains.

Builder and World War II veteran George Zysk spent his golden years covering his home in Grand Haven, Michigan, with more than fifty hand-painted missives railing against everything from traffic to taxes, occasionally calling out specific local and federal officials. He kept on painting, even when threatened with jail time. But in 2001, just a few years before George's

death at age eighty-nine, his son Craig removed and discarded twenty years of work.

Kea Tawana was a church caretaker in Newark, New Jersey, who triumphed over adversity with the creation of a meticulously designed ark (a "new" ark) three stories high and eighty-six feet long out of boards and other materials scavenged from ravaged buildings in the city's Central Ward. Built over a period of five years, the ark rested peacefully overlooking the parking lot of the Humanity Baptist Church and became a symbol of hope and the salvation for a riot-torn and blighted community. When the neighborhood was zoned for redevelopment in 1987, city officials ordered it destroyed. "It's a nice story, but hey, it's gotta go," the assistant director of the city's Department of Land Use Control told a *Chicago Tribune* writer. Ms. Tawana fought back, spray-painting the phone numbers of the mayor, the chamber of commerce and the *Newark Star-Ledger* on the boat, but despite letters of support from art historians countrywide and countless calls from outraged community members, the state's Superior Court ordered it demolished. Tawana herself cut it apart and used it for firewood.

According to SPACES' Jo Farb Hernandez:

> *Usually the times when the work comes down before the artist's passing, it's because some bureaucrat suddenly discovers—after the whole community has obviously been aware of the site for years, if not decades—that it violates some kind of building code or urban plan. Duh! Our effort in terms of advocacy has been to try to convince governments that these kinds of sites need to be treated in a manner different than that applied to ordinary buildings; they need to be approached as works of art and respected and managed as such.*

Cleveland Turner's dust-up with the Department of Public Works notwithstanding, Houston's practically nonexistent zoning restrictions have allowed its visionary environments to flourish. All the same, some remarkable sites have been erased by the passage of time and the ongoing need to turn over valuable lots. Luckily, some of the work has been rescued and survives in private and public collections, albeit in a less potent form, stripped from its original context.

Ida Kingsbury lived in nearby Pasadena, several miles east of Jeff McKissack's neighborhood in the direction of the ship channel. Born Ida Mae Haseloff in 1918, she was one of ten (or maybe twelve) children from a German family near the tiny farm town of Schulenberg, west of Houston;

after her mother died, her father sloughed off the kids to various relatives and adoptive families. When she came of age, she went to work in a hospital and as a waitress in La Grange. Then she moved to Pasadena in the 1940s to keep house for a well-off refinery worker named Robert Kingsbury and to care for his dying wife, Bessie, and their two daughters. Two years after Mrs. Kingsbury's passing, Ida married Robert, twelve years her senior.

The community was scandalized, and Robert's daughters were enraged. A neighbor, Myrna Elliott, spoke to the *Chronicle*'s Patricia Johnson about Ida in 1990: "I was in second grade when we moved next to the Kingsburys. They were ostracized by the neighbors, and my mother was warned not to let us visit. But to me, Ida was one of the sweetest people in the world." Ida and Robert maintained a formal relationship, never calling each other by their first names when others were present, but they remained married for thirty years, and during that time, she filled their home with fine furniture, dolls, doilies and porcelain figurines.

When Robert died in 1971, Ida was completely on her own. Her collecting escalated into hoarding, and by the '80s, she had completely filled her once tidy house, the contents spilling out onto the porch and into the yard and garden. But even though she bought too much and never threw anything away, hers was no ordinary trash. She turned a wide variety of materials, from washboards and anchors to inner tubes and dented icebox trays, into a bustling community of what Susanne Theis described as "farmyard animals and stock country characters," sort of a paean to Kingsbury's rural upbringing back in Schulenberg. "She built her own little world where she was loved by all her little people and her animals," observed Myrna Elliott, the neighbor.

Fence post pilgrims donned tin bonnets and held tiny guitars. A pair of hinged boxes with star and crescent moon cutouts became "his" and "hers" outhouses, both bearing the slogan "home sweet home." An orange teapot read, "Polly, put the kettle on." Pieces of Bible scripture were painted on trash can lids. Plywood boards were transformed into smiling people. Here's Uncle Sam. There's Old MacDonald. A cowboy. A policeman. A comical canine on wheels sported oversized sunglasses and a sign that reads, "Beware of Dog." And there are cats, dozens of cats with crazed expressions. One hand-lettered sign reads, "I hate cats!"

In the mid-'80s, commercial builder Tom LaFaver and his wife, Moira, became hooked on folk art and started volunteering at the Orange Show, always keeping their eyes peeled for possible Eyeopener stops. An acquaintance who had joined them on an early tour started directing the LaFavers to yards he thought might be of interest. "I don't know how many concrete ducks

dressed in raincoats he showed us," Tom said, laughing. "I'd always say, 'No, John, that's not it.'" Then, in January 1989, John drove Tom by Kingsbury's teeming garden. "This time I was like, holy shit, yes, this is it!"

Tom went back a month later to have another look and to try to speak with Kingsbury, but the day was so damp and cold that he didn't have the heart to ring the bell and risk bringing the old woman out in such weather. For the time being, he contented himself by snapping some pictures through the chain link fence, vowing to return again. Tom told Susanne Theis about the place, but by the time she made it out to Pasadena to meet Ida and photograph the yard, it was too late. In February, Ida's postman had noticed her mail piling up and became concerned. Neighbors called the police, who found her dead in her driveway of an apparent heart attack. They speculated that having been crowded out of her own house, she had taken to sleeping in her car.

The weeks following Ida's death were a whirlwind at 210 South Randall Street. The property was left to the stepdaughters, while the contents of the overstuffed house were willed to one of Ida's kinfolk. "And everyone thought there was money in there somewhere," Tom said, recalling relatives smashing hundreds of dollars worth of valuable china dolls on the misguided hunch that cash might be hidden inside one of them. Meanwhile, a salvager began dismantling the display outside and carting it off to the dump.

Over the objections of Kingsbury's stepdaughters, Theis worked out an arrangement with the salvager, and she coordinated an emergency rescue of Kingsbury's artwork with the help of about forty volunteers. One of these was Bryan Taylor. "Disgusting," he said, wincing at the very memory of the experience. And when this profoundly casual fellow says that something is disgusting, I believe that it must have been truly awful. "Bugs!" he said, wrinkling his nose and shuddering. "That was a gross, disgusting two days, muddy and cold and wet. And it was sad to see all this work out in the rain. Getting it out of the ground it would break and crumble. And there's her family telling us, 'Get this stuff out of here. Throw it away.'"

For five months beginning in August 1990, 130 pieces from Ida's garden were exhibited at the Children's Museum of Houston. A student architecture group at U of H went to work documenting what remained of the collection, but after that, the items spent almost fifteen years packed away in Theis's garage. Not a single institution in Texas would take the work. In 2005, however, about two hundred pieces found a permanent home at the Grassroots Arts Center in Lucas, Kansas, its first acquisition of the works of an artist from another state.

"We decided she needed a home," said Rosslyn Schultz, Grassroots' director, citing Kingsbury's prolificacy, her humor, her unusual biography and the fact that she was a woman in a field typically dominated by men as factors contributing to her importance. "It goes along with our premise that creativity, it's hard to hold it down."

"It's been such a hit with people that it's kind of become a permanent exhibit," she added, laughing. Kids especially love it, and Schultz has organized workshops for the little ones where they're encouraged to make their own characters out of similar materials. "For nobody giving her much recognition in her hometown," said Schultz, "I think she must be smiling down from heaven now."

A long way away from heaven, and even from Pasadena, Gillette Street is on the western edge of Houston's Fourth Ward, which came to be known as Freedman's Town after hundreds of emancipated slaves purchased swampy land west of downtown and just south of Buffalo Bayou in the late 1800s, harvested the old-growth cypress trees from its banks and built row after row of tiny shotgun homes. By the 1980s, it had become a dangerous place flooded with crack cocaine and spiked with violent crime. When I first came to Houston in 2001, my girlfriend owned a house just a few blocks to the west of Gillette. Things there had improved quite a bit since the time a bleeding, bullet-ridden body had been dumped on her front lawn in the mid-'90s, but still, she warned me not to wander too far to the east, especially if I was alone.

Within this hardscrabble area stood another of Tom LaFaver's discoveries. The OK Corral at 1912 Gillette was the art yard of a mild-mannered, overalled house painter named Howard Porter. Nobody seems to know very much about him, but people certainly remember his yard. A lifelong fan of cowboy movies, especially Burt Lancaster's 1957 flick *Gunfight at the O.K. Corral*, his fence was hung heavy with boots, rifles, skillets, farm tools and other items suggestive of the Old West (as well as such oddments as plastic flamingoes, hubcaps, license plates, an old vacuum cleaner and a toilet seat). Inside the property was a collection of lawn furniture painted in bright, bold rainbow shades and embellished with delicate, lacy white swirls.

It was a technique he'd copped from a wall in a house he'd once painted. The owner explained that it had been done with a feather duster dipped in paint, and Porter eagerly tried out the method in his own bathroom, painting everything including the tub and toilet a bright shade of purple and then applying a layer of white filigree. He moved on to the rest of the

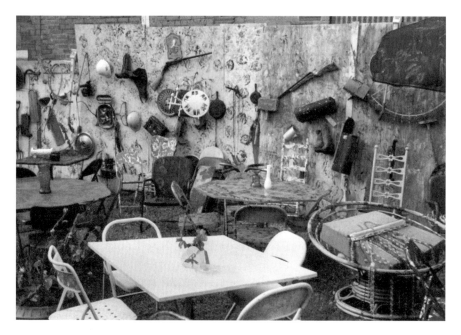

Yard view of the OK Corral. *Courtesy Barbara and Marks Hinton.*

house's interior and then to the picnic tables and chairs in the yard, where his friends would gather for frequent barbecues. Porter happily demonstrated his technique for filmmaker Laurie McDonald when she visited in the late '90s, his feather brush skating gracefully over the surface of a lemon-yellow metal glider swing.

"I didn't have nothin' to lose 'cause I wasn't doin' it for nobody. I was doin' it for myself," he told McDonald in what may have been his only recorded interview. "When I paint, I got no idea which way I'm goin', got no idea how it's gonna turn out until after I get it painted."

But people liked what he did, and in time, he even started to take a few commissions. "He'd charge five or ten bucks to paint a chair," remembered Jack Massing, who also knew Porter and hired him to decorate the furniture in the Art Guys' studio. Susanne Theis asked him to paint a couple of file cabinets for her office at the Orange Show. They're still there today, and Porter's touch is instantly recognizable.

Down the street lived a fisherman named Ray Shelton, who often remarked, "These days, you can catch a lot more than fish in the Gulf." Whenever he drew up an old chandelier, doll or appliance in his fishing net, he'd bring it back to Houston and affix it to the fence across the street

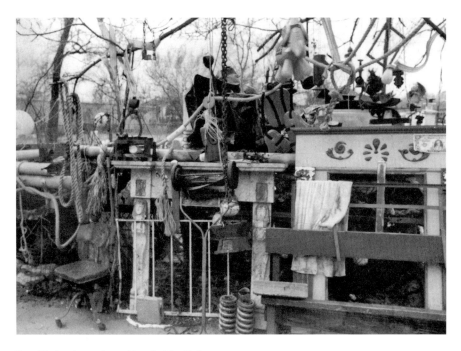

Ray Shelton's yard art. *Photo by Tom Lafaver.*

from his home or hang it from one of the trees. Howard and Ray developed something a friendly rivalry with their yard art until Shelton passed away in November 1991 after a short illness.

Their efforts were a bright spot in a difficult neighborhood, and after LaFaver's discovery in the mid-'80s, it became a favorite of the Orange Show's Eyeopener crowd. Bryan Taylor used to conduct a mobile Labor Day party that snaked its way through Houston with a blues band and generator on a flatbed truck, and the OK Corral was always one of the stops. Neighbors would come out to dance with Taylor and his art pals, and Porter would fire up his grill and sell brisket for five dollars a plate. "He'd put the meat on to smoke," remembered Susanne Theis, "and people would come over and eat and enjoy the view of that 'millionaire's skyline,' as he used to call it." Indeed, Freedman's Town extends westward from the base of downtown's soaring skyscrapers, and the view, especially at night, is spectacular.

But by the millennium, the row house Porter rented was one of only nine holdouts in a rapidly gentrifying neighborhood. Porter's landlady died, and the property was sold. Taylor went to visit with Porter one day,

129

and as he approached, he saw an empty house, a yard overgrown with weeds and a sign advertising the coming of a new townhome. "I knew that was it," he said. "The doors were open, everything was gone and I asked some kids, 'Do you know what happened to Mr. Porter?' They didn't know." Most of the remaining shotgun houses nearby were vacant, too. Porter, like half the block's residents, had vanished.

On September 10, 2004, a fire at 1912 Gillette was reported just before 2:30 a.m. The blaze quickly consumed the entire house, the rubble was promptly bulldozed away and today the neighborhood consists of a sea of identical townhomes situated around an empty, featureless park. The shotgun houses' timber-frame construction of cypress heartwoord was as strong as steel, but ultimately it was no match for the developers' bulldozers.

It was July 29, 1984, and Victoria Herberta was as happy as a pig in mud. Like Howard Porter, she painted houses for a living, but she took the day off to drive about an hour northwest of the city to Lake Somerville, joined by some friends and her beloved pet Priscilla, who loved to swim. If you're imagining a doggy-paddling pooch, think again. Priscilla was a three-month-old, twenty-two-pound blue butt piglet who didn't just swim—she also ate Twinkies, wore lipstick, listened to zydeco music and shared Herberta's bed.

At about 5:00 p.m., Herberta's friend Carol Burk decided to take one last dip before they called it a day, and she brought Priscilla along. Her eleven-year-old son, Anthony Melton, a resident of the Brenham State School for the mentally disabled, couldn't swim, and she warned him to stay on the shore. He waded in after his mother regardless, and when he suddenly stepped into deeper water, Anthony screamed and went under. Burk heard his cry and swam furiously toward her boy, but Priscilla was faster. "He went down once," Burk told the papers shortly after the incident, "then he went down another time. I told him to catch hold of Priscilla's leash. Then they both went down. I thought, My God, I've lost them both." A moment later, the pig's ears and nose poked out of the water, and then the boy's head, as the two struggled to stay afloat. While Herberta and her friends cheered from the opposite shore, too far away to offer help, Priscilla pulled Anthony back to shallow water. His life was spared, and Priscilla was recognized as a hero. She was lauded in newspapers and magazines coast to coast, including a short blurb in *People* and a series of sensationalized articles in the *Weekly World News* supermarket tabloid.

Priscilla was a sensation. She was selected to be the first member of the Texas Pet Hall of Fame by the state's Veterinary Medical Association,

and she received an invitation to appear on Johnny Carson's *Tonight Show* (although logistics prevented this from happening—pigs can't fly). Mayor Kathy Whitmire proudly proclaimed August 25, 1984, as "Priscilla the Pig Day."

That November, Priscilla was rewarded with the William O. Stillman Award, the American Humane Association's top honor. At a ceremony at the Houston Society for the Prevention of Cruelty to Animals, the pig preened in purple panties, purple lipstick and a purple felt cape decorated with ostrich feathers. "I'm all choked up," wept Herberta as she accepted the award on Priscilla's behalf, dressed in a matching purple blouse, purple nail polish and purple sneakers. "She's saying she really appreciates it," Herberta added helpfully as the pig oinked in the direction of the handsome wooden plaque. "I was thrilled and overwhelmed by what she had done," she told gathered reporters, "but I have always said Priscilla is sensitive to human pain."

The rescue inspired Herberta to transform her lavender bungalow at 4208 Crawford Street into Pigdom, "a shrine to swine," where a collection of altered road signs ("Slop," "No Porking," "Pignic Area," "Root 66," "Piggywood" and "Swine") were mounted to celebrate her heroic hog. "Not a day goes by that I don't have people drive up in front of the house and want to know where Priscilla is," she told the *Houston Chronicle* in 1985. "I wasn't planning this. I wanted to live in obscurity."

Herberta's wish to keep a low profile was certainly thwarted by her eye-catching property. This self-proclaimed "Ma Porker" decorated the exterior of her abode with neat rows of bakery packing flats, colorful license plates from around the country, vintage advertising signs and strings of tinkling soda cans (perhaps inspired by Milkovisch's work?). She filled its interior with sprawling collections of pig figurines, souvenir ashtrays and shot glasses, as well as what she believed to be the country's largest stash of vintage glass soda bottles. She self-published an eighty-page collectors' guide in 1982, and when her house-painting career ended, she made ends meet by buying and selling rarities. "It's part of American history," she said of the bottles, "and a kind of folk art that needs to be preserved. Besides, this is real Pop Art."

It was in June 1984 that Priscilla first came home with Herberta as a six-week-old piglet, purchased from a rancher who was breeding compact pigs by mating litter runts. "I'd raised dogs all my life," remarked Herberta, "but that little animal surpassed all my expectations. She was much more intelligent and easier to train, and she was the most affectionate creature in the world."

The offspring of Ralph, the famous swimming pig from Aquarena Springs in nearby San Marcos,[9] Priscilla didn't immediately take to water. Herberta would hold the piglet in the Brazos River west of Houston as if she were a toddler. "She screamed and hollered," Herberta recalled, "and everyone asked if I was trying to drown that poor little pig." But on the sixth attempt, the pig swam like a fish.

Traumatized by little Anthony's ordeal, Priscilla wouldn't swim in a lake or a river after the accident, but she continued to show off her natatory prowess in small ponds or swimming pools, including a high-profile appearance at the International Bellyflop Contest at the University of Illinois in Chicago, where she arrived in a limousine to the delight of 2,500 screaming fans.

Before long, she became too heavy to float at 150 pounds, and by December, she'd developed a drug problem after munching on her owner's opiate-laced morning glory vines. Heartbroken, Herberta relocated her to a farm back near San Marcos to detox, but soon the mantle of swimming pig, as well as her wardrobe, was passed on to Priscilla's younger sister, Little Priscilla.

"Big Priscilla used to have about ten costumes," Herberta told the *Chronicle*, "but she ate three of them. I'm not sure Little Priscilla will wear them. It gets so hot in the summer. I won't book her to do anything in the summer where she can't swim."

"This Priscilla is much bossier than the other," she continued. "And she swims at a funny angle, not like Big Priscilla, who was completely graceful. But she does swim." At four months and seventy-five pounds, Little Priscilla made her public pig-paddling debut at the Orange Show's steamboat pond on July 9, 1985.

Herberta, born Victoria Herberta Zeisig in February 1939, grew up in the German-speaking enclave on the southern end of Rutland Street in the Houston Heights. She dropped her legal last name somewhere along the way, since she said nobody could spell it or pronounce it correctly. When she was four, she saw a picture of a pig in her alphabet primer and fell in love at first sight. At eighteen, she drove to Arkansas to visit pig farms in the Ozarks. "I thought they were the most marvelous things in the world," she told writer Sally Sommer in an article that was picked up by newspapers around the country in 1985. "They have an impressive figure that is absolutely precious."

"When I was about 18, I decided life just would never be complete for me unless I had my own pig," Herberta told syndicated columnist John Keasler, "but I was 45 before I got one. Now I know I could never live without one, and there will always be a Priscilla here."

Alas, it wasn't long before Little Priscilla topped 800 pounds and broke her backyard wading pool. At 1,500, pounds, she was also relocated to San Marcos to cool off and be with her mom.

Happily, Big Priscilla spawned another porcine pal for Herberta: Jeffrey Jerome, an adorable pig with one blue eye and one brown. He was no lightweight either, gulping down nine cases of Mountain Dew each month, not to mention troughloads of chocolate chip cookies, tuna fish sandwiches, grapes, avocados, boiled rice, peppermint candy, Ding Dongs, sweet potatoes, chicken hot dogs, cheeseburgers and ten-inch Gino's pizzas. He liked pastries, too, and Heberta turned to gathering stale bread from the dumpsters of area bakeries to supplement Jerome's voracious appetite.

One day in 1987, a homeless man noticed her returning home with her truckload of baked goods and asked if she might have any to spare. "You don't understand," she explained. "This is stale bread. I'm giving it to my pig." The homeless man told her he had no qualms about accepting the day-old bread, so she gave him all he could carry and encouraged him to tell his friends. By the day's end, she'd had forty more hungry visitors.

It was a defining moment that prompted her to begin throwing weekly "Pig Parties." She'd dress up Jerome for the occasion and asked guests to bring a can of food as the price of admission. The parties went on for well over a year; one Halloween get-together netted more than one thousand units of canned goods. Herberta found that she could easily put together forty grocery bags of food for the homeless each week. Some of the needy still came right to her door, but she also began a delivery route with her Chevy "pig-up" truck (license plate: "A HOG 4 U") to bring food directly to the increasing number of people sleeping under Houston's bridges and overpasses.

"People were going to the city council and asking, 'Why aren't we doing more for the homeless?'" remembered Bryan Taylor, who befriended Herberta while working for the Orange Show. "Of course, they'd say, 'Well, it's not as easy as you think. You can't just go out and feed hungry people.' Then one woman stood up and said, 'Yeah it is. There's this lady Victoria, and she and her pig collect lots of food and give it out every week.' That made the local news." It wasn't long before Jerome became famous around Houston as the "Ham-bassador to the Homeless."

Herberta would sometimes get Taylor to drive a delivery route, or she'd ask her neighbor, the Art Guy Jack Massing, upon whom she also frequently prevailed to fix her plumbing or patch her roof. Massing remembered her as a complex personality, both needy and generous in equally large proportions, and difficult to say no to.

It was an incredible phenomenon, beautiful and surreal, until a cranky neighbor squealed. Herberta had asked her to turn down her radio late one night, and she retaliated by complaining to city council member Rodney Ellis about "that bodacious hog-wallow over on Crawford Street." Despite the obvious cleanliness of her property, in October 1988, Robert Armstrong, head of the Bureau of Animal Regulation and Care, authorized a citation for Herberta's violation of City Ordinance Section 6-11, which forbids keeping swine within the corporate limits of the city of Houston. Jerome would have until the end of the month to vacate, or his keeper would be fined $200 per day. Herberta said she wouldn't comply and vowed to seek a formal hearing.

In the end, Jerome left town on October 31. In tears, Herberta struggled to coax the panicked pig onto Jack Massing's truck with a plate of Ding Dongs, and a flotilla of art cars escorted Jerome to the city limits. Two days later, newsman Richard Schlesinger reported the situation on the CBS evening news.

Jerome took up residence in a muddy tin shed at a hog farm in Waller County, where he was bitten by a jealous horse and ostracized by the farm's other pigs. In the depths of depression, he lost more than one hundred pounds. Herberta relocated him to a farm in San Marcos so she could check on him and help nurse him back to health. Taylor drove the weeping Herberta back and forth from Houston to the farm frequently until she herself moved to be closer to Jerome.

"He was dying of a broken heart," she explained to the *Chronicle*. "He wouldn't eat unless I was there. I've had to close down my house in Houston and move up here to be with him. I can't be away from him for more than five days or he thinks I've abandoned him. In the meantime, I've become indigent. I can't find a job here. San Marcos is a college town, and they don't want a fifty-year-old woman."

In January 1989, Municipal Court judge Sam Alfano granted prosecutor Ron Beylotte's request to dismiss Herberta's citation. The courtroom applauded. Herberta was off the hook, but Jeffrey Jerome would have to stay in San Marcos. "Pig's Owner Gets Reprieve but Still Can't Bring Home the Bacon," crowed a headline in the *Chronicle*, which covered the saga in detail.

Others rushed to their aid. In March 1989, Houston's Democratic state representative Ron Wilson introduced House Bill 1571 exempting pet pigs like Jerome. Animal Regulation chief Armstrong was flown to Austin to defend his citation and was flabbergasted when "Jerome's Law" passed the Agriculture Committee (although it eventually died with thousands of other bills when the legislature adjourned). The Patrick Media Group donated a

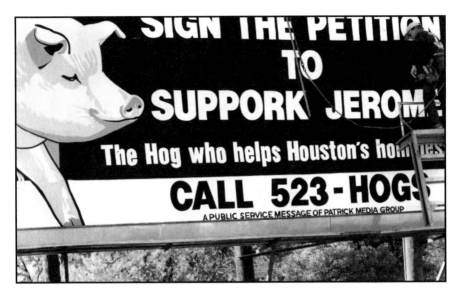

"Sup-pork" Jeffrey Jerome. *Photo by Tom Lafaver.*

billboard at the intersection of Truxillo and Fannin Streets for six months, which featured a picture of Jerome and the message, "Sign the petition to sup-pork Jerome the hog who helps Houston's homeless. Call 523-HOGS." Supporters led by socialite and activist Carolyn Farb paraded in front of city hall (Taylor made a sign that read, "If pigs are outlawed, only outlaws will have pigs."), and Mayor Kathy Whitmire's office received more than one thousand calls. The city dug in its hooves; Jerome would remain porcina non grata within the Houston city limits.

With her savings dwindling, Herberta eventually moved back to Houston and a Pigdom bereft of swine. Jerome died in June 1994 when he was struck by lightning while taking shelter under a tree during a storm; Reuters circulated his obituary nationwide. Herberta was devastated but kept the memory of Priscilla and Jerome alive through the artwork at Pigdom. Behind the sky-blue picket fence, more signs were added to the façade (as well as a traffic pig-nal), and the mailbox and lawn furniture sprouted ears and snouts. Kodak included the house on a list of places to photograph in Houston, and the Eyeopener tour bus rolled up to the curb for years. Bryan Taylor turned a battered Buick into his first art car, a tribute to Jeffrey Jerome. Art car pioneer Tom Kennedy helped build and attach the ears and snout. An art bus full of supporters arrived at Pigdom on Memorial Day for a tear-filled ceremony.

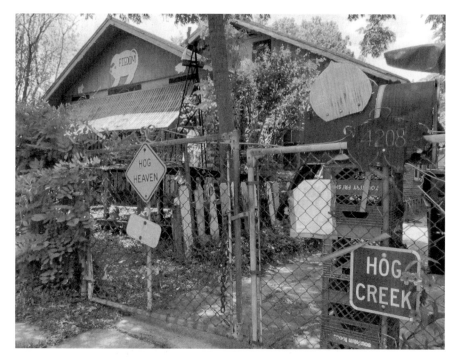

Pigdom in disrepair, July 2011.

Herberta continued to welcome visitors and tell the story of her beloved pigs over the next fifteen years, until she passed away in September 2010 at the age of seventy-one. When she entered the hospital, by way of helping to get her affairs in order, she asked Jack Massing to give her room a fresh coat of paint.

When I made my first pilgrimage to Pigdom in the summer of 2011, I found the still-cheerful purple cottage in a state of disrepair. Its signs are intact but fading in the Texas sun. The shutters are closed, and Christmas lights spelling out "Sow-son's Gruntings" are still mounted despite the sweltering heat. The once well-groomed garden has become an overgrown rain forest of vegetation. A small item in the newspaper indicated that Pigdom had been foreclosed upon on the previous December 15. In fact, according to Barbara Hinton, the lawyer contacted the Orange Show with an offer to sell. "He wanted us to buy Pigdom," she laughed. "I mean, we don't have that kind of money. I told him he could donate the property, though, and he'd get a nice tax deduction."

I tuck a note inside the pig-shaped mailbox and receive a call later from Herberta's longtime friend and housemate Judy Greinke. She's been packing

and sounds depressed. "Victoria told me I could stay as long as I wanted," she said. "Now they're making me leave." She's vague about who "they" are and doesn't much feel like talking about old times. One gets the feeling that the house's remaining days are few.

Maybe the greatest loss of all has been a curious assemblage created between 1978 and 1995 by a lifelong tinker and builder (and onetime carnival worker) named Bob Harper. Bob was an exceedingly quiet man who lived in the neglected Third Ward, only a few blocks north of the corner lot where Cleveland Turner once resided. Like the Flower Man, Harper gathered the neighborhood's refuse from off the curb and from junk-strewn vacant lots, and then he hauled it all home to fashion the debris into…well, some would call it art. Dominique de Menil, the patron saint of Houston's modern art scene, surely did.

"Bob was one of her favorites," related Orange Show board member Barbara Hinton. "When she had guests, that's a place she'd always bring them." I looked through a handful of snapshots of Bob's yard show at the Hintons' high-rise apartment and wondered what Dominique's wealthy friends made of the symmetrical towers of anthropomorphized junk, with leering, alien faces constructed from baby carriage wheels and television sets and water skis and beer signs and everything but the kitchen sink. Wait…no. In one picture, there's the kitchen sink as well. Two of them.

"I build for the Lord," Harper once declared. "Everybody can look at what I build and know that there is a God up above because I get my ideas from the blue sky."

"Yeah, sure enough, I knowed him!" gasped Cleveland Turner, his memory jogged one afternoon as we sit at a Denny's with a couple of cheeseburgers between us. "He was a cool operator, and he knowed his stuff. I sure could see his point. It was art, all right, but it wasn't my type of art, y'see. It was his art."

It's true. Even if in a general sense Harper and Turner's modus operandi seem the same—a man becomes divinely inspired to collect junk and assemble it artfully, improving his blighted neighborhood—the environments of Turner and Harper are worlds apart. In the extensive feature piece he wrote about Bob for the *Houston Press* in 1994, Susanne Theis's husband, David, allowed that while "there may be a touch of meanness in comparing the work of artists who are not only untrained but unpaid as well, Harper's creation is simply more complex and challenging than Turner's…You look at the Flower Man's wild profusion of plants and vines and paint and say immediately, I get it. Not so with Harper."

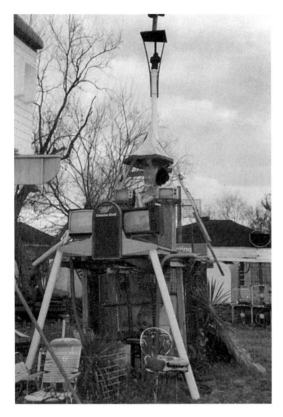

Detail view of the Third World's interior. *Photo by Barbara Hinton.*

It's hard to know what one was to "get" from these piles of carefully arranged cast-offs. Harper himself never prescribed any particular meaning to any of his combines. One was a structure built from plastic bread trays, lengths of PVC pipe, old stovetops and broken TV sets. A female mannequin is perched on top of the assemblage, her legs crossed daintily, her missing arms replaced by a two by four. Her headgear looked to David Theis like "a cross between an Oriental Hat and a massive lampshade." Higher up, the hat peaked with a spire on which was mounted a toy King Kong figurine. Harper's name for the piece? *Beauty and the Beast.*

The entire property was surrounded by a high fence decorated with blue plastic bakery flats, advertising signs (including those for such luxury brands as Oscar de la Renta, providing a dollop of irony) and countless electric fan blades, which spun in such pinwheel-like profusion on the property that they gave rise to his nickname, the "Fan Man." A large sign over the door scavenged from a defunct restaurant bestowed upon the site its name, the "Third World."

We would know very little about Bob Harper today if it weren't for David Theis's dogged attempts to shake loose some biographical information while preparing his feature for the *Press.* "Bob was the least excitable man, and possibly the least verbal man I've ever met," he told me over drinks one day at Bohemio's, a little art gallery café just up Telephone Road from the Orange Show. "He'd drag it out word by word. You'd ask him to explain something, and there'd really be nothing there. Why'd you choose that? 'I

liked it.' Why'd you put these things together? 'I liked it.' That's what talking to Bob was like."

Unable to coax many facts out of the soft-spoken Fan Man, he turned to Bob's younger brother, Quincy, a retired construction worker and neighborhood preacher who was as loquacious as Bob was reticent. "His brother was just the opposite," said Theis. "Without the brother, there would have been no story."

A quick summary, then. The fourth of five sons raised in various working-class neighborhoods around Houston by their stepmother and their construction worker father, Bob was born in 1934 and began building playhouses and decorating the fence of the family residence as a boy. During his teenage years, he worked alongside his father, Willie, laying brick, plastering walls and tearing down scaffolding. Then, at seventeen, he joined a traveling carnival called the Bob Hammond Show, which hired him to set up, operate and then break down rides before moving on to the next town and doing it all over again. He did this until he was in his mid-thirties, at which point he returned to Houston and began to make tamales and sell them out of the trunk of his car. He was quite successful and told Theis that on a good weekend he'd sell as many as "three or four hundred dozen." City health officials put a stop to that around 1980, and he went to work at the Express Mart around the corner from the house on Drew Street, where he'd moved with his mother in 1978.

First he decorated its interior walls with objects he'd found while driving around in his old pickup—record jackets and wicker planters and images of political and religious leaders. Then he cleaned the huge yard, which had for years served as a Third Ward dumping ground. He began to use the trash as building materials, erecting first a watchtower from which he could survey the neighborhood and then a series of rooms, walkways and abstract sculptures. The people who lived on Drew Street were suspicious in the beginning, but eventually they began to admire the quiet man who was building something up while everything around him seemed to be coming down.

Bryan Taylor noticed the site one day in the mid-'80s after having taken a wrong turn on his way to Cleveland Turner's place and reported his find to Susanne Theis. The Orange Show included Bob's place on several subsequent Eyeopener Tours, bringing him to the attention of the city's art community. Busloads of visitors would roam through the property, while Harper smiled shyly and quietly watched. The U of H grad student and McKissack researcher Becky Jacobs-Pollez was on one of these stops and

remembered a gaggle of tourists looking at Bob's pieces and having strange flashes of recognition, saying things like, "Oh my God, I just realized what that is!" Guests would pepper him with questions. Where did you get those helmets? Oh, by the side of the road. And those water skis? Oh, by the side of the road.

Then, disaster. One Sunday morning in January 1992, Harper was attending services at the nearby Christian Home Baptist Church when a neighbor dashed in to tell him that his house was on fire. An old gas heater had exploded, and the place had erupted in flames, with his mother still inside. Bob ran home to find firefighters already on the scene; Theis's article describes the adrenalin-spiked struggle of 145-pound fireman Jackie Hanson carrying Bob's unconscious 280-pound mother from the collapsing building. But it was too late. With extensive third-degree burns, she died two days later. Some neighbors whispered that Bob's accumulation of junk had hampered the rescue efforts, but Captain Clifford Reed denied this, telling Theis that while Bob's artwork may have slowed them down, "Mrs. Harper couldn't have been saved."

And then Bob, although getting up in years and suffering from a bad back, began to rebuild both his life and his artwork. He moved in with Quincy on Altoona Street in the Fifth Ward, creating something of a satellite Third World there, while at the same time putting his old sculpture garden on Drew Street back together. Within days of the fire, he had borrowed a shovel and a wheelbarrow and quickly cleaned up the charred debris of his old house. "He started right away," Quincy told Theis. "He's got to keep busy."

Bob's talent and resilience inspired Theis to write his article the following year, and he went so far as to bring the famous installation artist Ed Kienholz to the Third World in an apparently ill-fated attempt to try to get an expert assessment of Harper's abilities. Kienholz was a friend of Marilyn Oshman, and with his wife and collaborator, Nancy, he had established a winter studio in Houston. No stranger himself to the junkyard, he was a true West Coast avant-gardist who didn't let his lack of formal art training get in the way of making disturbing, bitingly satirical assemblages of found objects. "I just wanted to get validation that it was art," said Theis. "But I think Kienholz was kind of leery about what it was I wanted from him. He said something like, 'Yeah, of course it's art,' and not much else."[10]

In the article, David describes a touching scene that occurred during one Eyeopener visitation. As rain began to fall, Oshman encouraged Harper to step away from the rest of the crowd with her and into his watchtower, where she asked him whether he felt like an artist. "I'm starting to," he told her.

After the piece was published, Theis brought Bob a copy of the paper. David doubts that Bob read it; in fact, with his limited education, he doesn't think Bob could read much. Still, he said, "I think it made him feel good that people were interested. The attention he was getting did mean something to him."

Sadly, Bob's health began to decline rapidly, and in 1995, he was diagnosed with lung cancer. The Orange Show Foundation organized a benefit on his behalf, complete with a gospel choir and a potluck dinner, but it was too late. Bob Harper died at Ben Taub Hospital on December 5, 1995, five days before the event took place. The benefit went on as planned, and with Quincy and another of Bob's brothers in attendance, it became a celebration of the life's work of the Fan Man. Small pieces of his artwork were sold to friends and admirers, and larger ones auctioned, raising more than $1,500 to defray his medical and burial expenses. It was a rare case in which such work wasn't simply loaded into a dumpster after its creator's demise.

"You know," said David, "the last time I drove by there, four or five years ago, you could still see pieces of his sculptures up in the trees. It was kind of ghostly looking. When I saw it, it touched me. It kind of felt like Bob's spirit was still there a little bit." We finished our drinks and decided to try to find the lot.

We made a presumption from the text of his article that the house was on Sampson Street, and we plotted a course with my iPhone. As I drove along behind David's car up and down Sampson, through neighborhoods of falling-down houses and falling-down people, the tuneful pop of Wilco wafting from the car stereo seemed wrong, out of place. Hmmm, what else is in the player? Ah, here's Big Moe, freestyling soulfully about Bahr-brand purple drank over the damaged hip-hop of the south side's own DJ Screw. Better.

We stopped periodically, but there were so many vacant lots strewn with garbage that it was hard to know whether we had found what we were looking for. We doubled back and retraced our route. After things began to get a bit too goose-chasey, David called Susanne, who clarified that Harper's Third World was actually on Drew Street, just off Sampson. We hung a left and pulled to the curb in between a dilapidated laundromat and an entire block completely empty except for a billboard advertising an upcoming Project Row Houses building initiative and four elderly black men sitting at a picnic table.

"Did you know Bob Harper?" David asked them. We meet blank, suspicious stares. "The Fan Man?" he tried again. "He used to have a yard around here with sculptures made from junk, fan blades and things?"

"Yeaaaah," one answered warily. "Lotsa flowers? That was down south'a Elgin, though, Sampson and Francis." No, that's the Flower Man's old corner, David said, although it seemed the distinction was lost on this gentleman. "Hey man," he responded, irritated, "you said you was looking for a yard full'a shit, and that's what I'm tellin' you about."

David remembered the laundromat, though, and he's become convinced that this was the place. But the last time he was here, the neighboring houses still stood. Now the entire block has been cleared, swept clean. "It's all gone," David said, looking around. "Even the ghosts in the trees."

Chapter 5

# NOTSUOH BY JIM PIRTLE AND ZOCALO/ TEMPLO BY NESTOR TOPCHY

On downtown Houston's Main Street, just south of the city's birthplace, Allen's Landing, and across from the Harris County Tax Office, the city's shiny new light rail whizzes past the historic Kiam Building, a five-story red brick corner office building constructed in 1893 by architect H.C. Holland for use by the Edward Kiam clothing store. An upscale Italian restaurant called Mia Bella's now occupies the building's cozy ground-floor corner space, but beside it to the north, ten-foot-tall neon letters placed amid diagonal rays scream "The Home of Easy Credit" above smaller vintage signs that still advertise two long-gone retailers, "Clark's" and "Dean's Credit Clothing."

Look inside the plate glass bay windows, though, and you won't see today's fashions or even those of yesteryear. Instead, the window shopper is confronted by the naked lower half of a mannequin with a protruding, quasi-penile nub; another mannequin so deconstructed as to resemble a pile of cast-off prostheses; thrift store paintings; a vintage clothes rack draped with macramé jewelry; metal shelves piled with unsleeved records; a bedspring; an antique tricycle; shutters taken off their hinges; some unidentifiable trash; a statue of the Virgin Mary with a lampshade on her head; and a collection of demented-looking clown dolls half-buried in a drift of artificial snow. Inside the front vestibule is a chair with no seat and a decaying upright piano stripped of its keys but painted a lovely shade of purple. It's encrusted with beads, dominos, ceramic chips and other bits of bric-a-brac. Two men sit at a table just outside, arguing. A passing homeless person panhandles them for change. Houston, we have a problem. Welcome to Notsuoh.

Notsuoh's exterior façade, June 2008.

Inside, a similar explosion of detritus testifies to the building's previous life as Clark's Clothing & Jewelry and White Sellis Jewelry and Pawn. Shelves are piled high with women's shoes and their original shoeboxes. Bicycles and about fifty baseball caps hang from the ceiling. An impromptu coffee table made from a Lucite box contains a lounging skeleton with a mannequin head. Another table displays an old-fashioned microscope and a green… well, I don't know what that green thing is.

It's a slow Monday night, and I bellied up to the bar with a Lone Star. While I waited for Jim Pirtle, Notsuoh's owner and proprietor, to arrive, I watched some friends reinventing jazz standards on the long, narrow stage. Three local avant-gardists played it relatively straight for a change, while a fourth scoured the songs' melodies with the crackling sound of an electric guitar played with steel bolts, sidewalk chalk and a pet brush. Speaking of pets, their most attentive audience member was the dog that lives there, which pads over to the space in front of the band and urinates on the floor. Soon, Pirtle walked by toting a jagged piece of wood. It turned out to be the bottom half of the men's room door, now split open to reveal an ancient

corrugated cardboard latticework sandwiched between two pieces of plywood. "Really?" said Pirtle, shaking his head in disbelief while stopping to give me a closer look. "This is how they made a door?"

Pirtle had the slightly weary look of someone who's been awake too long or who's run a downtown coffee shop/bar/gallery/performance space for fifteen years, or both. He's a performance artist himself, best known for ingesting large amounts of mayonnaise and picante sauce while crooning 1970s AM fare, then throwing up at the song's climax. He's also painted portraits on polyester clothing and jumped off roofs for artistic effect, but these days he spends almost every night behind the bar at Notsuoh. Running this place filled with a century's worth of orphaned objects is the performance piece of a lifetime, and he was glad to point out some highlights.

"Well, there's the Chinaman, there," he said, gesturing across the bar to a six-foot Chinese warrior statue that'd recently been de-accessioned at the closing of the Forbidden Gardens in Katy, just west of Houston, which reproduced to scale Emperor Qin Shi Huang's buried Terracotta Army. ("That's not the preferred nomenclature, Dude," I can't help but think. "This isn't a guy who built the railroads.") "I'll show you something else," he added, leading me through the adjacent space known as "Dean's" and up

Interior view of Notsuoh, August 2011.

a trash-strewn flight of stairs to the building's safe, whose combination had been lost in 1948. "If you ever get that safe open," the previous owner said to him, "tell me what's in it."

When he bought the building in 1996, Pirtle hired a safecracker who worked unsuccessfully for five hours, went home frustrated, dreamed about the safe, returned in the morning and had it open ten minutes later. Inside was a bunch of old guns and forty ledger books that hadn't seen the light of day in a half century. Some of the papers still rest on the safe's shelves, but much of it is now dispersed around the building. A dusty, leather-bound ledger on the bar contains records of long-ago transactions in flowing, fountain pen script. Its frontispiece instructs employees not to refer to "colored" customers as "Mr." or "Mrs." or "Miss."

Later on, after the safecracking, Jim fell asleep and forgot to lock the front door. When a couple of regulars arrived to find the place deserted, they became concerned and called the police. The responding officers stumbled across the cache of guns and went upstairs to find Jim asleep surrounded by thousands of vintage ladies' shoes. He awoke to find a gun shoved in his face as the fuzz interrogated him about the mismatched tables and sofas that spilled out onto the sidewalk.

"Is it illegal to have furniture out on Main Street?" Jim asked.

"No," one cop responded. "But it's weird."

For better or for worse, Notsuoh preserves the weird, ragged scraps of the city's hidden history, even with its very name. From 1899 to 1915, Notsuoh (Houston spelled backward, in case you haven't already realized it) was an annual festival, trade show and masquerade ball that entertained and educated townsfolk and farmers who came from Nagadoches, Huntsville, Hempstead and Columbus to see livestock shows, farm tool demonstrations and a prototype art car parade with torch-lit, horse-drawn floats carrying "King Nottoc" (cotton spelled backward) at the lead. En elderly jazz musician once dropped by with a gift: an invitation to the first-ever Notsuoh ball, held in 1899. Today it hangs in a frame behind the bar.

Pirtle's friend Cameron Armstrong, a local architect with a longstanding interest in the city's site-specific works, calls Notsuoh "the ultimate site-level Duchampian move. Jim found an installation and declared it art, and it was." Indeed, it's a Duchampian ready-made. It also functions as a Beuysian social sculpture. One again thinks of conceptual artist Tom Marioni and his performance piece *Free Beer (The Act of Drinking Beer with Friends Is the Highest Form of Art)*, a salon and artist's club that he's presented on an occasional basis in museums, bars and private studios since 1970. The idea is simple:

Marioni and friends gather, throw back a few Pacificos and socialize. Notsuoh amplifies the concept in scope, scale and duration.

"There are three elements that make up the sculpture of this place," said Pirtle, breaking it down for me as we sat at a table by the sidewalk out front. "You have the phenomenal architecture of this incredible 1893 building. Then you have all the objects, which are not 'nostalgic' or 'retro' because they've never left the building; they'd have to be removed from here to become retro."

The third, of course, is the human element. The accumulated dross of the past decades acts, as he puts it, "as a kind of filter for the types of people who feel comfortable here." Those who are attracted to this diorama of cultural debris, he said,

> *are usually pretty damn interesting to talk to. You'll run into a homeless person. You'll run into an artist. You'll run into a NASA scientist. You'll run into the director of the Sydney opera. He hung out here for two weeks. You'll run into Robert Pattinson, from* Twilight. *You'll run into roughnecks. We had a guy in here last night who was on that oil rig that blew up in the Gulf; he was telling us about that night. You'll run into doctors that are recovering drug addicts. You'll run into oil CEOs, schoolteachers, street punks, hipsters. It's like coming into a world with all social classes, all the different sexual affiliations and races and everyone's filtered to be cool.*

"Notsuoh is a nexus where things come together in a good way," agreed Pirtle's longtime friend, the Art Guy Jack Massing. "Well, maybe not in a good way, but certainly in an *odd* way. It's one of those points on planet Earth where things are just allowed to happen."

Pirtle was born in Houston in December 1960 to a schoolteacher and an economist and grew up in a middle-class neighborhood near the Brae Burn Country Club. A self-described "class clown," he developed such a hatred of elementary school that he taught himself to vomit on cue. Each morning at the end of the recitation of the Pledge of Allegiance, the punch line "and liberty and justice for all" would invariably be followed by the sight and sound of young Jim puking into the nearest trashcan. While his classmates began their studies, Jim would head to the nurse's office and then on to his grandmother's house for popsicles. After losing thirty pounds, he was switched to a different classroom, which was palatable enough to quell the constant upchucking. But he continued to be the misfit kid and was voted

"most unusual" in his class. Later, his GPA would put him fifth in a class of almost eight hundred.

After high school, Pirtle enrolled at Baylor University in Waco, where he and like-minded others composed the NoZe Brotherhood, a quasi-fraternal Skull and Bones–type secret order that smoked pot and lampooned Baylor's conservative Baptist milieu with a barrage of pranks, performance pieces, programs on the campus radio station and a newspaper entitled the *Rope*. Strangely enough, the brotherhood's most famous member was none other than future Kentucky senator and Tea Party darling Rand Paul. "He was a 'brother' of mine," confirmed Pirtle, wincing and shaking his head. "I mean, I didn't vote for him. I thought he was a dick, but I went to Europe for a year, and while I was gone, they let him in."

A 2010 *Rolling Stone* article on Paul's involvement in the group paints NoZe as an equal-opportunity offender. The juiciest allegations involve Paul and another NoZe brother kidnapping a fellow swim team member in 1983, "forcing" her to consume numerous bong hits in a dorm room and then driving her to nearby creek. "They told me their god was 'Aqua Buddha' and that I needed to bow down and worship him," the woman told political reporter Matt Taibbi. But Taibbi was more appalled at politically incorrect *Rope* articles that poked fun at Latinos and African Americans. Articles were published without bylines since the group had become persona non grata at the university, having been thrown off campus for "making fun of the pope," as Pirtle told it. Under the threat of expulsion, brothers went about their business wearing disguises—"wigs, fake beards, nose glasses, thrift store clothes. That's when I began getting interested in thrift store stuff, actually."

"I was really good at planning and performing these elaborate happenings or interventions," remembered Pirtle. These "conceptual, fuck-with-people's-heads ideas" included constructing a large aerosol can atop one of the campus buildings and threatening to spray it and destroy the ozone layer if the group's demands weren't met. During one school parade, a small dead fish was hauled behind an eighteen-wheeler. Another year, NoZe drove a float featuring a headless John the Baptist statue that gushed a fountain of blood from its neck.

After grad school at the University of Texas, Pirtle found work as an orderly at the Austin State Hospital, where he spent his time "breaking up fights and collecting piss." Noting my raised eyebrow, he quickly explains, "To me, if you're going to be an artist, you've got to fill yourself up, know about life. I was more of an emotional artist, so I wanted to see people on the edge." His time in the mental ward led, naturally, to a decade as

a kindergarten teacher in Houston's public school system, where as Pirtle told it, he was the only "constant male figure in the lives of these kids of eighteen-year-old mothers in an all-black school."

He took solace in his double-life as an emerging painter and performance artist, with a particular penchant for polyester. Not only did he like to paint on polyester thrift store clothing, but he also wrapped his entire Sixth Ward house in the fabric, Christo style, and left it that way for two years. For the piece's debut, he fetched a pair of goats from the feed store up the road. He borrowed an enormous ladder and was delighted when the goats capered up it to the roof. How'd the neighbors like it? "They were all Hispanic," said Pirtle. "They all had chickens in their yards. They couldn't have cared less."

Pirtle retained his ability to vomit at will and put it to use in the development of a character named "Stu Mulligan," a dysfunctional hobo-cum-lounge-singer type specializing in cloying hits familiar from the AM radio of his childhood. "I had gotten really into polyester," Pirtle recalled, "and wore only polyester and started pursuing '70s music. And I thought, why don't I do Peter Frampton's 'Do You Feel Like I Do?' and then vomit at the end?" He'd consume huge quantities of mayonnaise and smear it on his face, invading the personal space of audience members during a heartfelt rendition of the Carpenters' "Close to You," ending in the regurgitation of said mayonnaise, finishing with the delicate placement of a cherry on top.

"People started expecting me to vomit," he said, "so I had to keep upping the ante, to make it more interesting." He'd croon a straightforward rendering of Bob Dylan's "Lay Lady Lay" to a chicken perched on a brass bed, swallow a dozen raw eggs and then puke them into a bowl, having medleyed neatly into "Blowin' in the Wind." Assistants fried the gooey mess into omelets and offered them to the audience. There were no takers.

"Okay, a lot of people thought it was about shock art," said Pirtle, stubbing out a cigarette and eyeing a man panhandling an adjoining table.

*But it was really about disgust and what's the nature of that emotion. It's about why we do drugs and become addicts, and why we overconsume food, we overconsume alcohol and we overconsume everything, because we're looking for something, some kind of pleasure, and it keeps going away. All the songs were from the early '70s from around the time you had your first kiss, and you're always trying to get back to that moment, where you first had that spark, that 'Wow!' and about gorging yourself to try and regain that. It wasn't shock art, it was about turning love into consumption.*

Pirtle had by then fallen in with the denizens of the Commerce Street Artists Warehouse (CSAW), a party-friendly environment with cheap studio rent, founded in 1985 by Lawndale Annex expatriates Wes Hicks and Kevin Cunningham. Among the first artists to rent space in the cavernous, twenty-seven-thousand-square-foot former Westinghouse motor manufacturing plant were Rick Lowe and Nestor Topchy.

The son of Ukrainian parents who'd been displaced to Somerville, New Jersey, Topchy was born in 1963 and grew up making pysanky, eggs decorated with intricate geometric patterns that carried mystical weight for his ancestors. Handing me one as we talked in his studio space one afternoon, he said, "This is an ancient art. As long as these eggs are made, evil is controlled, the monster is in chains. If the art dies out, the monster is set free, and it's curtains for us. What a great instructive metaphor for talking about art."

He was also an avid sketcher who, as a boy, crawled under his father's car with a ream of computer paper and made a detailed schematic drawing of its undercarriage. From 1981 to '85, he attended the Maryland Institute of Art in Baltimore ("pretty traditional painting and sculpture…it's good to have a thorough, straight-ahead training"). He chose the University of Houston for graduate school, thinking that he'd find a place where he "wouldn't be overstimulated" in the way he might have been in New York. He found that he didn't really like the program and wanted more autonomy in his studies, so he began designing his own courses and finished the three-year program in two years. "I was a bit obnoxious in those days," he admitted. "I was your typical arrogant twenty-one-year-old guy. I just wanted to do what I wanted to do when I wanted to do it. So I got that out of the way."

And he stayed in Houston. "It seems like I washed up on the beach," he said. As the seasons passed more or less indistinguishably, "I couldn't tell the time. Time got away. And every time I was about to leave, something would happen that was pleasant, that I wanted to follow up on. Like everyone, I complained about things, but if you can't do something wonderful here, it's because you haven't really tried."

Topchy had been living in his father's gas-guzzling 1973 Mercury Marquis station wagon in the U of H parking lot, so as soon as he set up his studio at CSAW, he moved right in. Without electricity or air-conditioning, the heat was stifling, and Topchy and Lowe spent their evenings gliding around the mostly empty downtown streetscape on inline skates, drinking until closing time at an ancient, candlelit (and supposedly haunted) saloon called La Carafe. Topchy would return to the warehouse and retire inside

a bedsheet cocoon to fend off mosquitoes. "The only way to sleep through that feeding frenzy was to get bollixed," he said. "It was a way of coping until the electricity got turned on."

He built out the walls for his own studio space within the CSAW compound and on its loading dock, a small yurt made from plastic sheeting and PVC pipe, having picked up a few tricks from a local architect named Guillermo Trotti, who worked as a consultant to NASA, helping to design the International Space Station from his workspace at U of H. "If you're a sculptor, you build," said Topchy. "A sculptor does what an engineer does, what a builder does. You don't differentiate that much. You just know how to build things."

Jim Pirtle started showing up at CSAW with a friend named Charlie. "They both had beards," remembered Topchy, "and at first we couldn't really tell them apart, so we just called them 'the guys with beards.'" Topchy hit it off with Pirtle and took him under his wing, subletting him some space in his studio cubby and offering advice as Jim learned to paint.

It was a heady atmosphere full of creativity, potential and fun. Topchy cut away the roof of his father's station wagon and welded the doors shut. He'd fill it with drunk young artists, and they would drive merrily through rush-hour traffic or roll up to gallery openings, causing disruptions as they went. It ran in early art car parades as the "Artogogh Gallery on Wheels," with artwork by the old masters decoupaged to the outside and a Calistoga wagon-type cover that Pirtle made from polyester shirts that would flap in the breeze.

In the studio, he continued to produce sculptural spheres, refining a concept that harkened back to the pysanky he'd made in his youth and that made manifest the concept of the "pregnant void" he'd appropriated from the work of one of his heroes, the French modern artist Yves Klein. Some spheres were actually decorated with geometric patterns like pysanky. Others were encrusted in vivid International Klein Blue pigment.

As the scale and scope of his work increased, Topchy grew more interested in making "art that didn't just take up space, that was purpose-driven in a way." Meanwhile, the rent had slowly edged higher as CSAW "began to be run more like a company," as he put it. "There was bullying going on, and a dystopian situation generally."

Topchy broke from CSAW in 1988 and founded a new arts commune, which he named Meaux's Bayou after his Bassett Lab. For $400 per month, he rented a former freight truck depot and chop shop at 5223 Feagan Street in Houston's West End, less than a half a mile from John Milkovisch's Beer

Can House. Lowe and Pirtle followed, as did a fourth artist, Dean Ruck, who had just completed a prestigious postgraduate residency as a Core Fellow at the Museum of Fine Arts, Houston's Glassell School of Art.

Beginning with a preexisting five-thousand-square-foot tin warehouse situated on a six-acre piece of property, Meaux's grew organically as Topchy added structure after enigmatic structure, until its improvised campus included a drive-in movie theater, a kitchen, a fountain constructed of beer bottles, a pavilion from whose ceiling dangled several of Topchy's sphere sculptures and offices and studios made from trailers and shipping crates. "Twelve people could live on a school bus," Pirtle marveled. "It had a café inside it, a kitchen. It had a rooftop we made into a stage, with drop movie screens. It was like a pirate community."

The kitchen was a fulcrum for the communal site, which was now being called "Zocalo" in reference to the immense public plaza in the heart of Mexico City. Topchy recycled a corrugated aluminum shed into a rooflet under which they installed a hand-me-down microwave and an old fridge, spray-painted silver. A glass door from a vacant downtown store became a picnic table. Topchy outfitted two rolling hospital gurneys with propane tanks and turned them into portable stovetops. "Everybody went there and cooked and fought over who was eating whose food," he remembered. "There were horses in the field next door, and they would come and stick their heads in the window like Mr. Ed, and people would feed them bagels."

There were plays and poetry readings, films and performance art, and Topchy described an atmosphere where almost anything could happen: "The night that Jason Nodler threatened to kill a raccoon because it had upstaged his performance of *Waiting for Godot*—now that was priceless." He remembered one occasion when Pirtle slithered across the stage, his face buried in a pizza box and his butt in the air. Topchy imitated the dignified voice of his friend, the famed playwright Edward Albee, who happened to be in attendance that night and excitedly asked Pirtle afterward, "Where did you study mime?"

No doubt about it—this was social sculpture, too. In fact, the complex was becoming more notorious for its parties and hungover Sunday brunches than for the art being produced. Even today, it seems to be something of a conflict for Topchy. On the one hand, when asked to identify Zocalo's biggest success, he cited its community. On the other hand, he seemed somewhat let down by a lack of responsibility among its populace that got in the way of more serious work. "From the get-go, the place was a nut magnet," he remarked, furrowing his bushy brow. "There were always

people there who had one foot on a banana peel."

For $1,000, Topchy bought a thirty-foot 1971 school bus that had most recently served as a transport vehicle for the Texas Department of Corrections, painted it pink and yellow, outfitted it with onboard gas generators and constructed a twenty-five- by seven-foot stage on its roof. The Zocalo Mobile Village was ready to roll, and in August 1995, Topchy, Pirtle and eight other Zocalo regulars stuffed the bus with bikes, tents, theater lights and public address speakers for a tour that would take them through New Orleans, Baltimore, New York City, Boston, Provincetown and

Jim Pirtle performs in a Zocalo stage show. *Photo by George Hixson.*

Raleigh. They were only a mile into the journey when they realized that the turn signals didn't work and the brakes were almost shot. But they did have a canoe and an American flag with which they hoped to restage Washington's crossing of the Delaware when they passed through D.C.

Each performance introduced the host city to the lunatic fringe of Houston's art scene. Prickly poet Malcolm McDonald acted as the revue's grouchy emcee, who set up one show by saying, "What you're about to see is so incoherent as to defy any sort of description." But you can be the judge. As the picante-swigging Stu Mulligan, Pirtle sang a medley of schmaltzy pop tunes and munched on bouquets of geraniums in between verses of "You Don't Bring Me Flowers." Meanwhile, donning the guise of his deliberately unfunny "Spunky the Anti-Clown" character, Topchy scaled a thirty-foot aluminum tripod supporting a giant canvas movie screen on which his grimacing, face-painted visage was projected. Their co-conspirator Roger Schoenbaum walked a tightrope, marched around on stilts and smashed watermelons, which participants and audience members ate off the ground.

"I see the bus as monumental," Topchy told writer Brad Tyer, who rode along to cover the tour for the *Houston Press*. "It's kind of like sculpture on wheels. I tend not to separate industrial objects from art objects, so the bus has all these weird connotations like school, church, Partridge Family, utilitarianism, all these concepts. So no matter what you do with it, it's going to be a loaded plate."

"We have two totally different working styles," Pirtle said of his longstanding relationship with Topchy. "Mine was always 'keep doing,' if you think of it, do it. And after a couple of years, you're like, 'What is all this about? What does it mean? It must add up to something.' For Topchy, the meaning comes first, then he does it. Define it first and then make objects that fit that definition. Neither style is better than the other. He's an incredible sculptor. I was more the idea man, the social man. I could come up with the crazy ideas, he could build 'em."

A stunt in late 1995 that left Pirtle with a broken back was a turning point. Following a Zocalo screening of Robert Altman's fanciful 1970 cult classic *Brewster McCloud* (in which a young Bud Cort stows away in the Astrodome and uses it as a laboratory in which to build and test a pair of wings), Pirtle scaled a ladder high over the crowd. "There was some Stephen Sondheim quote I read, 'You have to climb a ladder tall with your art, otherwise what's the point?' So I was on top of a ladder jumping into some cushions, and I missed. Just did a preacher's seat on the concrete." Laid up in the hospital and out of the classroom, a funny thing happened. "I realized I was getting happy. And that not going to that job was cool. So I decided I'm not going to do this anymore. I realized my well being was more important than this job."

At this point, even life at Zocalo had worn thin, thanks to bickering and "control issues" among some of the artists. Ironically, the space was thriving; Topchy had formed a nonprofit organization that formalized his concept and attracted legions of young artists. But Zocalo's first wave was checking out. Dean Ruck bought a house and began creating large-scale, site-specific work out of abandoned houses with fellow sculptor Dan Havel. Rick Lowe threw all of his attention and energy into developing Project Row Houses and had departed by 1997.

Even Topchy was happy enough to loosen his grip on the space. He'd met his wife-to-be, Mariana, and decamped to Asia for a year. Upon his return, he'd revise his concept, renaming the site "TemplO," the capital O representing the "pregnant void" that had consumed his vision. The site would reach its crescendo when Topchy constructed a five-story pagoda

from triangulated electrical conduit pipe, light but strong, resulting in a spidery, skeletal, "tantric Buddhist temple" that kindled his latent interest in sacred geometry. It was completed just in time to be dismantled after the landlord (who happened to be Harris County district attorney Johnny Holmes) decided to sell off the increasingly valuable property in March 2001. "I learned something important," he says now. "Don't build anything you're not prepared to take apart." The once wild neighborhood is now, as Topchy described it, "a congealed array of McMansions."

After his back mended, Pirtle began spending most of his time staring at the chessboard at a Westheimer Road coffee shop called Brasil. Eventually, said Pirtle, "Dan, the owner, said, 'No more chess.' It was me and a bunch of AA-ers playing chess and just sitting there, drinking one cup of coffee, and he wanted to turn tables over. So I thought, 'Hey, I'm quitting my job, I'm tired of the artists I'm working with and I just want to sit and play chess and drink coffee. So why don't I check out some property?'"

In October, Pirtle married Missy Bosch, a young sculptor he'd met a few years earlier when as a volunteer at the local art space DiverseWorks, she'd helped him set up for a performance. She moved in while Jim was laid up to help take care of him and his pets; somewhere along the way, they started researching the history of Jim's house in the Sixth Ward and of Houston in general. They drove around the downtown area and marveled at the magnificent architecture that stood disused and boarded up. "We already owned our house," said Bosch, "so we started thinking, well, how much more expensive could one of these buildings be? We just felt sad that everything was so run-down."

They discovered 314 Main in 1996, when "there was absolutely nothing down here but closed-down porno houses, closed-down pawnshops," remembered Pirtle. In fact, practically the only thing still open was the bar next door. "It was kind of a Mexican transvestite bar," he said, "run by a Korean. Yeah, it was a weird scene. You'd always see these high-heeled Mexican transvestites and then a lot of crackheads. But everybody got along."

The first order of business was to break in and have a look-see. A locksmith helped him get through the heavy chains across the north entrance. To admit himself to the adjoining storefront to the south, Pirtle kicked a hole in the wall. "Then we came up to the second floor, and it was just…solid shoes. Just rows and rows of shoes. And we were like, whoa! And guitar cases. About 150 guitar cases all stacked up. Just fucking crazy!"

There were ten thousand pairs of women's shoes, fifteen thousand coat hangers and the entire stock of the pawnshop that had closed down. "He

wasn't a very good pawn dealer," said Pirtle, "so there was all the stuff he never sold, plus all the window dressings. The Jewish man who owned the building since the '40s, he never threw anything away, so there was all this stuff for a retail store, for selling shoes and clothes, the window dressings, Christmas designs. And I'm like, 'I want to own this and live here.'"

Through the building's tax records, he tracked down the owner in New York, called him up and worked out a deal. He and Missy pooled their resources, and for $20,000, they bought the deed to the building. There was also the matter of a $75,000 tax debt from the previous owner. "But I figured, they're not going to foreclose because nobody else would bid on it. I mean, this was totally irrelevant property. So I thought I could just sit on it, and if the neighborhood ever started to come back, I could get a loan and take care of the back taxes. Sure enough, it bounced back, and sure enough, I took care of it."

As soon as the deed was theirs, said Pirtle, he and Missy started inviting friends over, and Notsuoh was open for business. They fired up the coffeepot they'd received as a wedding gift and began charging friends ten dollars apiece for membership cards inscribed with names from the old ledger books. "We had a chessboard out, and a ping-pong table and a couple of twelve-packs in a fridge. And all of the sudden it became this bar! I didn't even drink that much," he laughed. The building was inspected and coded out, "and it became this hangout."

"We served coffee through bulletproof glass," he remembered. "It was just absurd. We had these Frankenstein light bulbs from the '30s. We had reel-to-reel players and an old record player. We played only the records that were here in the building. Before I started bringing things here from the warehouse at Zocalo, it was just all the original stuff from the building, other than the coffeepot. It was just so charming and weird."

People continued to arrive with items to pawn until the city demanded that Pirtle remove a large sign offering "Money to Loan," accusing him of "willfully misleading the public." ("I'm an artist," he quipped. "That's what I've been doing for my whole life.")

Notsuoh began staying open twenty-four hours a day after Jim and Missy lost the key to the front door; some customers would hang around for eight-, ten- or twelve-hour stretches. They eventually changed the lock, but the space continued to stay open all night, 6:00 p.m. to 6:00 a.m. It was a place to drink and play chess, yes, but it also became a venue for Pirtle's friends to scratch their own idiosyncratic artistic itches. Richie Hubscher, a refugee from the Houston Ballet, used the second floor as the home of Easy Credit

Theatre, staging edgy dance productions with his own ragtag troupe. Mike McGuire, a poet and guerrilla radio man, organized a Wednesday night open-mic poetry series that's still ongoing. There were avant-garde puppet shows by Joel Orr's Bobbindoctrin Theater and lots of music, including a record release party by local legends Culturcide and a twenty-four-hour set by Houston's antiauthoritarian brass band Free Radicals.

In 1999, the Art Guys turned a tiny broom closet under the stairs into the "Mop Tsu Oh Art Center," designated as such by a stately brass plaque on the door ("Open 24 hours or by appointment. No food or drink. Dress code strictly enforced.") They issued a press release noting that the twelve-square-foot utility room had become "reknowned [*sic*] worldwide for its innovative exhibitions and cleaning utensils," presenting "a distinctive and distinguished array of artists, performers and detergents" ranging from a display of photos snapped on an Instamatic by a friend's four-year-old to a major retrospective of more than three decades of work by the important Fluxus artist Ken Friedman.

Jim even began to make some money. When Camel cigarettes attempted to force a monopoly by paying off Houston bars to sell its brand exclusively, Notsuoh made a point of stocking a wide range of smokes and installed an ATM machine, two maneuvers that attracted a steady flow of customers.

Jim and Missy's daughter, Martha, was born in 1997, and Jim went about his business at Notsuoh with a baby tucked under his arm. Some appreciated this as a tender expression of fatherliness. As Martha grew from infant to toddler, others admit that they felt uneasy as they watched her romping in a dirty nightgown among homeless drop-ins into the wee hours of the morning, and at least once a patron complained to Child Protective Services. "America, land of the free," Jim railed to Lauren Kern of the *Houston Press* shortly after the incident. "Freedom is scarier than shit to people. When they see Martha [awake] at 2 AM, they know we're not leading a nine to five, and her freedom and my freedom is threatening to them."

Yes, it was all very strange and creative and a lot of fun to visit, but by 2000, after living there full-time for about four years, Missy decided that she'd had enough. "It was a pretty hard environment to be in, pretty unstructured," she said. "I got kind of claustrophobic there, staying up all night and sleeping all day. Then, having a kid and being even more stuck at home." Partygoers on the second floor would routinely drift up to Jim and Missy's living space on the third floor and disturb her privacy. "There was always something, right?" she sighed. "You know, like, we're never going to finish that bathroom, are we? So I'm leaving."

Then, in 2002, in the midst of an exhibition marathon titled *52 artists 52 weeks* came a flashpoint, both literal and figurative. On the night of June 12, a fire broke out in the apartment above Notsuoh. "I was smoking a cigarette and fell asleep," Pirtle admitted sheepishly, "and I woke up naked and in flames." He grabbed a painting off the wall, wrapped himself with the canvas and ran outside. Pirtle watched the fire trucks arrive as he sat in a lawn chair in the middle of Main Street, still wearing only the painting. After firefighters extinguished the blaze, they called in city inspectors, who were appalled by the hazard they found. In a news item about the incident in the *Houston Press*, Pirtle remarked, "Apparently we're like a new textbook case for screwing up."

The damage was fairly extensive, and the initial plan was to get a loan, remodel, obtain a liquor license and operate a more professional establishment. But business had been in a slump. Pirtle decided to rent out the downstairs while he continued living in the loft and to, as he put it, "just collect the money and not do anything."

He'd already leased the southern storefront to a bar and clothing boutique that took its name from the sign above the door, "Dean's Credit Clothing." Beginning in 2003, the same owners booked live music as they expanded into the space that had been Notsuoh, likewise renamed Clark's after one of the building's previous tenants, Clark's Jewelry & Clothing, whose giant metal sign was found upstairs and remounted on the exterior façade.

Pirtle kept a low profile, although in January 2006, he dusted off his junk, as well as artwork gifted to him by friends such as Lowe, Ruck, Giles Lyon, Carter Ernst, Paul Kittelson and many others, for a semiprivate second-floor show that he dubbed *Never Give Your Art to a Slob*. Topchy entertained attendees by long-jumping a pile of debris as the Ukrainian national anthem blared in the background, and Pirtle went around telling people that he was going to rent the remaining floors for office space and move to Bulgaria. But when 2007 arrived, he was still ensconced in the Kiam, and Clark's gave up its lease due to sluggish business. What was there to do but reopen Notsuoh? Now there was a liquor license, a more professional AV system left over from Clark's and, with the bulletproof glass gone, a "proper" bar.

In September 2008, Pirtle packed up a selection of his shoes, records, coat hangers, ledgers, artwork, a chess set and two vials (one marked "tears" and the other "snot") and drove the items 1,600 miles to New York City to recreate Notsuoh for an exhibit curated by the Art Guys at the Cue Art Foundation in Chelsea. Photographs of regular patrons were taped to the floor, and gallery visitors were encouraged to treat the installation as if they

were inside the bar itself, lounging on the vintage furniture among half-empty cans and bottles of Budweiser and Negro Modelo.

Jack Massing, Nestor Topchy, Richie Hubscher, Rick Lowe and other members of Pirtle's inner circle were all on hand for the opening, and Stu Mulligan obligingly smeared his face with mayonnaise and crooned for the multitude. A year later, Pirtle and Notsuoh were represented by a similar simulacrum at the CAMH's *No Zoning* exhibit, including plexiglass display cases containing Miracle Whip, picante sauce and half-empty bottles of liquor. It was an unexpected (or perhaps totally inevitable) signification of the space's importance and now legendary status.

"For the people who were around when I opened the place, they all think, 'Eh, it's just not the same,'" said Pirtle. "And yeah, it's not the same place it was in 1996. But for these twenty-one-year-old kids here tonight, they're like, 'Wow, look what someone can do. Look at the creativity someone can put into a place.'" To the jaded hipsters who frequented Notsuoh 1.0, he says, "Hey, you've had your moment, but don't deny them. People in here tonight who are twenty-two were five years old when I started this." Then, pausing and watching one of his bartenders come out to hassle some loitering teens, he added, "Maybe it is time to move on."

It certainly hasn't all been smooth sailing lately. On February 22, 2009, a visitor named Nathan Fisher got hopelessly wasted and, in the wee hours of the morning, fell from a second-story window to the pavement below, where he was discovered lying in a pool of blood. Nobody is sure exactly what happened, but in the aftermath of the accident, Pirtle was devastated, telling friends that he wasn't sure he'd even keep the space open. In a MySpace blog post shortly after the incident, he wrote, "I don't want to do this anymore. I just want to wear a jumpsuit and have a metal detector and walk along the beach mumbling to myself and getting excited about finding a lost Timex that keeps on ticking."

Fisher survived and predictably filed suit against Pirtle and Bosch as the building's owners, as well as the limited liability companies that control Notsuoh and its neighbor, Dean's Credit Clothing, alleging that both bars continued to serve him past the point where he'd become a danger to himself and others. For his pain and suffering, as well as a range of personal care needs from medicine to a maid and a gardener, Fisher's attorney, Donna Roth, demanded $12 million (and forty-seven cents). Pirtle and Bosch finally met their accuser in court in December 2011, and after several days of testimony, a jury found in their favor.

"My art is about memory," Pirtle told me as the summer sun set on Main Street. "Houston tears down things. It's hard to have memory in this place,

and architecture is what binds us to past generations. And we lose a lot of those bonds with our community because we keep tearing these things down. So, part of the mission of owning this building downtown was that I could keep it from being torn down to some surface lot, that there would be some civic memory preserved."

In that sense, mission accomplished. But what about the shoes?

> *People go up there and say, "Wow, you could sell these and make all this money on eBay," but then you'd just have an empty room, and you wouldn't have the memory. You know, people come back after twelve years and say, "There are those shoes." It creates a kind of a consistency that you can count on, and Houston lacks that. You feel afraid to fall in love with places because people are going to rip them out from under you. There's sort of a resistance where you can't really give in. And Notsuoh is about creating a place where you can give in, where you can fall in love and where it isn't going to leave you.*

However, just moments later, a man approached to confirm a meeting at ten o'clock the next morning. Somebody wants to buy the building. Pirtle is asking for $1.5 million. "That's a weird thought for me," he said. "If the building is bought, it'll be cleaned out—all the things gone. And decontextualized from this place, they'll have no meaning anymore. It'll just be a bunch of dusty stuff, and the place will be nothing more than a memory."

It's not the first time Pirtle has considered selling the joint. In November 2008, Pirtle posted a message on his MySpace page that he'd fielded an offer from an investment banker to buy the building for $2.8 million. Then, in April 2009, the *Press* reported the building's sale for an unspecified but "ungodly" sum to Tom Wilson, the owner of a chain of local bars, as if it were a done deal. But in both cases, Notsuoh just kept on ticking. "Real estate is very tricky," Pirtle told the *Press* when it attempted to follow up on the story. "And what you write today may end up being wrong tomorrow... so be careful." When I stopped in again a week or two later, I asked Pirtle about his latest offer. "Nah, that's not happening," he said offhandedly and with a shrug. "Economy's bad."

Chapter 6

# A VISION FOR THE FUTURE

It's Sunday, September 25, 2011, and the twenty-fifth-anniversary edition of the Orange Show's Eyeopener Tour is about ready to roll. I climb aboard one of the two enormous Sierra Trailways buses choking off Munger Street, settle into my plush upholstered seat and divide my attention between the can of beer and the program I've just been handed. "Eyeopener Tours reveal and share the work of self-taught artists and the folk traditions of our culturally rich communities," explains the brochure. "The tours are unlike any you've ever taken. You will discover the extraordinary among the mundane, the whimsical among the commonplace."

On our bus, Barbara and Marks Hinton lead the tour, donning sunglasses and visors and calling out landmarks through a PA system from the seat immediately behind the driver. "The Eyeopener Tours began when Orange Show volunteers, the executive director and artists got together and started scouring the city to find interesting places," Barbara explains to our group, "and over these twenty-five years, we've expanded that concept to include lots of culturally rich facets of our community. We've visited more than sixty different sacred spaces. We've visited artists' studios, art collectors, cemeteries, international markets, all sorts of different tours." The Eyeopener crews have also traveled all over the continent, including weekend folk art and architecture safaris to the Carolinas, Wisconsin and Mexico under the leadership of aficionados like Larry Harris and Tom LaFaver. "Today's tour is sort of a 'best of,'" Barbara remarks, "with a few little drivebys that I think you'll find interesting."

Cleveland Turner welcomes Eyeopener Tour guests, September 2011.

We roll by the elaborate sculpture garden of attorney and art collector Tim Hootman at the corner of Pierce and Dowling on our way to our first stop: the Flower Man's House. We pull over in front of the park beside his property, and as if on cue, Cleveland Turner comes riding up on his flower-laden bike. Today he's dressed to the nines with a dark pinstriped suit and silk tie, like he's pedaled out of the pages of *GQ*. In fact, he's just returning from church. He steps up onto the air-conditioned bus to take the microphone and give his standard rap ("Y'all know what the skid row is?") before gamely allowing a procession of at least fifty people to traipse through his cluttered yard and house and ask such questions as, "What are your chickens' names?"

"Huh?" he responds, cracking a sparkling gold smile and looking sympathetically at the woman who'd asked, as though she might be crazy. "You name your chickens?" Another visitor wants to have his picture taken with the Flower Man. As they drape arms around each other and a camera clicks, Cleveland says to me with a wink, "This is what you call your salt and pepper shot, right here."

Driving out of the Third Ward and onto the Southern Freeway, we move toward our next destination, a Crown Plaza Hotel near the aging, unoccupied Astrodome and its neighboring offspring, Reliant Stadium.

Back when the first Eyeopener Tour visited in 1986, the Astros still played in the Dome, and the Plaza's ninth floor was still active as the Celestial Suites at the Astro Village Hotel, a thirteen-room fantasyland designed for Houston's flamboyant ex-mayor and ballclub owner Roy Hofheinz by Harper Goff, the Academy Award–winning art director of the 1954 Disney picture *20,000 Leagues Under the Sea*, to the tune of more than $1 million.

Born in 1912, Hofheinz became a lawyer at the tender age of nineteen, a state legislator by the time he was twenty-two and a county judge when he was just twenty-four. He was an FM radio pioneer and made his fortune recycling steelmaking byproducts into road building aggregate, but he was a politician at heart. He was Houston's mayor from 1953 to 1955, and he served as Lyndon Johnson's campaign manager when LBJ ran for Congress and Senate.

Hofheinz's Celestial Suites were reserved for the exclusive use of the judge and his fanciest friends. After all, when Michael Jackson, Richard Nixon, Muhammad Ali, Elvis Presley or Johnny Cash came to Houston, you obviously needed to put them up in a place like the jungle-themed Adventure Suite or the circus-themed P.T. Barnum Suite, with its bed made from an antique bandwagon.

The suites have been closed to the public for more than twenty years, and we're only allowed in by special arrangement with the judge's son, Fred, an attorney, and a former mayor of Houston himself. It's a sticky visit, as the hotel no longer runs the air conditioning on this disused level. Time has truly stood still in this opulent fantasyland, high in the sky over Houston, where the stately and the tacky are just steps away from each other, or blurred together. The library, modeled after the royal palace in Madrid, is stacked high with dusty clothbound *Reader's Digest* anthologies and accented with delicate stained glass. Down the hall there's a bedroom with South Pacific tiki-style décor, complete with bamboo, rush hut and mosquito netting. Designer Goff once said in an interview, "When hoity-toity people came in and whispered about the bad taste, [Hofheinz] loved it." Art Buchwald took a different tack in the *Wall Street Journal*: "I've stayed in some pretty good places, but nothing quite so ridiculous as that joint. It's the perfect place for an orgy."

We descend back down the elevator (just six or seven at a time, please) and climb back on the bus. After another clockwise quarter turn around the city on the 610 loop, we headed east on Memorial Drive, straight for the Beer Can House. We happen to have the world's preeminent authority on the house with us, and Marks Hinton gives a succinct and entertaining overview as somewhere above John Milkovisch stirs up a stiff breeze out of

Marks Hinton addresses Eyeopener Tour guests at the Beer Can House, September 2011.

absolutely nowhere that sets his can top curtains a-tinkling. The place looks great, and other visitors arrive, mingle with our group and move on. I have just enough time left to buy for my wife a pair of bottle cap earrings made by Ronnie Milkovisch before Barbara is shepherding me back to the bus so we can keep on schedule.

Next we drive a bit north of town on Interstate 59 to look at a site only recently discovered by veteran folk art bird dog Larry Harris. Just off the highway, we find the home of retired welder and former deacon Isaac Long, who's filled his yard with hand-painted, multicolored signs both big and small that offer Biblical verse and other didactic messages of salvation ("Try Jesus / he will help you make it / he is faithful"). As we all pour out of the bus, Long ambles from his house, a seventy-something black man skinny as a rail and clad in jeans, a denim vest, a ten-gallon hat and large aviator glasses with yellow lenses.

Looking slightly star-struck at the assembled mob, the soft-spoken man can barely be heard over the whizzing traffic about one hundred feet away. He began putting up these signs back in the '90s, he tells us, when he noticed neighborhood kids regularly getting high in the vacant lot

Isaac Long with Eyeopener Tour guests, September 2011.

between his house and the school. "I don't think I'm going to stop them from doing what they're doing," he drawled, "but at least I can give them something to think about."

Our next stop is the Menil Collection, its main building exquisitely designed by the Italian architect Renzo Piano. Toby Kamps, who's been its curator of modern and contemporary art since he left the CAMH in 2010, meets us at the door and guides us through an exhibit they've just hung up of visionary drawings acquired by John and Dominique de Menil over the decades. The show also includes several pieces borrowed from the collection of Orange Show board member Stephanie Smither, who happens to be with us on the tour. Among the de Menils' primary interests were the Surrealists, "art brut" and various strains of native and tribal art from around the world, so it's really no surprise that Dominique gave money to save the Orange Show upon Jeff McKissack's death and visited and supported Bob "Fan Man" Harper.

"This is somebody who has no formal training," says Kamps, asked by Barbara Hinton to define for the group the "visionary" artist, "the kind of artist who is unselfconscious about his craft, working in isolation, and

compelled by an inner vision." Assembled by Curator Michelle White, Seeing Stars: Visionary Drawing from the Collection is a remarkable overview of a century's worth of outsider artists. Upon entering the gallery, we come face to face with a double-sided collage on a long sheet of butcher paper by Henry Darger, a Chicago janitor who created a multivolume history of the Vivian Girls, a troupe of heroic young sisters who battled to free enslaved children from a quasi-Confederate army. After a lifetime of furtive work, Darger's bulging, hand-illustrated scrapbooks were discovered by his landlords as he lay on his hospital deathbed. Some individual pages have made their way into private collections around the world, but the bulk of his work (as well as a restaging of the contents of his tiny studio apartment) now resides in Chicago at Intuit: the Center for Intuitive and Outsider Art.

There are dynamic scenes involving animals and people by Bill Traylor, a man born into slavery who began making art in the 1930s at age eighty-five, his studio a rickety table pushed against a Coca-Cola cooler on a busy sidewalk in Montgomery, Alabama. There are early sketches made by Jackson Pollock under psychotherapy years before he became the famous action painter, as well as pieces by Unica Zurn, a prolific German Surrealist writer who produced detailed pen-and-ink drawings while institutionalized. She frequently tore them apart during hysterical fits, and her husband, the Dada artist Hans Bellmer, would gather the scraps and piece them back together.

There are drawings that once hung in the Prison Art Gallery in Huntsville, north of Houston, including symbolic jail yard landscapes that crackle with energy, rendered with stubs of red and blue accountant's pencils by Frank Jones, imprisoned for murder from 1964 until his death in 1969, and wild, outer-space scenes dreamt up by Henry Ray Clark, or the "Magnificent Pretty Boy," as he liked to call himself. First incarcerated in 1977 at the age of forty-one for assault with a deadly weapon, he took an art class for inmates and began covering every inch of the manila envelopes that held his legal papers with wild geometric patterns and cosmic themes in multicolored ballpoint ink. "I am the creator from the planet Birdbeam," reads one. "The royal jewels of my planet Garza," reads another.

Perhaps most intriguing of all, the show features work from the scrapbook albums of turn-of-the-century Houstonian Charles A.A. Dellschau, who after retiring from his career as a butcher and a saddle salesman became one of America's earliest-known outsider artists. On display is an album from 1911 ("Back when this town was just a flyspeck," Kamps points out), filled with coded stories and detailed drawings of fanciful flying machines, outlining the purported history of the Sonora Aero Club. At least in Dellschau's mind,

the club roamed the skies of Gold Rush–era Northern California, led by the heroic Peter Mennis, pilot of the *Aero Goose* and inventor of a magical substance called "suppe," which powered the contraptions and reversed the forces of gravity. When Mennis died in the 1860s, his secret formula died with him, and the club disbanded—or so Dellschau tells the tale in a German/English hybrid laced with misspellings.

Dellschau's life was plagued with tragedy (his wife and children all predeceased him), and he himself died in Houston in 1923. But he left behind a two-hundred-page journal and five thousand ink-and-watercolor drawings created over some twenty years. After his death, they were relegated to the attic of an in-law's house until the 1960s, when a nurse's aide purged its contents, tossing everything out on the curb. A trash man at the dump set aside Dellschau's scrapbooks and sold them to a junk dealer for $100. They lay for several years under a tarp at the OK Trading Center on Washington Avenue until being discovered in 1968 by Mary Jane Victor, a student at the University of St. Thomas who was working for Dominique de Menil. She told Dominique about her find, and the maverick arts patron bought four of the earliest books for $1,500. All four still reside at the Menil, but individual leaves cut from later books have sold for as much as $15,000.

After the presentation, Kamps encourages us to stroll through the museum's permanent Surrealism gallery just down the hall, generously stocked with Magrittes, Ernsts, Schwitterses and Cornells, canvases, photographs and sculptures that poke and prod at the conscious and subconscious mind in ways not dissimilar from the works of the self-taught visionary artists they themselves sought out and admired. There's an entire room entitled "Witnesses to a Surrealist Vision" that's filled floor to ceiling with small objects—shells and masks and tribal figurines that the Surrealists collected and were inspired by. It's easy to imagine the Surrealists being drawn to the Orange Show and the Flower Man's House or sipping wine while pontificating over the chessboard at Notsuoh.

Everyone enjoys an orange-frosted birthday cupcake as the bus makes its way back to Munger Street. We pull up to the long, skinny lot north of the monument, vacant as long as anyone in the neighborhood can remember. It's now the site of the emerging Smither Park, an outdoor playground and gathering area inspired by Houston's tradition of self-taught visionary art. Barbara Hinton hands the microphone to Stephanie Smither, seated across the aisle from her up front.

"Smither Park was started in memory of my husband," she says, "and it's going to be a memory park for all of Houston." The man in charge of

the park's design is Dan Phillips, a self-taught builder who works almost exclusively with cast-off and recycled materials in the tiny town of Huntsville, just north of the city. He's designed and built fourteen whimsical houses out of bones, wine bottle butts and reclaimed wood that have transformed not only the materials from which the homes are made but also the very lives of their occupants, and his floor-to-ceiling cork and bottle cap mosaic for the Waste Management Center in downtown Houston is truly a masterpiece.

By far, Smither Park will be Phillips's biggest canvas to date, and the people at the Orange Show expect it to be a major tourist attraction. Smither ticks off the key components that will compose the park. There's the memory wall, already under progress, which will become completely encrusted with marbles, keys, chipped pottery and other materials by a team of volunteer artists. Later, the plan allows for such features as a grotto amphitheater, a meditation garden, a series of riddles encoded into various surfaces of the park's structure and a playful coin-drop apparatus on which quarters will ride down a kinetic sculpture and into the Orange Show's coffers.

It's a pretty hot day, so even though the Orange Show itself is on our itinerary, most of my fellow riders have quickly dispersed before making it inside, and Barbara and Marks call it a day. It's too bad, as despite the structural wear, the shrine has never looked better cosmetically. A few of us walk inside and enjoy a rote, five-minute overview by an enthusiastic young volunteer. I can't help but stay and look around a bit, walking up to each of the amphitheater's individual boxes and overlooks. If you want to see them all, you have to go in turn by different routes because they don't really connect. *Houston Chronicle* writer Ann Holmes called them "Elizabethan" in an article published shortly after Jeff's death, and it is funny to think about the monument in those terms when you're looking down at the absurd steel steamboat, run aground along its little circular model of the Chattahoochee's turn-of-the-century ports of call. In the same old newspaper clipping ("What's Next? Move Afoot to Save Houston's Wacky Example of Naïve Art"), Holmes called McKissack the "Don Quixote of Munger Street," which seems just about right.

I've been here no fewer than a half dozen times lately, spending hours walking around and studying the place in detail, but as always, my attention falls on something I've never noticed before. It's a bizarre little twelve- by thirty-six-inch mosaic ledge, hidden almost entirely from view below a back staircase that takes you up to the upper boiler rooftop. Unlike the balanced geometric patterns McKissack usually favored, it's a busy, seemingly random assortment of left-over square tiles to its upper edge, broken grids of chocolate brown,

mint green, pale pink and sky blue, with irregular rows of heart-shaped tiles below in powder and slate blues. Five dark, oblong tiles to the left look almost like fish schooling together in the sea. It's a delicious abstraction and a minor masterpiece that almost nobody will ever really notice.

The Orange Show and the Beer Can House—precariously preserved in their advancing years. Cleveland Turner—seventy-seven years young and hanging in there. Bob Harper's Third World, Ida Kingsbury's yard full of "friends," Howard Porter's OK Corral and Nestor Topchy's Zocalo—all just a memory. Pigdom—shabby, empty, in foreclosure. Notsuoh—still weird and still open, at least until the right bidder comes along and Jim Pirtle heads to the beach with his metal detector or, like Duchamp, retires from making art to play chess. But what about the future of visionary environmental art in Houston? What lessons have been learned from McKissack and Milkovisch, and how do they apply in the twenty-first century? What comes next?

With his master's degree in sculpture and an unquenchable thirst for knowledge that has led him to the formal study of calligraphy, judo and "sacred geometry," Nestor Topchy is hardly a naïve, self-trained artist, and even if his Zocalo/TemplO provided the local arts community a place to let its hair down, he's too firmly established within the goings-on of the Houston art scene to be thought of as an outsider. But it'd be hard to argue that he's not a visionary. To wit: at the moment, he's preparing for the biggest, most high-profile work of his career, one that will do nothing less than invite Houstonians to reexamine the way they live. It'll be constructed mostly from metal shipping containers.

"I don't care about shipping containers," Topchy said as he puts on a kettle for tea inside his studio. "I care about what they can do. And that's a huge distinction, from a materialistic focus, and transcending that, for social and spiritual gains." He started thinking about shipping containers in the '80s, noticing them stacked ten high on barges coming up Houston's ship channel. In a country with a serious trade imbalance, more containers were coming in than going back out, and the units had become plentiful and inexpensive, so he used a few of them at Zocalo as artists' studios. Now he plans to employ 486 containers as the basic building blocks of *Hive*, an inhabitable work of sustainable social sculpture that will affordably house artists, writers, researchers, clinics and businesses while growing its own food, generating its own power and filtering the murky waters of Buffalo Bayou. The proposed site lies to the north of the city's East End, accessible via the citywide bike trail and a light-rail metro line currently under construction.

Looking at a drawing of the proposed site, its title makes perfect sense. A square perimeter wall of containers stacked three high surrounds a massive cylindrical structure of staggered units linked by a gently sloping walkway (think of the coiling construction of the Guggenheim, for example). In the center, its bottom is open to the ground, or possibly a pool of water. Its top is open to the sky. Only bicyclers and pedestrian traffic will be allowed inside the walls. The tiny humans shown in the drawing are the busy bees buzzing around the hive, making up a whole that's something greater than its component parts. The built environment and nature, form and function, harmoniously integrated. It's simple and beautiful in its geometric grace and looks every bit like the city of the future. Topchy has a particular preoccupation with geometry, and he's the only person I've met lately who offhandedly refers to himself as a Pythagorean in casual conversation.

"Everything I do comes from the same geometry," he said, and Topchy's geometry comes from, as he explained it, "the pregnant void, to a point, to a swollen point, which is the sphere." Then, from point to point, you get a line and, eventually, the conjunction of circles and lines. He showed me an intricate piece of graph paper, in which petalled flower shapes are superimposed over a more standard grid. The more I looked at it, the more it began to play tricks on my eyes, which constantly recontextualized the lines and curves into all manner of little shapes. Turns out, Topchy's already been eagerly mapping them. The next paper showed a collection of tiny cutaways from the grid, shaded with colored pencil and titled with opaque paint marker.

"If you and I and twenty other people look at this one, we might all say it's a gem or a diamond. So this shape, I call it a 'deme,' which is like a 'meme,' but its visual. And if I use it in conjunction with an image, I call it a 'demicon.' It's a shape, it's specific." The grid, which he calls his 'demigraphia,' yields an almost infinite supply of demicons. Fox. Muffin. Sad dog. Rabbit. Kite. Man-o-war. Music book. Sail. Buddha. Topchy's been working on a survey that will help him better understand what to call his demes.

"All of the design principles are born out of geometry," he said of his art. "Whether it's a drawing, the shape of these paintings or the sculpture texture, it all comes from the mother source, the intersection of spheres." My mind started to wander, considering the repeated geometric patterns of John Milkovisch's Beer Can House and then contrasting them with the chaos of the Flower Man's House. And what about Zocalo? On the one hand, it was a seemingly haphazard collection of industrial scraps jury-rigged to a truck-washing station and a chop shop barn. But then there was the temple itself, perfect in its structural geometry.

"I hadn't planned on doing something like that again," said Topchy, thinking back to the last days of TemplO in 2001, just before the creep of gentrification made the property too valuable for his landlord to keep. And yet "not enough people really did get to experience it once it finally reached a critical mass of being a distinct thing, that had a distinct identity that really looked like something. I'm glad things worked out the way they did, but I also know that if it had continued for five more years, ten more years, it would have had a better run, more people would have gotten something from it." Pouring me a cup of chai, he paused and added, "I think after something craters like that, after all that work, it takes time to recover."

After losing the lease on TemplO, Nestor and Mariana found a new place on the north side of town to settle into and raise their daughter, Minerva. Topchy built a studio out back, planted some fruit trees, dug a huge pond and ringed it with small buildings made from corrugated metal ("sculpturtecture" he calls it). The most ambitious project in his yard so far is still in progress, a sixty-three- by twenty-five-foot greenhouse-like structure with twenty-five-foot ceilings made largely out of welded-together cast-off warehouse windows.

In 2004, Rick Lowe invited Topchy to participate in an annual arts festival presented by Project Row Houses. His contribution, in collaboration with architect Cameron Armstrong and Art Guy Jack Massing, was entitled *Seed*: a single shipping container that housed a collection of mockups of such units repurposed to serve as inhabitable, functional spaces. A school. A jail. A hospital. An apartment.

After the installation of *Seed*, Topchy began thinking about a raft of unrealized plans for increased interactivity between the TemplO nonprofit and local architecture programs, as well as other community groups. He made sketches of a more elaborate environment built from containers and then a little maquette out of brightly colored wood blocks stacked in a circular pattern. The sculptor puzzled over matters of scale, proportion and purpose and showed his plans to architects he knew, including Armstrong. He pointed out to Topchy that one can tilt a floor by a degree or two virtually imperceptibly and sketched out a diagram on a placemat as they ate lunch at a Vietnamese restaurant. "Contractors get away with this all the time," said Armstrong. "If you tilt these containers by a degree or a half, the last container in the circle would be high enough in the air to go over the first one. You just have to shorten the radius by a couple of inches with each container. That was really the beginning and the end of my contribution."

Next, Topchy consulted Si Dang, a 1998 graduate of the University of Houston's architecture school. Besides working on commercial and industrial buildings, Dang cofounded in 1999 the Preston Workshop, an art and architecture collaborative supporting public engagement with contemporary, site-specific projects. He became the first committed member of the Topchy's nascent team. "When I first met him, I told him about *Hive*, and he got the vision right away. We became instant friends, and that fact that he could draw it?" Topchy snaps his fingers. "No problem. It didn't stump him. That was another indication that the guy could do it."

The project was publicly unveiled (under the working title *Organ*) when a drawing, the original maquette and other studies were included in Toby Kamps's No Zoning exhibition at the CAMH. Of the work, Kamps is enthusiastic, effusive: "It's the next phase of the extra-institutional, self-determining art world, culture, flowing, seeping into life."

Not everyone was quite as enraptured. "Nestor Topchy's maquette and images for 'Organ' feel a little sad," snarked the *Houston Press*'s Troy Schulze in his review of the show, calling it the kind of project that "has a golden heart but will probably never actually happen due to prevailing self-consciously cynical attitudes." Of course, only time will tell for sure, but Topchy and his team are moving forward with vigor, and he insists that with $500,000 to start, the project is shovel-ready.

Since No Zoning, the *Hive*'s support staff has expanded considerably. Topchy met Heidi Vaughan when, as a public events coordinator at the Menil Collection, she asked him to give a lecture and demonstration about fresco painting. Before long, he'd invited her in turn to become *Hive*'s executive director. Topchy picked up Juan Walker, another CSAW alumnus who happened to also have experience creating habitable buildings from shipping containers, as his construction manager. Engineer Hisham El-Chaar's résumé ranges from work at Walt Disney World to water transmission projects in Abu Dhabi. Mayrav Fischer, his consultant for public programs and education, worked in the education department at the Guggenheim before moving to the Museum of Fine Arts, Houston. Topchy's wife, Mariana, was bestowed with the titles of performing arts curator and fundraising director, no small task for a project that needs serious money to get it off the ground. A volunteer attorney and a coalition of volunteer business and artistic advisors round out the team.

If this sounds like a lot of cooks in the kitchen, well, it is. But then again, it's an unusually ambitious project for an artist. "It takes a village to raise a village," Topchy remarked, admitting that as a creative thinker it's something

of a mixed blessing. "What if the Orange Show guy had to get a consensus to do what he wanted to do," he asked rhetorically, "or the guy who did the Watts Towers?"

"I think as artists we all fall to the left somehow," said Topchy. "Because our aim is true, and in order to catch that wave, that inspiration, we have to be willing to jump. It's better to have great intentions and face the mystery in something, and not understand which genre its transcending and which genre its including at the time, but knowing it's going to bear fruit in the future and explain itself. This will come true."

Munger Street isn't all that far from the plot of land on the bayou that the *Hive* team has been eyeing for its complex, and another designer has ambitious plans of his own for the long, skinny tract of virgin land just north of the Orange Show.

On an unseasonably chilly October morning, in front of a mosaic-edged billboard displaying an artist's rendering of the completed site, stood a wiry older man with glasses, a gray ponytail and a bushy mustache alongside an eager young artist enveloped in a black, hooded parka. Builder Dan

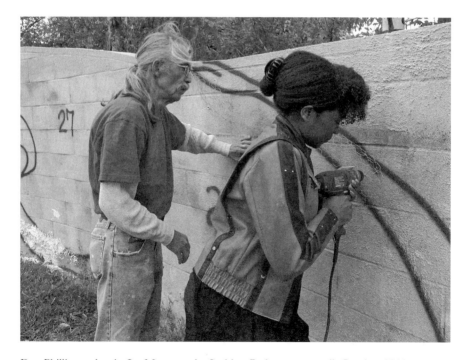

Dan Phillips and artist Joy Moore at the Smither Park memory wall, October 2011.

Phillips was taking sculptor Mayte Porras on an imaginary tour of what will over the coming years be transformed into a "memory park" honoring the tradition of visionary artists in Houston and beyond, as well as attorney, arts patron, collector, father, husband and friend John Smither, who succumbed to lymphoma in June 2002.

Smither was a senior partner at Vinson & Elkins, Houston's largest law firm, where for thirty-six years he specialized in labor and employment litigation. He served as the president of the Houston Ballet in 1998 and '99 and then as the chairman of its foundation until 2002. He was also a director of the Folk Art Society of America and a member of the Orange Show's board for fifteen years, where he was instrumental in the foundation's acquisition of the Beer Can House. He met his future wife, Stephanie, when they were both teenagers growing up in Huntsville, seventy miles north of Houston, in the '50s. They married in 1960, raised three children together, traveled the world and assembled an incredible private collection of folk art. "Art in all forms represents the conscience of society," John wrote in 2001 for a statement in the Orange Show Foundation's strategic plan. "Where art flourishes, culture flourishes."

They formed a close friendship with Phillips, who was pointing out some of the key elements of the park's proposed design. Here's the grotto amphitheater. Here's the meditation garden. Here's an elaborate track on which quarters will roll merrily toward an underground container, where they'll be shop-vacced into the coffers of the foundation for park maintenance. And snaking behind it all is the memory wall. That was of particular interest to Porras as she's one of the hand-picked young artists who'll create one of fifty linked folk art mosaics that will adorn it when complete. "They can't just be a design," he told Porras. "We want something with content. And I don't want you just to pull from inventory. I want you to be outrageous!"

He talked to us about the work with an unbridled enthusiasm that had his head bobbing and his sinewy frame shifting from side to side. "Are you a dancer?" asked Porras. It just so happens that Phillips studied and taught modern dance for years. I was reminded of the famous quotation most often attributed to Martin Mull: "Writing about music is like dancing about architecture." Well, yes. Here was Dan Phillips, dancing about architecture.

At that point, only a bit of mosaic work had been completed: a fish-themed panel by Stanford undergrad Sabrina Bedford, who'd spent the summer with Phillips as an apprentice, and an angel by Edie Wells, an artist, teacher and the administrative director of Phillips's building enterprise, the Phoenix Commotion. The rest of the four-hundred-foot wall was still bare cinderblock,

with numbered sections above, below and between graceful, wave-like curves marked by spray paint all along its length. Porras was here that day for a brief consultation, during which she would be briefed on the concepts behind the art of the memory wall and given some practical tips on the safe and efficacious use of chicken wire and thin-set mortar. Soon, we were up to our elbows in charcoal-gray goop with the texture of buttercream cake frosting, scooping it by the handful and slinging it at the wall as we began to build out the ropy curve that will bring unity to the mosaics. "Reminds you of being a kid, doesn't it?" asked Phillips, patting me on the back as he passed.

Later, we were shown around an immense warehouse owned by the Orange Show Foundation stuffed with tools, a few orphaned art cars and more raw materials than a typical junk shop—the decommissioned dishware, lamps and mantelpiece knickknacks that have until recently clogged the attics and storage units of foundation friends and patrons. Other materials bear a special significance. Stephanie Smither donated a "best camper" trophy her late husband earned in his childhood for inclusion in the memory wall. The goal is to cover every inch of it with elaborate bricolage, producing something along the lines of the Watts Towers murals or those of Philadelphia's Isaiah Zagar, who has transformed more than one hundred public walls in the city of brotherly love into eye-popping visionary art ("I just put one thing next to another," he explained modestly in the 2008 documentary *In a Dream*).

Phillips, Smither and Barbara Hinton donned hardhats encrusted with corks, shells, figurines and plastic fruit for the official groundbreaking in February 2011. Instead of driving their spades into the earth, they produced mosaic chips by smashing dinnerware with the tips of their shovels. Stephanie's hardhat now rests on her coffee table as something of a centerpiece in a room hung heavy with some of the finest outsider art available on the planet. There's a Thornton Dial canvas over the fireplace. A few busts fashioned from bottle caps and paint brushes by Gregory "Mr. Imagination" Warmack line the shelf behind the bar, and around the corner, there are mosaic-tiled figurines by Nek Chand, a former road inspector who secretly turned twenty-five acres in Chandigarh, India, into an enchanted kingdom known as the "Rock Garden," all built from trash.

There are Bill Traylors on the wall, and on the piano, there is a miniature cathedral made from hundreds of tiny shards of broken glass by another of Houston's folk art enigmas, Vanzant Driver. The doorbell rang at Smither's home, and a courier from the Menil dropped by to return a loaned canvas ("Would you mind signing for this?"). It all adds up to a positively breathtaking collection of contemporary folk art.

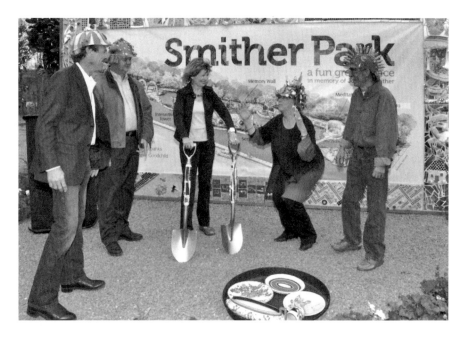

Builder Steve Goodchild and Todd Johnson with Barbara Hinton, Stephanie Smither and Dan Phillips at the dedication of Smither Park, February 2011. *Courtesy Orange Show archives.*

In the library, surrounded by the work of the Texas folk artist Johnny Swearingen, Stephanie was curled up on the couch and puffing on an electronic cigarette as her cat glided around the room like a little storm cloud. Stephanie is an animated talker, her hand seeming to paint on an invisible canvas in the air in front of her as she speaks.

For years, she and John had been interested in African art, and his Christmas gift to her in 1987 was a five-week trip to Cameroon and the Ivory Coast. With John tied down with work back in Houston, Stephanie "didn't know a soul" on the museum-sponsored trip, but she quickly hit it off with a quiet, understated man named Bert Hemphill. "It seemed like he needed a little help being taken care of," she remembered, "and we got to be friends." He told her about his collection of folk art, which happened to be one of the largest and most exquisite in existence; in fact, much of it had recently been purchased by the Smithsonian Institution. Stephanie didn't immediately get it. "To me, folk art was duck decoys, weathervanes and quilts," Smither said, shrugging, "what we now think of as Americana."

Hemphill was a pioneering figure in the study of contemporary folk art, one of the first collectors to appreciate, purchase and promote such work. In 1962, he founded the Museum of American Folk Art, and in 1974, he

coauthored the field's first serious reference work, *Twentieth Century Folk Art and Artists*. "Bert had enough money that he didn't have to work much," Smither said, "but he didn't have a lot of money to spend, and this work was very, very cheap at the time."

She kept in touch with Bert and offered to host him in Houston while he trawled the back roads of Texas for new artwork. "I don't know how I knew to call the Orange Show," she said, "but they gave me a list of places to visit, and we struck out over Texas." Bert and Stephanie hooked up with John's brother in Dallas, the preeminent gallery owner and art dealer Murray Smither, and as a trio, they visited artists in Dallas, San Antonio and in between. "I fell instantly in love with the work," she said. "It spoke to my heart."

It was the first of several such treks, in which she and Bert (and sometimes John, if his work schedule allowed) would drive around the American Southeast in a Suburban, calling on important folk artists like Mose Tolliver and Howard Finster, buying art and eating barbecue three times a day. One memorable road trip culminated in a jam session on painter Jimmy Lee Sudduth's porch in Fayette, Alabama, with Jimmy Lee blowing harmonica, Stephanie playing a battered piano and golden-voiced John singing "Amazing Grace." "You could do that back then," she said wistfully. "It was so special to travel and get to know these artists. It's rarely possible anymore."

The Smithers were off and running with their collection, and soon they were invited to join the boards of the Folk Art Society of America and the Orange Show. It was also around this time that they bought the home that had belonged to John's grandparents in Huntsville and had it moved to the shores of nearby Sunset Lake. They needed help reassembling and renovating it, and that's what brought them into the shop of Dan Phillips and his wife, Marsha, where they restored and sold furniture and folk art.

"I had gotten to know Dan," said Stephanie. "Anytime I went hunting for folk art near Huntsville, he seemed to be there. If I went to a yard sale somewhere, there was Dan. If I went rummaging around in somebody's attic, there was Dan." He restored some tramp art they owned, and given their budding friendship and Phillips's inclination toward building, he was obviously the man to do the renovation.

"They were fun," said Phillips, "because they had the resources to do whatever they wanted to. I'd come up with these lunatic ideas, and they'd say, 'Yeah, let's do that.'" For example, Phillips, who besides being a modern dancer and a former army intelligence officer had also syndicated a cryptogram puzzle to newspapers across the county, proposed installing a series of secret compartments in the Smithers's Huntsville home.

"Give me two $100 bills," he told them. "I'll tear them in half and put each piece in a separate compartment. Then I'll give you a year to find them. If you find halves that match up, you keep them. If you don't, they're mine." A clue given in German, albeit spelled backward, proved to be too easy. The Smithers found another half by accident. But the halves didn't match, and they failed to find the others. At the end of the year, Phillips collected his two hundred dollars.

Phillips was born in 1945 and grew up in Littlefield, Colorado, the youngest of three children. His father, George, owned a lumber company; his mother, Phoebe, was a housewife. As a kid, he built treehouses and explored the local junkyards. Lacking the money for a new bike, he made his own from scrap when he was fourteen.

By his early twenties, he was attempting to stay one step ahead of the draft by attending school and teaching at the University of North Carolina, where he earned his doctorate in education, and at Sam Houston State University in Huntsville, where he found his future wife, Marsha. When he finally ran out of deferments, he studied to become an intelligence officer and served for two years in Germany. He returned to Huntsville to teach modern dance at his alma mater for much of the '70s, and while he's still an adjunct professor there, he'd already drifted into antiques restoration by 1983.

When a few lots near the Sam Houston campus came on the market in 1996, Phillips decided to take the plunge and pursue a long-considered dream of building houses from reclaimed materials while at the same time helping people in need. With Marsha's blessing, Dan mortgaged their home to establish his construction company, the Phoenix Commotion. Self-trained as a builder, plumber and electrician, he bought the lots and, after eighteen months of labor, completed his first house in 1997. Number 1323 Avenue N is an eccentric, charming little Victorian inspired by San Francisco's "Painted Ladies." It's made largely from salvaged items, including the double front door, the stained glass in the front spire, absolutely everything in the kitchen and the shingles that clad a fanciful turret topped with architectural buttons made from plaster of Paris–filled eggshells. A bookstore clerk named Annie Zellar bought the house for just $68,000, and it changed her life. "I'm real quiet," she told *People* magazine, who picked up on the story in 2002, "but this house has taught me to be more creative and extroverted."

Over the next decade, Phillips and his crews built a total of fourteen quirky homes in Huntsville. He invited me to make the hour and a quarter drive up Route 45 from Houston, past sculptor David Adickes's sixty-seven-foot concrete statue of Sam Houston[11] and the Huntsville State Prison, where

Phoenix Commotion houses in Huntsville, January 2012.

Frank Jones and the Magnificent Pretty Boy Clark once did time, and I was rewarded with a tour of many of the properties.

Next door to the original house on Avenue H is his second construction, the so-called Budweiser House, easy to spot with its red-and-white checkerboard pattern and a barley-and-hops design on the front gable. As we continued to cruise the neighborhood, we found what's known around town as the "Storybook House." With its Tudor half-timbering and its mushroomy roofline, one imagines Little Red Riding Hood's grandmother living there. On the adjacent lot is another of Phillips's constructions. It's an artful spin on the Charleston courtyard style, clad in reclaimed chocolate brown shingles behind an ornate metal gate and a fence punctuated with striking bottle art. Fully three-quarters of the material used in each of Phillips's projects were at one point destined for the landfill.

When he first began building, skeptical city inspectors hovered around his job sites. But as they've come to know Phillips, they've grown to be some of his closest allies, helping him research the laws concerning various unusual building materials—like, say, surplus foam rubber. Energized by Phillips's work, in 2004, town officials went so far as to open a warehouse facility called Trash into Plowshares, where manufacturers and demolition crews earn tax

deductions when they drop off excess materials that would otherwise have ended up at the dump.

Phillips pointed out that he's hardly unique as a builder working with reclaimed materials ("Just take a look at the Third World, for example"), but what does set him apart is the social mission of his project. He favors energy-efficient and environmentally sensitive designs with abundant insulation, tankless hot water heaters and toilets and washing machines that draw from rainwater cisterns. He mentors unskilled laborers who work for minimum wage but invariably graduate to higher-paying jobs with other crews. And he rents to struggling artists or sells to low-income families who otherwise would have no hope of owning a home of their own. He stressed that the Phoenix Commotion is an entirely for-profit endeavor. ("I have control over what I do and how I do it," he said, lighting another cigarette. "If I want to sell T-shirts, or pancakes, I can.") But he also works in concert with a nonprofit organization called Living Paradigm, which helps families of limited means build their own sustainable homes.

As our tour continued, he pulled up in front of a modest house on a corner lot and shook his head. "This house was built by a single mother and her daughter. I was the mentor, but they did about 60 percent of the labor. When she finished, her payments were $199 per month, taxes and insurance included." Then, he explained, old friends from a safe house showed up, moved in, ate her groceries and refused to pay their way. She quickly fell behind on her monthly payments. "She defaulted," he sighed. "That's the cycle of poverty. Tough lesson for her; tough lesson for us." We drove on.

It's not the only time that a resident of Phillips's properties has defaulted, and in those cases, someone else is always eager to move in. "That's the way gentrification goes," he said. "I'm targeting lower-income families, but when they sell, the gentry move in. That's not all bad, because it means the middle class is buying into the concept. I'm okay with it."

Around the corner on Thirteenth Street, we parked in front of what's become one of Phillips's most famous works, which he completed in 2006. As seen from the street, there's not much to attract attention. Sure, the exterior is slathered in a thickly scored stucco undercoat, and the porthole windows made from Pyrex dessert dishes and casserole lids do catch the eye. Moreover, the recycled brick drive and diamond-patterned wood trim are giveaways that this is a Phoenix house. But as we walk through a gateway and onto the back deck, we find the main attraction: an expansive wooded view and a small wooden outbuilding lodged thirty-five feet above Town Creek in the limbs of an enormous Osage orange bois d'arc tree. Otherwise known

as *Maclura pomifera*, the bois d'arc (pronounced "bodark") has talismanic properties as far as Phillips is concerned.

"The wood doesn't rot, and termites don't eat it," said Phillips. "There are fence posts made of bois d'arc up in Oklahoma that are over a hundred years old. Treated wood doesn't last that long. Metal doesn't last that long. The tree is still as healthy as when I first built that house. But even when that tree dies, it's still going to be there for another seventy-five years." With its iridescent grain, the wood is prized by sculptors and jewelers, but all too often it's considered a nuisance by developers and cavalierly tossed on a bonfire.

We crossed the deck and went up a small stairway with a railing made from twisting, rough-hewn bois d'arc branches. We were still firmly in storybook territory, and I had to wonder if Dan sometimes hires elves or fairies for his building crew. Inside the tree house are all kinds of interesting little details. A small window in the floor allows for an astonishing view of the creek directly below. The kitchen counter's shiny veneer is made from circular slices of bois d'arc limbs, and wine bottle corks cover the bedroom floors in a dramatic, rippling pattern. We stepped out onto a tiny balcony that put us up in the sylvan canopy. We were in the very center of Huntsville, and only a stone's throw from town hall, yet the sense of quietude and isolation was pervasive. "Anyone who doesn't like a treehouse is bound to have had a bleak childhood," Phullips said, breaking the silence after we pause to listen to the birds sing.

Stepping inside the main house, a rentable studio space for artists, the visitor's gaze is immediately drawn upward to a ceiling completely covered in thousands of mismatched, wildly zigzagging frame corner samples. "When they rotate their inventory, they just throw these things away," said Phillips. "And of course, I'm standing there. Repetition creates pattern; now it's an elaborate herringbone design on the ceiling." The bathroom sink is recycled, drizzled in an aqua glaze and refired in a potter's kiln. "Suddenly it sings songs," observed Phillips. The door to the bathroom is covered in shards from a twenty-four-karat dish set given to him by the mother of a friend who died a few years ago. "'Do you suppose you could find a place in your project for these?' she asked me. So here it is, Joey's door." A wood stove once resided on a nineteenth-century ship. Its heavy, dark iron filigrees make for a neat contrast with the modern white porcelain tiles that surround it. "This is the kind of house you just want to *be* in," I remarked. "Yep, that's the point," said Phillips, winking. Last September, the Huntsville City Council passed an ordinance allowing residents to sell baked goods from their homes. Now the artists renting this studio have a thriving cupcake business.

Next, we were a bit farther down on Avenue N and walking up to what's popularly called the "Bone House." This is actually the second Bone House, the first having mysteriously burned to the ground in February 2009, only a few months after its completion and only a day before its tenant, a dance student, was due to move in. But just like the organization's namesake, this house has risen from its ashes and contains many elements of the original. Phillips began rebuilding almost immediately after the fire, and before the work was through, he had acquired the help of a gaggle of University of Kansas students who drove all the way from Lawrence in a creaky van, inspired by a piece on Dan's work in the "Home and Garden" section of the *New York Times*.

Inside and out, the bone motif is seen everywhere, in vertebrae that resemble smiling faces and are hung like Christmas ornaments, in the ribs used as deck railings and in a full set of patio furniture made from wood and bone. A few years back, a local butcher had offered Phillips his leftover beef bones. They reminded Dan of the ivory he'd sometimes worked on back when he was restoring antiques and struck him as being the very structure of life itself. "Nice little primal slam on the staircase here," he said, motioning toward bones that serve as end pieces to each step. The surfaces of the steps themselves are made from swirling circular cross-sections of bone, covered in a shiny polyurethane finish. Bones make up the uneven surface of the kitchen counters. Even the drawer handles are made from bone.

The floor of the bedroom upstairs is inlaid with bottle caps. Floor tiles are made from bamboo and sliced redwood. A gorgeous stained-glass window near the arched ceiling was lifted intact from a dumpster. The stools mounted at the kitchen's bar came from Huntsville's old Goolsby Drugstore that went out of business in the early '80s. Every square inch of the bathroom walls is covered in a mosaic of broken mirror shards. "Yeah, if you don't feel good about yourself naked, you shouldn't be in that bathroom," Phillips deadpanned.

The cracked mirror motif is repeated on a large wall in the studio in back, which currently serves as the workspace of his assistant, Edie Wells. In the center of this airy, high-ceilinged room is a ladder and a twelve-foot scaffolding from which hangs a tangle of aluminum drywall corner mounts. It's the trial-and-error laboratory in which the Smither Park coin-drop is being engineered. So far, so good: Phillips dropped a quarter in the uppermost slot, and in Mousetrap-like fashion, it clanks from bracket to bracket until it drops to the floor and rolls away.

On the way out, I notice a large metal bouquet sculpture made from scrap metal, wire and a few cast-off DVDs. One of the abstract metal shapes had

been the original house's copper fuse box wiring, and another had been a pneumatic drill gun; both melted to puddles in the fire. "Perennials," he said dryly as I took a closer look. "Have you ever shown these smaller sculptural pieces in galleries?" I asked. "Oh, occasionally," he said, shaking his head and making a sour face. "But then it becomes something different. If I show a chair, then I'm a chair builder, not a builder."

Before we returned to the current job site, he wanted to show me just one more construction, his latest, which he finished in November. It's an office building commissioned by his friends at T.J. Burdett and Sons Recycling. He doesn't normally do commercial buildings, he explained, but he offered to donate his services in exchange for complete control over the design, as well as permission to cherry-pick from its inventory and store materials on its lot in perpetuity. The Burdetts enthusiastically agreed.

Dan's battered truck rumbled over muddy ruts and through puddles like small ponds, squeezing in between precarious piles of twisted metal. "It's like a candy store in here, innit?" he said with a smile as he hunched over the steering wheel. We parked, and he led me to a small cabin somewhat in the distance. As we got closer, the entire structure seemed to yaw to one side, as if being blown by a strong cartoon wind. Inside, it's full of signature Phillips techniques. The ceiling is covered with the mirrored playing surface of old CDs, which magnify the effects of a bit of track lighting and fill the room with bright light. Interior walls are made from irregularly stacked granite countertop samples spiked with pieces of broken stained glass, and the exterior walls are covered with old metal signs, including Burdett's original hand-painted billboard from the company's earliest days. Dan pointed to Burdett's logo, a riff on the familiar image of a pointing Uncle Sam. He's crushing an empty in his other hand alongside the legend, "I Want Your Can!" "Take a look at that," he said, "You'll want to remember it."

We stepped back into the muddy lot and walked around to the rear of the building that faces the highway. Dan lit another cigarette and nodded his head in the direction of its back wall. It's Uncle Sam again, this time twenty feet tall, rendered in eye-popping, multicolored scrap metal—hubcaps, squashed fenders, springs, dented sheets of corrugated steel and precisely cut slivers of reflective highway signage. Dan chuckled as he pointed out the buckshot-perforated piece of metal placed right in the center of Sam's chest. The band of Sam's hat bears the tri-cornered recycling logo rather than a star. Sam's powdered wig is represented by tufts of wadded metal mesh, and a length of iron pipe is clenched in his mouth like a cigar. "I Want Your Can!" he bellows in an enormous die-cut speech balloon. In the moment,

it struck me as possibly the most stunning piece of art I've laid my eyes on. John Chamberlain would probably have loved it. "Isn't that just goofball?" Phillips asked. It's the work of his protégée, Matt Giffords, who pieced it together over the course of four months.

Giffords is one of the vanload of students who came down from Kansas in early 2010. He had graduated in December 2009 and was working part time in a bookstore and candle shop while "looking for something to do with this fancy degree I'd just earned," he told me the following weekend as a day of work was about to begin at Smither Park. He'd studied metal smithing and jewelry making but became disillusioned after watching documentaries on South Africa's blood diamonds. "Could I really spend my energies as an individual contributing to something so inherently materialistic and shallow, just making fancy, shiny things for rich people? I guess I just had too much hippy in my blood." When a friend showed him the *Times* article, the course of his life changed. "My jaw just dropped," Matt said. "I knew I had to go work for this man."

After the group's week of work on the Bone House over spring break, he gave Dan his résumé and portfolio and pestered him with monthly phone calls and care packages full of corks, beer labels and bottle caps he collected from the bars that flanked the campus. In June 2010, said Giffords, "I just decided to move to Huntsville and get a job flipping burgers until a position opened up." Okay, Dan told him, you can stop bugging me. You've got a job.

"I'll be hard-pressed to find a better boss," he said. "He's really spoiled me. He's just so compassionate and kind and treats you like an equal, which is rare. You can tell when he asks your opinion that he's sincere."

Stephanie Smither was at the worksite, too, all smiles, with some four-foot mosaic tiled figurines she's made from plaster and swimming pool noodles. They looked like something right out of Nek Chand's Rock Garden, and I helped to hold the largest against the wall so she could mark off where to drill holes for its mounting brackets. On this unseasonably warm January morning, a bustling community of artists had begun to assemble, and the memory wall was just starting to take shape.

When Stephanie first proposed the creation of Smither Park to the Orange Show Board in the fall of 2010, she insisted on Phillips's involvement; no other designer was even considered. But he's got plenty of help. Like Phillips, architect Ed Eubanks and builder Steve Goodchild both agreed to donate their services. There's the growing crew of mosaic artists and the invisible hand of the Orange Show staff, working out logistics. "But from the start, Stephanie told me that I'm the head stick," Phillips said, "and that nothing

gets done unless I approve it, and I take that seriously. I don't want this to be a free-for-all. If one guy doesn't have his thumb on everything, it just ends up as mush." The park is expected to be complete by early 2015. On this point, the sixty-six-year-old Phillips is unabashedly frank. "There's no time to lose. I'm in my end game."

"You'll find very few people who aren't afraid to fail," Phillips continued, "because of our ingrained cultural expectations. You know, you better do it right or you're a bad boy! One of my conspicuous abiding skills is that I have the nerve to fail. I don't care about money, and I don't care what people think." Jeff McKissack had that skill. John Milkovisch, too. Also Cleveland Turner and Victoria Herberta and Bob Harper and Ida Kingsbury and Nestor Topchy and Jim Pirtle. These men and women didn't ask permission, and they weren't afraid to fail. "I don't know where it comes from," said Phillips with a shrug. "It takes an artist. They're willing to fail. Who else is that lucky?"

# NOTES

## CHAPTER 1

1. Consisting of architect/designers Chip Lord, Doug Michaels and Hudson Marquez, Ant Farm is probably best known for their 1974 installation *Cadillac Ranch*, a row of ten mid-century Cadillacs buried nose-down in the desert west of Amarillo, near the former Route 66.

2. After six years as director, Adler was edged out in the aftermath of a controversial show in March 1972 celebrating the opening of the CAMH's new building. Entitled *Ten*, it showcased ten pieces of cutting-edge art, including Newton Harrison's *Portable Farm* (with crops growing horizontally from its upright pastures), Michael Snow's colored light show broadcast on the Goodyear Blimp high above the city and, most notoriously, Ellen Van Fleet's *New York City Animal Levels*, with rows of stacked cages filled with cockroaches, rats, kittens and pigeons. The rats escaped into the crowd on opening night, the remaining animals eventually began killing each other and the stench of feces and rotting carcasses and vegetation soon became unbearable. The show was a critical success, but the public was scandalized, as were some board members, leading to Adler's departure.

3. The Palais Ideal in the southeast of France is one of the world's most impressive large-scale visionary art environments, constructed single-handedly by Ferdinand Cheval (like McKissack, a postman). Having tripped over an unusually shaped stone in 1879 on his mail route, Cheval became inspired to spend more than thirty years gathering rocks and

cementing them together into an elaborate stone palace with an Egyptian tomb, a Hindu temple, an Islamic mosque, a Swiss chalet and a pool and waterfall among its features. In 1912, the elderly Cheval opened the completed site to tourists, and his work was championed by Surrealists, including Andrew Breton and Max Ernst.

## Chapter 2

4. You'll find few swimmers in Buffalo Bayou today. Although considerably cleaner now than in the '70s, when it hosted the Reeking Regatta (billed as the "World's Smelliest Canoe Race"), it is still a breeding ground for bacteria that cause dysentery and is not recommended for swimming by the Parks Department.
5. This house still stands today, having been moved in 1984 to the corner of Phil Fall Street and Sackett Avenue, one of the "Gardens of Bammel Lane," fifteen restored turn-of-the-century cottages now housing boutique shops.

## Chapter 3

6. The plot of land on which Emancipation Park was founded was purchased for $800 in 1872 by a coalition of neighborhood churches as a place to hold the black community's annual "Juneteenth" celebration, commemorating the arrival in Texas on June 19, 1865, of the signing of the Emancipation Proclamation two years previously. Even decades later, after it had been acquired by the city, it was the only municipal park open to Houston's African American citizenry.
7. This happens to be the same make and model that artist Walter DeMaria meticulously restored and then pierced with twelve-foot stainless steel metal rods for his *Bel Air Trilogy* (2000–11), unveiled in Houston at the Menil Collection in September 2011.
8. As the Art Guys, Massing and his collaborator Michael Galbreth explore the absurdities of modern culture through conceptual art gestures. Since they met as U of H students in 1982, they've worked a twenty-four-hour shift at a Stop and Go, worn suits covered in advertising logos for

a year, mounted an exhibit of small trinkets pilfered from local museum directors and gallery owners and married an oak tree sapling in a large ceremony held in the Cullen Sculpture Garden at the Museum of Fine Arts, Houston. In 1995, a *New York Times* writer described them as "a cross between Dada, David Letterman, John Cage and the Smothers Brothers."

## Chapter 4

9. Like Lassie and Cheetah, there were several "Ralphs" over the years. They performed at the theme park alongside a witch doctor named Glurpo and a school of "Aquamaids," who ate pickles and drank Dr. Pepper underwater. Attendance declined in the mid-'80s, and Aquarena Springs is now a university-administered education center rather than a tourist attraction.

10. In the end, Kienholz didn't make the published article, and he'd be dead of a heart attack within the year, felled during a hike in the mountains near his Idaho ranch. In a memorial sendoff (and his final installation piece), his wife and collaborator, Nancy, placed his embalmed body behind the wheel of his 1940 Packard with a dollar and a deck of cards in his pocket, along with a bottle of 1931 Chianti and the ashes of his dog, Smash, by his side, as if he were being preserved in some modern-day sarcophagus with everything he'd need for the afterlife. Bagpipes droned in the background as the car rolled down a ramp into a hole dug on their property.

## Chapter 6

11. Adickes is a divisive figure in Houston's art community who's well known for his large-scale, ivory-white sculptural work, including busts of U.S. presidents that face Interstate 10 just northwest of downtown and a thirty-six-foot abstract cellist entitled *The Virtuoso* at the foot of the Lyric Centre. "Big Sam" was commissioned by the Town of Huntsville in 1994 to mark the bicentennial of Sam Houston's birth, and according to the town's visitors bureau, tax receipts from travel spending have increased by half in the years since. But art critics have had trouble warming to his

work. In 2004, Susie Kalil complained in the *Houston Chronicle*, "Adickes's work isn't funky enough. It's not hard-hitting enough. It's not surprising enough. There are absolutely no political, aesthetic or social issues. What is its purpose?" Houston photographer Don Francis snapped, "For David Adickes to be famous and Jeff McKissack unknown is obscene to me."

# INTERVIEWS

*All interviews were conducted in Houston unless otherwise noted.*

Alexander, John. Phone interview from Amagansett, New York, November 29, 2011.

Armstrong, Cameron. Personal interview at BRC, December 12, 2011.

Birsinger, Julie. Personal interview at Down House, December 19, 2011.

Bosch, Missy. Personal interview at Antidote, December 15, 2011.

Davenport, Bill. Personal interview at Bill's Junk, February 11, 2012.

Eckley, Ty and Ginny. Personal interview at their home in Kingwood, Texas, July 17, 2011.

Guevara, Ruben. Personal interview at the Orange Show, August 22, 2011.

Harithas James. Personal interview at the Station Museum, September 26, 2011.

Hinton, Barbara and Marks. Personal interview at Starbucks, June 20, and McDonald's, July 29, 2011.

Jacobs-Pollez, Rebecca. Phone interview from St. Louis, Missouri, September 23, 2011.

Kachtick, James. Phone interview from his home in Houston, July 2011.

Kamps, Toby. Personal interview at the Menil Collection, January 20, 2012.

Kopriva, Sharon. Personal interview at her studio, August 28, 2012.

LaFaver, Tom. Personal interview at Teotihuacan September 29, 2011.

Lowe, Rick. Personal interview at Project Row Houses, December 16, 2011.

Martin, William. Personal interview at James Baker Institute for Public Policy, Rice University, September 4, 2011.

Massing, Jack. Personal interview at Alma Latina, December 28, 2011.

Milkovisch, Ronnie. Personal interview at the Beer Can House, November 13, 2011.

Oshman, Marilyn. Personal interview at her home, November 16, 2011.

Phillips, Dan. Personal interview at Smither Park, then Bohemeo's, October 29, 2011, and on a tour of Phoenix houses in Huntsville, Texas, January 10, 2012.

Pirtle, Jim. Personal interview at Notsuoh, July 14, 2011, and various other dates.

Randolph, Lynn. Personal interview at her home, October 5, 2012.

Siml, John and Barbara. Personal interview at 219 Malone, July 25, 2011.

Sims, Tom. Personal interview at Onion Creek, September 4, 2011.

Smither, Stephanie. Personal interview at home, October 25, 2011, and December 8, 2011.

Taylor, Bryan. Personal interview at Chicago Italian Beef, August 1, 2011.

Theis, David. Personal interview at Bohemeo's, September 12, 2011.

Theis, Susanne. Personal interview at Discovery Green, October 13, 2011 and January 13, 2012.

Topchy, Nestor. Personal interview at his studio, October 18, 2011, and December 19, 2011.

Turner, Cleveland. Personal interview at his home and elsewhere, several times from July 28, 2011, to January 2012.

# SELECTED BIBLIOGRAPHY

Andrews, David. "Outside Houston." *Common Ground* (Fall 2010).

Anton, Mike. "Houston Home Is Garbage, Literally." *Los Angeles Times*, November 6, 2001.

Armstrong, Robert. "Law's the Law, Even in the Best of Swine." *Houston Chronicle*, August 4, 2002.

Beardsley, John. *Gardens of Revelation: Environments by Visionary Artists*. New York: Abbeville Press, 1995.

Berger, Joe. "Spoiled Rotten Pig." *Weekly World News*, December 27, 1988.

Byars, Carlos. "Pig's Owner Gets Reprieve but Still Can't Bring Home the Bacon." *Houston Chronicle*, January 14, 1989.

Crossley, Mimi. "Beer Can Artist Hated to Cut Grass." *Houston Post*, circa 1980.

Davenport, Bill. "Notes from the Middle Aged Underground." *Houston Chronicle*, February 5, 2006.

Feldman, Claudia. "Houston's Beer Can House a Shrine to Its Creator." *Houston Chronicle*, August 13, 1993.

Flynn, George. "Urban Jungle Jim." *Houston Press*, May 5, 2005.

Fox, Stephen. *Houston Architectural Guide*. Houston, TX: AIAH and Herring Press, 1990.

Germany, Lisa. "A Keeper." *New York Times*, October 13, 2002.

Gray, Lisa. "The Fall of the Museum of the Weird." *Houston Chronicle*, December 9, 2008.

———. "How Strange Turns Normal." *Houston Chronicle*, July 29, 2007.

———. "Small Wonders." *Cite* (Spring 2002).

Harris, Beverly. "Jerome Seeks Return to Hog Heaven." *Houston Chronicle*, December 1, 1988.

Haywood, Elizabeth. "Whimsical Wonders and Fanciful Forms." *Texas Highways*, May 1993.

Hinton, Marks. *Visitor's Guide to the Beer Can House*. Houston, TX: Orange Show CVA, 2008.

Jacobs-Pollez, Rebecca J. "Eat Oranges and Live: Jeff McKissack, The Orange Show and the Orange Show Foundation." Master's thesis, University of Houston–Clear Lake, December 2000.

Johnson, Patricia. "It's a Small World." *Houston Chronicle*, April 20, 2002.

Kamps, Toby, and Meredith Goldsmith, eds. *No Zoning Artists Engage Houston*. Houston, TX: Contemporary Arts Museum, 2009.

Keasler, John. "The Heroic Saga of the Swimming Pig." *Sarasota Herald-Tribune*, September 1, 1984.

Kern, Laura. "Unreal Estate." *Houston Press*, May 6, 1999.

Lomax, John Nova. "Notsuoh Hit with Lawsuit for Bizarre 2009 Falling Man Incident." *Houston Press*, August 9, 2010.

———. "Notsuoh Suit Over." *Houston Press*, December 13, 2011.

———. "Small Wonder." *Houston Press*, May 16, 2002.

———. "Smoke Damage." *Houston Press*, June 27, 2002.

Lomax, Joseph. "Some People Call This Art." *Folk Art in Texas*. Edited by Edward Abernethy. Dallas, TX: Dallas University Press, 1985.

Marshall, Thom. "This Little Piggy May Stay Home." *Houston Chronicle*, March 6, 1991.

Martin, William. "What's Red, White, and Blue…and Orange All Over?" *Texas Monthly*, October 1977.

Marvel, Bill. "A Wacky, Wonderful Attraction." *Dallas Times Herald*, April 18, 1982, Q2.

McLeod, Gerald. "Day Trips." *Austin Chronicle*, October 6, 2000.

Moser, Charlotte. "Steel Walls Do Not an Art Museum Make." *Texas Monthly* (September 1974).

Murphy, Kate. "One Man's Trash…." *New York Times*, September 2, 2009.

Nichols, Bruce. "World's First Orange Show and It's Beautiful." *Providence Rhode Island Journal*, May 7, 1978.

Pincus, Robert. "Seymour Rosen, the Champion of Folk-Art Environments." *Sign On San Diego*, May 1, 2005.

Racine, Marty. "Bayou City Bohemia: Pretty Much Anything—And Anyone—Goes at No Tsu Oh." *Houston Chronicle*, December 3, 1999.

Rees, Christina. "Caught in the Webb." *Dallas Observer*, November 12, 1988.

Rust, Carol. "The Orange Show: Jeff McKissack Built a Monumental Dream after the Treasure Hunt of a Lifetime." *Texas Magazine*, November 26, 1989.

Serrano, Shea. "Easy Credit." *Houston Press*, July 13, 2011.

Simon, Lisa. "Transcendent Shelter." *Cite* (Spring 2005).

Somer, Sally. "The Saga of Priscilla the Pig." *Bend Bulletin*, November 29, 1985.

Spies, Michael. "Star Tries to Hog the Spotlight." *Houston Chronicle*, June 8, 1985.

Stone, Lisa. "Can-Do Spirit." *The Outsider* (Fall 2008).

Tennant, Donna. "Giant Wind Chime Might Be Called Kitsch Art." *Houston Chronicle*, June 24, 1980.

Theis, David. "Welcome to the Third World." *Houston Press*, June 2, 1994.

Theis, Susanne. "The Drive to Create: Three Handmade Personal Spaces in Houston." *Folk Art Messenger* (Spring 1998).

Turner, Allan. "Animal Action: The Hero Ham." *Boy's Life* (March 1988).

———. "Artwork or Violation?" *Houston Chronicle*, June 30, 2000.

———. "Fire Guts OK Corral Tribute." *Houston Chronicle*, September 11, 2004.

———. "Flower Man's Home Damaged, but Volunteers Flock to His Aid." *Houston Chronicle*, October 2, 2008.

———. "Flower Man Uses Found Objects, Living Plants to Create His Oasis." *Houston Chronicle*, February 6, 2000.

———. "Folk Artist Given Deadline to Move Some of His Works." *Houston Chronicle*, July 18, 2000

———. "Has Fame Spoiled the Heroic Pig?" *Galveston Daily News*, October 31, 1984.

———. "Interview with Jeff." *Orange Press* (March/April 1991).

———. "Lightning Kills Jerome the Pig." *Houston Chronicle*, June 1, 1994.

————. "OK Corral" *Houston Chronicle*, August 10, 2004.

————. "Priscilla the Pig Hogs the Spotlight to Win Award." *Montreal Gazette*, December 1, 1984.

————. "Social Studies: Update on Jerome." *Houston Chronicle*, September 24, 1989.

# INDEX

# ABOUT THE AUTHOR

Pete Gershon was the editor and publisher of *Signal to Noise* from 1997 to 2013. During that time, the quarterly journal of improvised and experimental music was nominated eight times as "Best Periodical Covering Jazz" by the Jazz Journalists Association and for "Best Arts and Creativity Coverage" by the UTNE Reader in 2004. He currently coordinates the Core Residency Program at the Museum of Fine Arts, Houston, and is editing the forthcoming monograph on the life and work of Bert L. Long Jr., one of Houston's most iconoclastic and beloved artists. He studied literary nonfiction with writer Michael Lesy at Hampshire College in Amherst, Massachusetts, and is working toward a master's degree in library and information science at the University of North Texas in Denton.

*Visit us at*
www.historypress.net

·····································

*This title is also available as an e-book*